THE
ENCYCLOPEDIA
OF
PAINTING
TECHNIQUES

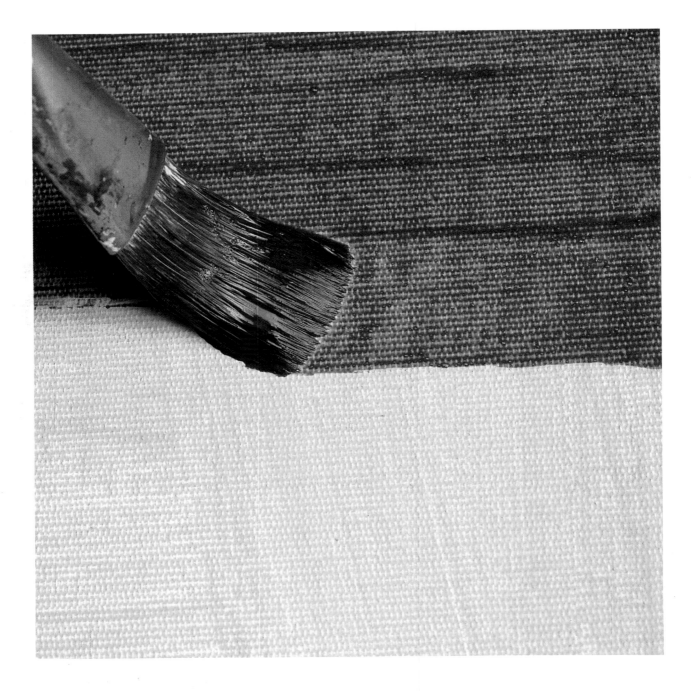

THE
ENCYCLOPEDIA
OF
PAINTING
TECHNIQUES

ELIZABETH TATE

Macdonald

A Quarto Book

Copyright © 1986 Quarto Publishing Ltd
First published in Great Britain in 1986
by Macdonald & Co (Publishers) Ltd
London & Syndey
A Member of BPCC plc

British Cataloguing in Publication Data
 Tate, Elizabeth
 The encyclopedia of painting techniques
 I. Title
 751.4 ND1500
 ISBN 0-356-12383-9

This book was designed and produced by
Quarto Publishing Ltd
The Old Brewery, 6 Blundell Street, London N7 9BH

Senior Editor Sandy Shepherd
Art Editor Marnie Searchwell

Proofreaders Sophie Hale, Robert Stewart

Designer James Culver
Design Assistant Gill Elsbury

Photographer Ian Howes

Paste-up Patrizio Semproni

Art Director Alastair Campell
Editorial Director Jim Miles

Typeset by Leaper & Gard Ltd
Manufactured in Hong Kong by
Regent Publishing Services Ltd
Printed by Leefung-Asco Printers Ltd, Hong Kong

Macdonald & Co (Publishers) Ltd
Greater London House
Hampstead Road
London NW1 7QX

**The publishers would like to thank Daler-Rowney for their
generous contribution to this book.**

CONTENTS

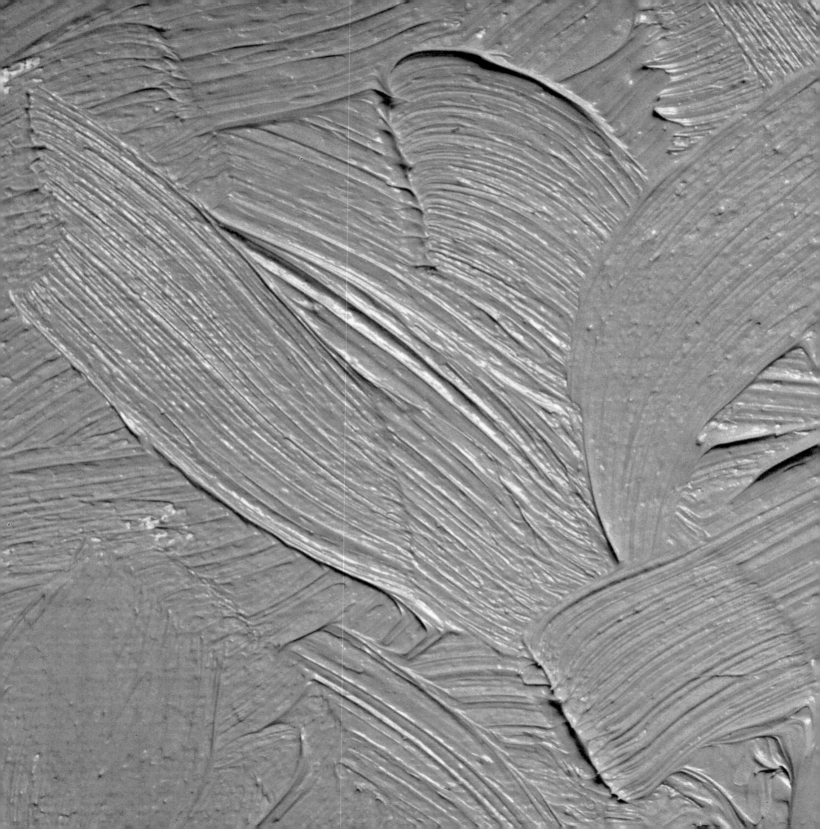

PART ONE

TECHNIQUES

T he theory that the language of painting pre-dates the spoken word as a means of communication is widely held. Precisely how, or for what reasons, our remote ancestors used painting for communication is not known and many psychologists and artists hold diametrically opposed views on this subject. However, what is certain is that whereas there are civilizations that have existed without written language, none has existed without some form of painting.

The history of painting and the techniques used by artists is fascinating not least because we do not know how some artists managed to achieve certain effects. In the National Gallery in London is the painting of the 'Arnolfini Marriage' by Jan van Eyck, which bears the date 1434. It is known that in this painting van Eyck used verdigrease (a green), lac (a purple-red) and orpiment (an orange). Today we know something about these colours but we are unable to use them ourselves — in the space of a few months the first goes white and the other two turn black. We do not know how van Eyck managed to isolate these paints so that they remain the lovely colours we see in his paintings today. Similarly, in the works of Sir Peter Paul Rubens (1577-1640), who painted very rapidly in contrast with van Eyck's slow and laborious methods, we do not know what medium he used. Many attempts have been made to construct it but to date none has been really successful.

Artists use what materials are available at the time. In the past, the way they painted changed because they discovered a new material or because the climate in which they lived forced them to find a new means of expression. For example, the frescos so popular in southern Italy, where the dry heat preserved them, soon deteriorated when painted in the damper, northern city of Venice. Artists in Venice therefore found a new support (canvas), adopted a new medium (oil) and, therefore, new techniques. Canvas was plentiful because the city was a sea port, and oil paint withstood the climate satisfactorily.

Today we do not have many of the colours used in the past because many have been replaced with new ones. Some of these, manufactured specifically for the plastics industry, are more brilliant and more stable than the older ones; for example, phthalocyanine blue has replaced Prussian blue and is superior to it in every medium. New materials are also increasing the range available to artists and with them new techniques are developed.

The usefulness of this part of the book is that it deals with the materials that are around now and presents an array of techniques which you can use with them. It deals with ideas

and is to be used both as a reference and a source in which you can find something you have not tried before. The author does not ask you to paint in a special manner, a traditional approach, or with abstract vision; she is more concerned that you should know what is possible. How you use the medium is your affair. She offers many suggestions which are useful whichever way you paint and does not go into the esoteric history of a paint or medium. Instead, her thesis is that there are a lot of materials and many ways of using them — some have been used for years and some are new. This is an exciting way to think about painting.

In a book of this size it would not be possible to mention all the ways of painting, nor would it be desirable. Over forty techniques are described here and the author's choice is not only interesting but often daring. For example, not many people would have the courage to include a section which describes how to make cracks in your own painting similar to those seen in many Old Masters' works, as is covered here under the title 'craquelure'. At the same time she has included straightforward, useful accounts of more traditional techniques, such as crosshatching. The purpose of this book is not to tell you what you ought to do but to acquaint you with what is technically possible now. It deliberately avoids an historical approach (a relatively modern technique — frottage — appears just before an ancient one — glazing) and concentrates on giving you ideas.

Most encyclopedias are not intended to be read from cover to cover, but dipped into to find out a particular fact. If you want to know what 'fat over lean' means and how to use it you can look it up here in the normal manner. However, it does pay to read this part of the book straight through because so many techniques are related or can be used together. The author is very aware of this relationship and throughout has provided useful cross-references. In this encyclopedia you will find a new approach to painting techniques. The format may seem familiar but what it sets out to do is quite different from anything that has been done before.

Whatever way you work, some of the techniques could be applicable to you and could help to alter the way you think. 'Blown blots' as used by children and Jackson Pollock (1912-56) many not be a technique you would normally use in painting, yet Leonardo da Vinci (1452-1519) writes about it in his notebooks, and Alexander Cozens (1717-86) uses a similar idea in his book on how to paint clouds and landscape. These are techniques to explore. I hope you enjoy them.

ALLA PRIMA

An Italian expression which can be translated as 'at the first try', this term describes a painting which is completed in a single session.

The alla prima approach involves working directly onto the surface, using rapid brushstrokes and working WET-IN-WET, as opposed to the traditional method of building up layer upon layer of colour. Often there is no preliminary drawing or underpainting: the idea is to capture the essence of a scene — the first impression — as boldly as possible.

The technique can be used with any medium — with the possible exception of egg tempera, which requires a more considered approach. However, alla prima is most often associated with oils and acrylics, which can be applied in thick IMPASTOS or worked wet-in-wet.

Alla prima painting first came into practice in the mid-nineteenth century when landscape artists such as Constable (1776-1873), in England, and Corot (1796-1875), in France, began rejecting the rather staid and idealized depictions of nature painted in the studio, which were then the accepted convention. Artists began to work directly from nature, which inspired a new liveliness and freedom of brushwork, a sense of light and spontaneity that could never be captured in the studio.

By the 1870s, when Impressionism was at its height, painters like Monet (1840-1926), Pissarro (1831-1903) and later Van Gogh (1853-90) were exploiting alla prima to the full to capture the fleeting effects of light which fascinated them so much.

The ability to apply paint quickly and confidently is the key to the alla prima approach, because you are dealing with shape, colour, tone and texture all at once. It is best to stick to a limited range of colours to avoid complicated colour mixing which might obscure the intended image. In addition, it is vital to start out with a clear idea of what you want to convey in your painting, and to dispense with inessential elements which do not contribute to that idea.

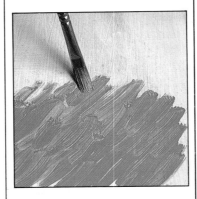

Alla Prima • Oil
1 Working on a prepared canvas board, the artist uses a No. 4 flat bristle brush to apply strokes of lemon yellow and sap green with short, spontaneous brushstrokes. The paint is diluted with turpentine only, so as to avoid the problem of cracking when further layers of thick paint are added.

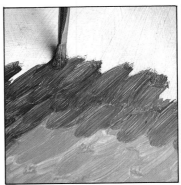

2 The artist continues to build up tones and colours, working wet-in-wet and allowing the colours to mix directly on the surface. Note how the previous layer of colour shows through in places.

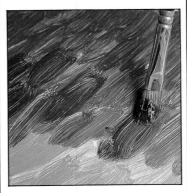

3 This is a swift, direct method of painting which can be used to create a bold and exciting picture. The shapes of the strokes themselves can add variety and movement to a scene. Each stroke should be applied decisively, otherwise the colours could become muddied. The advantage of using oil paint is that, if a wrong colour is put down, it can be scraped off easily and the artist can begin again.

Alla Prima • Pastel
In alla prima painting the advantages of working in pastel are obvious. There is no waiting for coats of paint to dry — a great advantage when you wish to capture a fleeting effect of the weather, or a moving cloud. A stick of pastel is ready to use as it is, without the need for brushes and other equipment; the pastel stick becomes an extension of your hand, allowing you to respond quickly to your subject. A single pastel stick is capable of producing a host of different effects: it can be blended with fingers, rags or stumps, built up thickly, dotted, scumbled, crosshatched, or combined with other media. In this illustration the artist is building up an area of colour with hatched and blended marks combined.

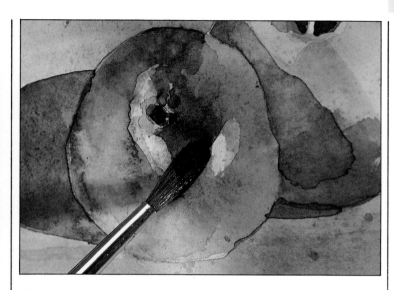

Alla Prima • Watercolour

Watercolour is often regarded as a rather exacting medium, requiring a lot of patience and skill. On the contrary, its effervescent, fluid behaviour makes it ideal for experiment and improvisation. By painting in the alla prima manner, you will learn quickly how to control and predict watercolour behaviour and how to capitalize on 'happy accidents'. In this illustration the artist is painting a group of apples. Working with fast, fluid brushstrokes, he reduces the forms to simple blocks of colour and applies the paint directly, combining glazes with wet-in-wet washes. The finished sketch captures the 'appleness' of an apple with freshness and simplicity.

BACKRUNS

Found in watercolour painting, backruns are those dreaded hard-edged shapes that sometimes creep into a clear wash when the paper dries unevenly and cockles. The backrun effect can, however, be used to advantage in a controlled situation, producing textures and effects that would be difficult to obtain with normal painting methods. The technique consists of dropping water or wet pigment into a wash that has lost its shine but is not yet dry. This loosens the paint and causes it to flow into the surrounding wash, accumulating in an irregular, hard-edged shape.

The manner in which the water or pigment is applied determines the finished result. For example, several drops of water, allowed to spread and diffuse, create a mottled texture suggestive of weathered stone or rock. In a winter landscape, delicate strokes of clear water applied with a soft brush will convey the impression of frost-covered trees in the distance.

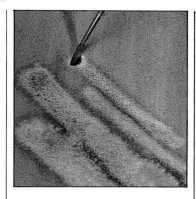

Backruns • Watercolour
1 Working on a sheet of smooth, Hot Pressed watercolour paper, the artist applies a wash of Payne's grey. He then takes a well-pointed sable brush, loads it with clean water, and shakes it to get rid of the excess moisture. When the wash is *almost* dry, the point of the brush is used to 'draw' lines into the paint.

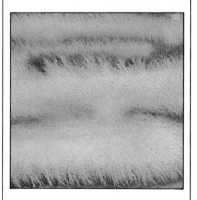

2 The finished effect. The weight of the water dislodges some of the paint particles as it spreads out into the wash. These particles collect at the edges of the water as it dries, creating a hard edge. This particular effect might be useful, for example, in rendering a dramatic interpretation of a stormy sky.

3 Attractive mottled patterns can be formed by dripping clear water into a just-damp wash, from the end of a brush held 7.5 to 10cm (3 to 4in) above the paper.

4 The finished effect depends on how damp the wash is. Water droplets applied to wet paper will produce a soft, diffused pattern; when the paper is almost dry, a crisper, more defined pattern will emerge. This mottled texture can be used to suggest rocks and stones in a landscape, because the patterns can be further developed with washes to suggest shadows and highlights.

BLENDING

Blending is a means of achieving soft, melting colour gradations by brushing or rubbing the edge where two tones or colours meet.

The softest blending effects are achieved in oils and pastels although with fast-drying media such as acrylics, gouache and egg tempera these effects are a little more difficult to obtain. Subtle gradations are made possible, even so, by the application of SCUMBLING or DRYBRUSH over the colours to be blended. In watercolour, a blended effect is achieved by allowing the colours to merge together WET-IN-WET.

The Great Masters such as Rembrandt (1606-69), Rubens (1577-1640) and Velázquez (1599-1660), achieved wonderfully subtle gradations from light to shadow through the careful use of this technique.

The delicate effects obtained by blending are very attractive, but the temptation is often to overdo it, with the result that all the life is taken out of the colours. When painting an object — say, an apple — it is not necessary to blend the entire area. From the normal viewing distance, the form will look smoothly blended if you blend just that narrow area where light turns into shadow or where one colour melts into another. Always remember the old adage that flat colour casually brushed looks brighter than graded colour thoroughly brushed.

Acrylic
Because acrylic dries so rapidly, you don't have time to brush and rebrush a passage to achieve a subtle transition from light to dark or colour to colour as you do in oils. However, the addition of a little gel medium to acrylic paint gives it a consistency nearer to that of oil paint, allowing a smoother gradation.

The simplest way to blend two colours is to wet-blend them: while the paint is still wet, quickly draw a moist brush along the edge where the colours meet.

Blending • Acrylic
1 Using a No. 7 flat bristle brush, the artist applies cadmium yellow and cobalt blue, side by side but not touching.

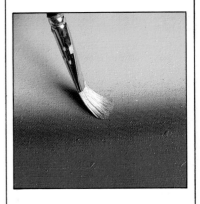

2 Working quickly before the paint dries, he uses a clean, wet brush to blend the two colours together lightly. Do not apply heavy pressure with the brush, because this tends to leave grooves in the paint.

4 The finished effect, showing a smooth transition from one tone to the other.

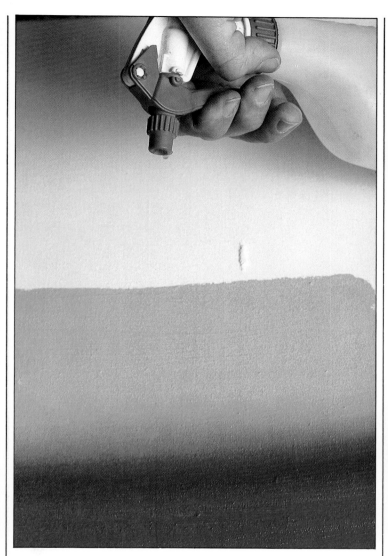

3 When you are working on a large area, if you spray the surface lightly with a spray diffuser this will help to keep the paint moist. Alternatively, add a little gel medium or retarder to the paint on the palette to lengthen the drying time.

5 Alternatively, tones or colours can be blended rapidly with vertical strokes of a soft, moist brush.

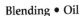

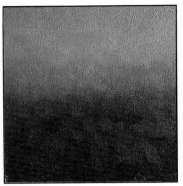

Blending • Oil

The buttery, viscous quality of oil paint makes it perfect for achieving softly blended tones. Oil paint for blending should be fluid but not too runny.

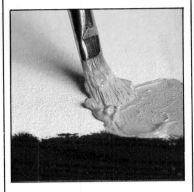

Blending Dry Colour

When painting with fast-drying media such as tempera, acrylic or gouache, remember that blended effects can be achieved even when colours have dried completely. Simply apply loose, scumbled strokes of fresh colour across the point where two colours or tones meet. Here the artist blends two tempera colours (yellow ochre and ultramarine) which have dried; he creates a mixture of the same two colours and scumbles the paint roughly over the edge where the dried colours meet. The scumble allows some of the original colour to break through. This 'disguises' the hard edge and creates the illusion of a soft blend.

Blending with a Fan Brush

Fan brushes are specially adapted for blending. While the paint is still wet, use a gentle sweeping motion with the brush to draw the lighter colour into the darker one. Then, with a light touch, keep working along the edge between the two colours until a smooth, imperceptible blend is achieved.

1 Here the artist uses a No. 4 flat bristle brush to apply two broad bands of colour (cadmium red and cadmium yellow) adjacent to each other.

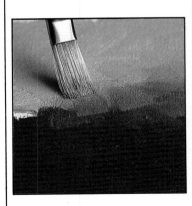

2 Using a soft, long-haired brush, the artist 'knits' the two colours together where they meet, using short, smooth strokes. For best results, always work the lighter colour into the darker one.

3 The finished effect. The colours are blended together softly, but the liveliness of the brushmarks prevents the area from looking too 'perfect' and monotonous.

Pastel

In pastel, colours or tones are fused by rubbing the two adjoining edges with a finger, a paper stump, a rag or a brush. For best results, use a fairly smooth, sanded paper and build up the first layers with hard pastel so that the grain of the paper doesn't become too clogged.

The soft, painterly effects obtained by blending in pastel are very pretty, but don't allow yourself to be seduced into excessive blending. Use it sparingly, otherwise the colours lose their vibrancy and the surface looks slick and mannered. However, a passage which has been overblended can usually be revitalized by the application of a few strokes of broken colour (see FEATHERING and SCUMBLING).

Blending • Pastel
1 Blended areas are a quick way of laying a foundation of colour in a landscape or a background for a portrait. The artist lays in an area of thick colour with the side of a soft pastel stick. He then spreads the colour out lightly from the centre outwards, using his fingertip. (Always make sure your finger is clean and free from grease.)

2 Use a torchon (paper stump) to refine the blending further. Paper stumps are made of tightly rolled paper, finely tapered at one end, and are ideal for blending small, fiddly areas. You can also use the side of the stump to soften and blend larger areas.

3 To set the colour and prevent smudging, the artist places a sheet of newspaper over the blended area and rubs it gently to push the pastel into the grain of the paper.

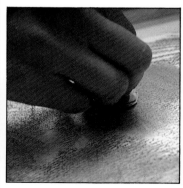

Blending large areas • Pastel
Pastels can be blended quite easily on paper with a good, smooth surface. Using a piece of cloth or tissue paper, you can cover large areas much quicker than if you were to blend the colour with your fingers.

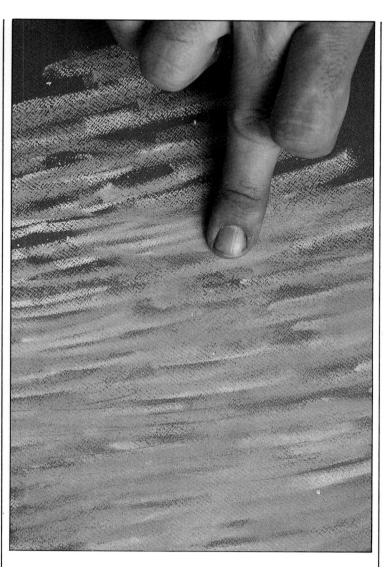

Rough blending • Pastel
In contrast to the highly finished, smooth blending technique shown left, some artists prefer to keep rubbing-in to a minimum. Certainly, if pastel is overblended it loses its freshness and bloom (this bloom is caused by light reflecting off the tiny granules of pigment). Here, the artist has applied hatched marks in orange and yellow pastel on a dark-toned paper. Using the tip of his finger, he softens the lines just a little to give a rough-blended effect which retains the sparkle and freshness of the colours. In most pastel paintings a combination of smooth areas and rough-textured passages gives the most satisfactory results.

BLOWN BLOTS

This exciting and spontaneous way of applying paint has its roots in the favourite children's game of 'seeing pictures' in ink blots.

Blowing vigorously onto wet blots of fairly liquid paint — or simply tilting the support in various directions — sends rivulets of paint travelling in all directions. The accidental shapes thus produced often suggest an image — flower forms, animals, a mysterious landscape — which the artist then develops with further applications of paint.

This kind of 'action painting' has much to offer for the artist who occasionally seeks a change from purely representational painting; allowing the painting to evolve of its own accord stimulates the imagination, and the benefits gained will have a positive effect when the artist returns to his or her normal methods of working.

The idea of applying colour in a free, uncontrolled manner was first given credence by Jackson Pollock (1912-56) and other Abstract Expressionist painters of the 1960s, who often laid their canvases flat on the floor and applied the paint in seemingly haphazard dribbles and splashes.

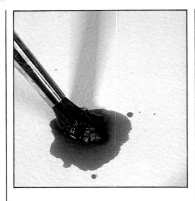

Blown Blots • Watercolour, Ink
1 The artist splashes a large brushful of yellow ink onto dry watercolour paper to produce a deep pool of colour.

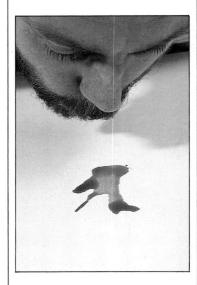

2 He then blows hard at the ink blot at close range, causing the ink to spread in spidery trails. Blow in several directions until the ink takes on an interesting shape.

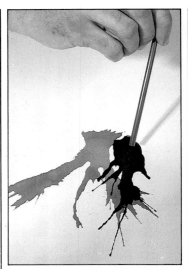

3 When the first colour is dry, a blot of purple ink is applied. Here the artist blows through a straw to create even finer trails of ink. This method allows you more control over the shape and direction of the trails.

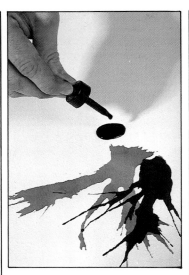

4 A blot of red ink is added, using an eye dropper. Experiment with several different colours, making them overlap partially, or try adding new colours while the previous ones are still wet. Then use your imagination to turn these 'accidental' forms into a recognizable image, or develop them with different media.

BROKEN COLOUR

Using 'broken colour' means applying paint or pastel in small, separate strokes of pure colour, without BLENDING, so that the picture is built up in the same way that a mosaic is. From the appropriate viewing distance, these small strokes appear to fuse, but because they are fragmented, they reflect more light and movement than blended colour does.

It was the English landscape painter Constable (1776-1837) who first used flecks of broken colour, in his desire to capture 'the dews, breezes, blooms and freshness' of nature. His lush green meadows and sparkling foliage appear so because they are composed of large numbers of different greens juxtaposed on the canvas rather than blended together.

The French artist Eugène Delacroix (1798-1863) developed Constable's ideas further, and anticipated the Impressionists by using pure, unmixed colours. However, it was the Impressionists — notably Bazille (1841-70), Monet (1840-1926), Pissarro (1831-1903) and Sisley (1839-99) — who exploited the full potential of the technique of broken colour. These *plein-air* (open-air) painters were eager to capture the fleeting, evanescent effects of light on the landscape, and found that small dabs and strokes of colour allowed them to work quickly and render these effects before the light changed or disappeared altogether. In addition, their fragmented brushstrokes seemed to quiver with light, enhancing the feeling of warmth and sunlight which pervades most Impressionist paintings.

The broken colour approach can be used with any medium, but it is important to keep your colours fresh and unsullied. Clean your brushes frequently, and re-charge your dipper or water jar at regular intervals.

This technique is very absorbing and rewarding, and is excellent for developing your powers of observation. As the Impressionists did, you must rid your mind of preconceived ideas about the colours of things — observe closely and paint what you see, not what you think you see.

Finally, it is advisable to stick to a fairly limited palette of colours so as to achieve an overall harmony rather than a discordant hotch-potch of colour. The Impressionist palette usually consisted of a selection of the primary colours (red, yellow and blue) and secondary colours (orange, green and violet) only. By juxtaposing complementary colours, they achieved brilliant hues; by mixing complementaries, they created colourful darks and neutrals, without the need for black, which tends to muddy colours. Thus a typical Impressionist palette might contain cadmium yellow; yellow ochre; viridian; emerald green; cobalt blue; ultramarine; vermilion; crimson alizarin; and cobalt violet. In addition, lead white was used to lighten colours and for its light-reflective properties.

Oil • Acrylic

Oil or acrylic paint used when applying broken colour should be fairly thick and dry so that each brushstroke retains its shape on the canvas without running. Rather than working on one area of the canvas at a time, aim to cover the canvas with coloured strokes and then add further layers if required. Each stroke should be applied confidently and then left alone; overworking will ruin the immediacy and spontaneity you are aiming for.

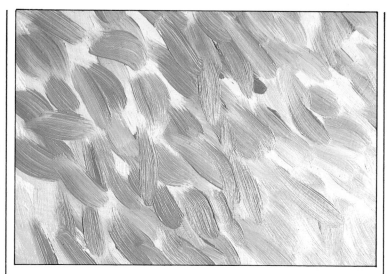

Broken colour • Short strokes

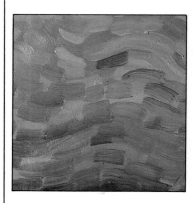

Broken colour • Fluid strokes

Broken colour • Stippled strokes

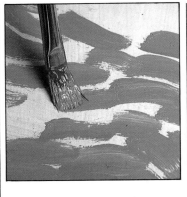

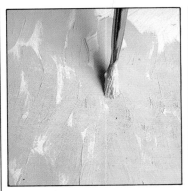

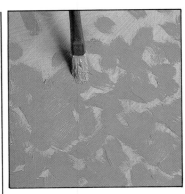

Watercolour • Ink
Because inks and watercolours are transparent, you can overlap strokes of contrasting colour to achieve interesting optical mixtures.

Pastel
Pastel is well suited to the broken colour technique, because it is a direct way of applying pigment. As the strokes of colour remain separate, it is possible to use the colour of the paper as part of the total painting. In addition, you can place strokes of colour on top of one another to create a web of sparkling colour.

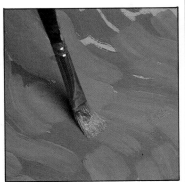

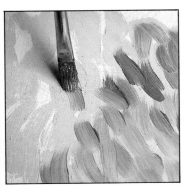

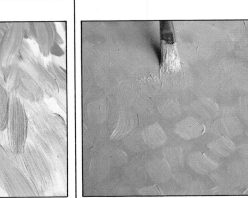

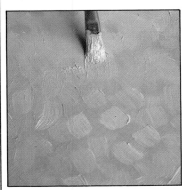

Fluid strokes
Here the artist uses a No. 4 flat brush to apply fluid, curving strokes. Light and dark tones are juxtaposed, without blending, to build up a mosaic of colour. The rhythmical force of these strokes brings to mind the paintings of Van Gogh.

Short strokes
Claude Monet was perhaps the greatest exponent of Impressionism: he covered his canvases with tiny, irregular strokes like these, colour over colour.

Stippled strokes
The gentle, shimmering quality of Alfred Sisley's paintings derives from his use of pale, translucent colours, applied with small stippled strokes with the end of the brush. Notice how the pale, creamy ground shows through in places.

BRUSHRULING

Making a perfectly straight line with a brush and paint can be tricky, because the brush tends to wobble and it is difficult to control the flow of the paint. It is best to use masking tape or a ruler if you don't have a steady hand. In order to avoid smudging, keep the ruler well away from the paint and always make sure that the underlying colour is smooth and dry before attempting to paint over it.

In most representational paintings, perfectly straight edges and lines are not desirable because they remove any 'painterly' effect. But brushruling is useful if you are painting in a deliberately hard-edge style, or if your subject is architecture or other man-made objects.

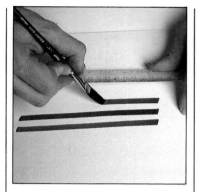

Brushruling • Broad lines
Holding the ruler in the same way as before, draw along it with a well-loaded flat brush. Again, keep the ferrule of the brush against the ruler. When the line is painted, remove the ruler carefully to prevent smudging.

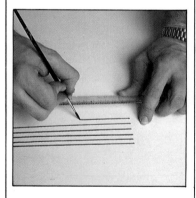

Brushruling • Fine lines
Hold the ruler at a 45-degree angle to the paper with your fingers bunched underneath it so that the edge is not actually touching the paper. Gently draw a small sable brush along the ruler. Keep the ferrule of the brush against the ruler's edge to ensure a straight line.

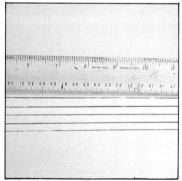

Brushruling • Imprinting lines
Use the brush to apply thick, fairly dry paint to the edge of the ruler. Press the edge of the ruler down firmly onto the paper. Lift the ruler off quickly to leave a thin line of colour. This method is useful where a straight but less 'mechanical' line is required.

BUILDING UP

In essence, building up is the pastel equivalent of the IMPASTO technique in oil painting, in that several layers of colour can be applied one on top of the other, without blending. Pastel (as well as watercolour) often suffers from the 'little old lady' syndrome — people assume that it is about delicate flower studies and wispy portraits of young children. Of course, the BLENDING and FEATHERED strokes typical of these paintings have a valid place in pastel painting but the medium is also capable of producing rich, resonant effects. One way of giving strength and body to a pastel painting — particularly in portrait painting — is through the technique of building up.

Contrary to popular belief, pastel *can* be laid on, coat after coat, so long as each layer is sprayed with fixative. (You must, however, make allowances for the inevitable darkening of the colour after spraying). Edgar Degas (1834-1917) often used this method, applying layer after layer of contrasting hue in scribbled hatchings. The result was a rich patina of colour 'like a cork bath mat', according to the English artist, Sickert (1860-1942).

Building up has the best results with soft pastels, used on their side. One of the advantages of the technique is that it enables large areas of the composition to be built up quickly. It will also encourage the faint-hearted pastellist to develop a bolder, more confident approach to the medium.

Building up
1 In the building up method, the side of a soft pastel stick is used to build the thick, solid layers of colour. Here the artist applies the first layer of colour, boldly and thickly.

2 Spraying with fixative between each layer allows you to build up several coats of colour. However, allow for the darkening effect of fixative.

3 A second coat of colour is now applied, completely covering the layer below, and then fixed.

4 In practice, you can apply colour over colour almost indefinitely, to achieve a rich patina that glows with depth and richness. Experiment also with applying different colours on top of one another.

COLLAGE

The word 'collage' is derived from the French verb *coller*, meaning 'to stick', and refers to an image which is created from pieces of paper, fabric or other materials glued to a support.

Picasso (1881-1973) and Braque (1882-1963) first introduced collage in the early 1900s, as a means of bringing an element of reality into their Cubist works: everyday objects such as theatre tickets and fragments of newspaper or wrapping paper were often included in painted still lifes. Scraps were also used to denote certain textures — a piece of oil cloth might represent the seat of a chair, for example.

Collage is not strictly a painting technique but it can be used alongside painted areas, and is an exciting way of introducing texture into a painting. For example, subjects as diverse as rocks, fabric, and waves can all be rendered by applying crumpled paper to a support and painting over it. Far from being a way of 'cheating', this method involves imagination and skill in creating the most appropriate pattern of folds in the paper and applying the paint so that the collage elements blend unobtrusively with the rest of the painting.

Collage need not be restricted to flat shapes, either: a three-dimensional quality can be achieved with objects such as pebbles, pieces of wood and scraps of metal, either glued to a strong surface or embedded in a thick layer of paint.

If you are interested in this technique, it is worth making a collection of bits and pieces and 'found objects': clippings and photographs, fabric scraps, wrapping paper, bits of string, corrugated cardboard, pebbles, shells, leaves — anything, in fact, that has an interesting colour or texture.

Watercolour

With a transparent water-based medium such as ink or watercolour, it is best to restrict the collage elements to small, delicate items that will not overwhelm the painted areas. Tissue paper, crêpe paper and coloured cellophane combine well with water-based media: their semi-transparency enables colours to be built up in layers, in the same way that washes and glazes are built up. In flower paintings, the vivid colours of certain blooms can be established with tissue paper shapes and then worked over with paint.

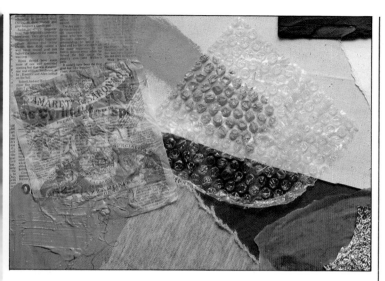

Collage

A collage is the ideal medium for learning to deal with the problems of shape, texture and pattern. It also allows you to try out unusual colour combinations more easily than you can with paint, because the collage materials can be moved around on the paper until you achieve a satisfying design. The collage above was made from scraps of paper, fabric, plastic and wood, accented with a few bright splashes of acrylic paint. This particular example is purely abstract, but a more representational collage can also be achieved, matching the collage materials to the texture or pattern of the subject.

Acrylic

Because acrylic paint is itself a powerful adhesive, virtually any object — even a chunk of metal — can be stuck to the surface of an acrylic painting while it is still wet.

When applying collage materials to a dry surface, matt or gloss acrylic medium serves as an excellent adhesive for lightweight objects such as paper or cloth, and also protects the material from wear and tear. Simply brush a layer of medium onto the surface, stick down the collage material, and then apply a second layer of medium on top to seal it.

For larger, heavier objects — pebbles, shells, bits of wood or metal — use acrylic gel, which is a more powerful adhesive than acrylic medium.

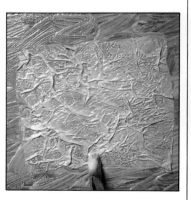

Collage • Acrylic

1 Acrylic medium acts as both an adhesive and a sealant, protecting fragile collage materials from wear and tear. Here, a sheet of tissue paper was crumpled into a ball and then carefully unfolded, still retaining the wrinkles. The paper was flattened out and pressed down onto a panel coated with acrylic medium. A second coat of medium was then brushed over the surface of the wrinkled paper to seal it.

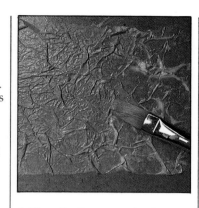

2 When the tissue was dry, it was ready to be painted. The texture of the wrinkles comes through, and can be further accentuated by drybrushing over the highpoints if desired.

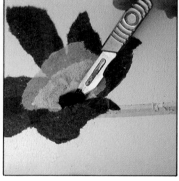

Collage • Tissue paper

Tissue paper is a good medium to use for collage because, being semi-transparent, when stuck down in layers it can create a variety of tones. Using a scalpel and a glue stick the bits of paper can be moved around until you are satisfied with the arrangement before finally sticking the paper into position.

CORRECTIONS

Nothing is more frustrating to an artist than discovering, during the middle of a painting, that something has gone wrong — the colours don't harmonize, the edges are too hard, or an object is in the wrong position. But even if the whole painting is a failure, it is often possible to retrieve it rather than consigning it to the waste paper basket.

Oil

While an oil painting is still wet, alterations and corrections can be made by the method of TONKING. Simply place a sheet of absorbent paper over the offending area, rub it lightly and then peel it away. This removes most of the paint, leaving a softened version of the original image, which can be re-worked.

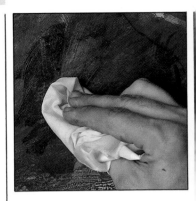

2 The scraped area is then wiped with a rag soaked in turpentine and is ready to be painted over. If desired, medium can be applied to the area surrounding the correction so that the new paint 'takes' more easily and blends naturally with the rest of the painting. This process is known as 'oiling out'.

Oil • Tonking

Once an oil painting is dry, mistakes can of course be painted over. But if the paint has been applied too thickly, you must scrape down the surface with a palette knife to create a smooth surface upon which to work.

Like tonking, scraping softens the original image, which can be used as a guide when you come to re-work it. This soft effect can be very attractive in itself. It is interesting to note that Whistler (1834-1903) scraped and repainted his canvases many times, building up tones and textures of infinite variety and subtlety.

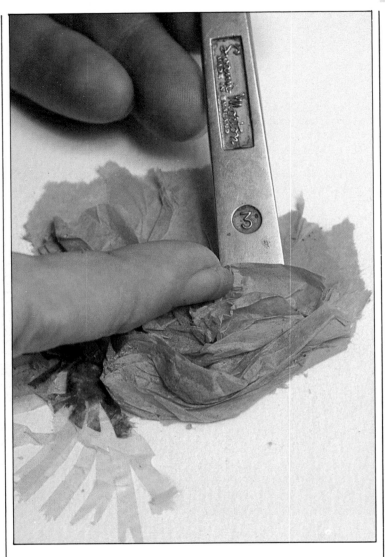

The other attraction of tissue paper in collage is that when it is crumpled it adds texture and a three-dimensional appearance to the image. Once stuck down, the paper can be teased out to get the desired effect.

Corrections • Oils
1 If you are disappointed with the final appearance of a particular passage, it can be remedied quite easily while the paint is still fresh. Here the artist is using a palette knife to scrape away excess paint from an area which has been built up too heavily.

Pastel

The best way to correct a mistake in pastel is to spray the area with fixative and then work over it with a fresh layer of pastel.

Tempera

Egg tempera dries to the touch in a very short space of time, so it is worth keeping a piece of cheesecloth in your free hand while you paint, to erase any mistakes while the paint is still wet.

A dry tempera surface can be corrected by rubbing gently with a small piece of sandpaper.

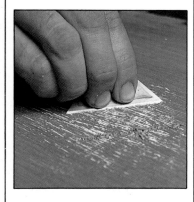

Even though egg tempera dries to the touch within a short time, corrections are actually quite easy to make. Keep a piece of damp, clean muslin handy for wiping out mistakes while the paint is still wet. Once the paint is dry, mistakes can be 'erased' by scraping with a scalpel or craft knife. Hold the blade at an angle of almost 90 degrees and scrape very lightly and carefully, taking care not to dig into the gesso. To avoid scraping the area adjoining the correction, mask it off with masking tape.

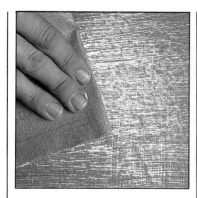

Scraping with sandpaper
Scraping out with a blade leaves the gesso with a very smooth surface. This surface must be roughened up to provide a key for the subsequent layers of paint, so sand the area with a fine grade of sandpaper. Cut up into small pieces, sandpaper is excellent for scraping small or awkwardly shaped areas. Wipe away the dust before repainting over the gesso.

Watercolour

Some people are a little afraid of watercolour because they've heard that a watercolour painting can't be corrected. Far from it — there are several methods which you can use to correct small areas, and you can even dunk the entire painting in a bath of water to remove the whole image, if desired.

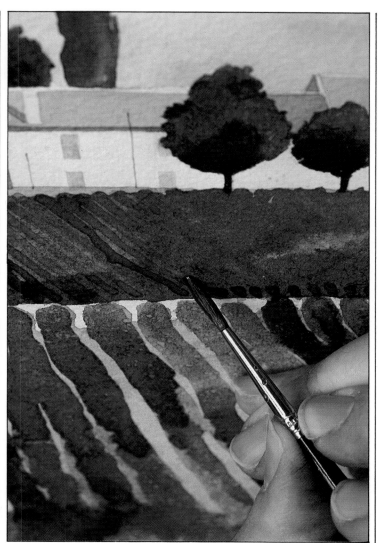

Blot-lifting with tissue and a sponge
1 This illustration shows a detail from a painting of a French vineyard. Having completed the painting, the artist decided that the converging lines of the field in the foreground were too strong in colour and needed softening. To correct this, he first loosens the colour by gently stroking the area with a soft brush and clean water.

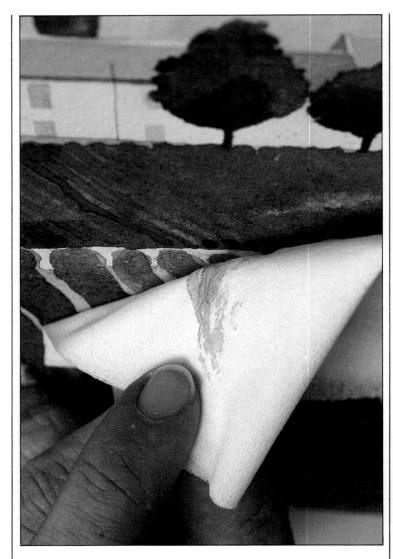

2 After waiting a few moments for the water to be absorbed, the artist lifts off the colour with a piece of tissue.

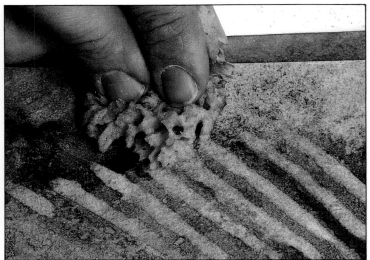

3 In another area of the painting, the artist uses a small natural sponge to soften the colour. The sponge is dipped in water and squeezed out so that it is just damp. The paint is then gently massaged with the sponge. This method softens the forms as well as reducing the intensity of colour.

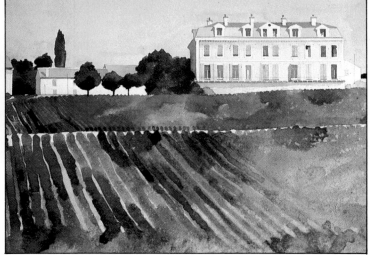

4 The completed picture. By varying the intensity of colour in the foreground, the artist has introduced greater textural interest and a sense of light into the painting.

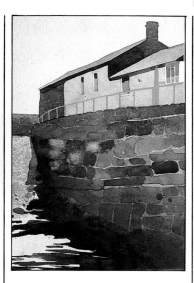

Using a cotton bud
1 An ordinary cotton bud is an excellent tool for lifting out colour in small areas when making corrections. In this painting of a canal-side scene, the artist wishes to add detail and textural interest to the stone wall, which has become too dark and solid-looking. He begins by picking out the shapes of some stones, using a soft brush and clean water.

3 The completed picture is enlivened by the variety of tone and texture in the wall.

2 Using a cotton bud, the artist gently massages the area to lift out most of the colour.

CRAQUELURE

Craquelure (pronounced 'crack-lure') is a French term which refers to the network of tiny hairline cracks that may appear on the surface of an oil painting as it ages. This occurs naturally, over a period of many years, due to the effects of heat, humidity and shrinkage — the effect can be seen on many Old Master paintings in galleries and museums.

If you wish to give one of your own, newly completed paintings the cracked, aged appearance of an Old Master, you can simulate the craquelure effect very simply, using a combination of oil-based varnishes and water-based gums. The technique depends for its effect on the resistance between oil and water — a water-based gum cannot adhere properly to an oily varnish base.

Alternatively, an even simpler method is to mix a few drops of carbon tetrachloride with the paint used in the final layer, which will also crack the paint.

The craquelure technique affects the surface of the picture only and will in no way harm the painting.

Craquelure
1 A traditional still life painting, before being given the craquelure treatment. Note that the painting must be completely dry before the treatment can commence.

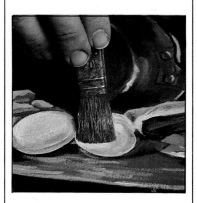

2 Using a wide, hog's hair brush, apply a layer of picture varnish over the entire surface of the painting. Allow it to dry for several hours or overnight.

3 Cover the dried varnish with a coat of transparent water-based gum medium. This shrinks as it dries, forming a network of tiny cracks — as shown in this detail from the still life. Apply a thick coating for a coarse effect, a thin coat for finer cracks. When the gum medium is dry, apply another coat of picture varnish. This seals the gum medium and prevents further cracking. Be careful not to fill the cracks completely with varnish.

To complete the effect of ageing, gently rub some Vandyck brown oil paint into the cracks with a soft cloth. Allow the paint to dry, then finish off with a final coat of varnish.

CROSSHATCHING

In crosshatching, lines and strokes of colour are criss-crossed on top of one another to create a fine mesh of colour or tone. As with HATCHING, this technique is used mainly in pastel and pen and ink. It is also one of the classic techniques of tempera painting.

In both hatching and crosshatching, the spacing between the lines can be varied, depending on the density of effect you want. The technique can be used to model form, to build up areas of light and shade, or to create lively colour mixtures.

Pastel

In pastel painting, crosshatching is a simple technique, but amazingly versatile in its application. It is worth experimenting with, because you will gain a lot of valuable knowledge about the behaviour of this medium.

Instead of crosshatching with vertical and horizontal strokes, try running lines in opposite diagonal directions to create a basketweave effect — or try a combination of the two. Experiment also with different colour combinations and with various colours of paper; when two or more colours are crosshatched on coloured paper, the effect is extremely vibrant. For a softer effect, vary the pressure on the pastel to create a series of hard and soft edges.

Edgar Degas (1834-1917) used a great deal of hatching and crosshatching in his pastel paintings, which appear to shimmer with light due to the vibrant optical effects produced by the interweaving colours.

Crosshatching • Pastel

1 A limitless variety of tone and hue can be achieved simply by altering the spacing and direction of crosshatched strokes. This is an example of multiple crosshatchings: vertical and horizontal lines were laid in and then crosshatched with diagonal strokes.

2 By intermixing different colours, the possibilities are extended even further. This example was done with four colours.

3 Alter the pressure on the pastel stick so that some lines are thick, others thin.

Crosshatching • Ink
Crosshatching is a classic technique of pen and ink work. By varying the density of the lines a wide variety of tones is achieved. Freely drawn lines like these look more lively and interesting than perfectly straight, mechanical lines.

4 A lively pattern is created by juxtaposing small patches of crosshatching that run in different directions.

Crosshatching • Acrylic
In acrylic painting, an old, splayed brush comes in handy for creating a slightly rough crosshatched texture in the paint because each bristle leaves its own tiny stroke. Here the artist has laid a flat wash of yellow ochre, and has then crosshatched in various directions using fairly dry paint. The underlying colour glows through the overpainting to create a subtle optical mixture.

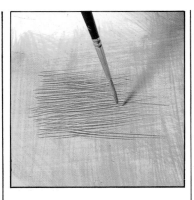

Crosshatching • Tempera
1 Using the tip of a fine brush, paint lines with slightly slanted strokes, working first in one direction and then in another.

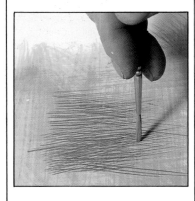

2 Applying a different colour, repeat the crosshatched strokes to create a fine mesh of textured colour.

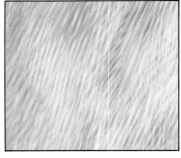

Tempera lends itself well to crosshatching because it can be applied in several layers and dries very quickly. Crosshatching can be done using any number of colours, brushed on in any direction. In this image umber and ochre have been crosshatched with white on a blue tinted support.

DRYBRUSH

In the drybrush technique, a small amount of thick colour is picked up on a brush which is skimmed lightly over a *dry* painting surface. The paint catches on the raised 'tooth' of the paper or canvas and leaves tiny speckles of the ground, or the underlying colour, showing through. The ragged, broken quality of a drybrush stroke is very expressive, and there are many subjects which lend themselves to drybrush treatment. The technique can be used to portray the coarse texture of the weathered surfaces of rock, stone and wood for example. Loose drybrush strokes convey a sense of movement when painting delicate subjects such as grass, hair or the foam of a breaking wave.

Drybrush allows you to suggest detail and texture with minimal brushwork; in waterscapes, for example, a deft stroke of dry colour which leaves the white ground showing through can convey the sparkle of sunlight on water with the utmost economy. This quality is particularly useful in watercolour painting, which relies on freshness and simplicity of execution (though drybrush works equally well in all media).

Never labour drybrush strokes: use quick, confident movements. The technique works best on a rough-textured ground which helps to break up the paint.

Drybrush • Watercolour
1 To produce a drybrush stroke, moisten the brush with very little water and load it with fairly thick paint. Flick the brush lightly across a piece of blotting paper to remove any excess moisture.

2 Use a chisel-shaped brush or, if using a round brush, fan out the bristles between your thumb and forefinger. Hold the brush at an angle of 45 degrees and drag it lightly and quickly across the surface of the paper. This technique works best on a rough or medium-rough paper; the pigment picks up the raised tooth of the paper, producing rough, irregular strokes.

4 By dragging, scrubbing or smearing with the brush, a whole range of patterns and textures can be produced, from delicate lines to heavy, broad passages. Experiment with rough and smooth papers and see how the character of the stroke differs with round and flat brushes.

Drybrush • Oil, Acrylic
The rough texture of canvas lends itself well to drybrush painting. Here the artist uses a loaded brush, moving from left to right with a rapid scrubbing motion. As the paint is depleted, the drybrush strokes become fainter. This method produces rough, lively gradations of tone and colour. Notice how the texture of the canvas determines the texture of the drybrush strokes.
In acrylic painting, blend a little matt medium with the tube colour. Gel medium will produce even more pronounced drybrush strokes.

3 Drybrushing with more than one colour or tone can create highly expressive effects, particularly when used in conjunction with washes; the underlying hue breaks through the drybrush to produce a fascinating optical mixture. Always work quickly — drybrush is a technique that looks best when handled freely and loosely.

FAT OVER LEAN

Oil paint diluted with an oil medium such as linseed or poppy oil is referred to as being 'fat'. When diluted with turpentine or white spirit it is known as 'lean'.

'Fat over lean' is one of the basic principles of oil painting, and refers to the fact that oil paints containing a high proportion of oil (the oil content should never exceed 50 percent) should always be applied *over* those containing less oil, otherwise there is a danger that the painting will eventually begin to crack. The reason for this is simple: if lean paint is applied over fat, the lean layer dries first. Slowly the fat layer underneath dries, and as it does so it contracts, causing the dry paint on top to crack.

For primings and undercoats, try to avoid pigments with a high oil content and always dilute them with turpentine or white spirit only. The use of oil should be increased as the layers of paint are built up.

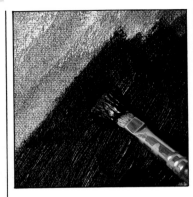

Fat over lean
If an oil painting is to consist of several layers of pigment, there are three ways to avoid the danger of cracking: make sure that the medium used for the initial coats does not contain too much oil; where possible, use quick-drying colours such as flake white, raw umber or light red for the under painting; and ensure that each coat of paint is thoroughly dry before adding the next one.

FEATHERING

Feathering is a technique used in pastel painting to enliven an area of colour which has become dull through excessive BLENDING or rubbing in. It can also be used to soften hard edges, or to blur the division between light and shadow. The finished effect of a feathered passage resembles the barbs of a quill — hence the name.

To feather one colour over another, use a hard pastel or a pastel pencil and make light strokes with an upward and downward movement over the area which requires altering.

As with SCUMBLING and DRYBRUSH, feathering allows the underlying colour to show through, producing an optical effect which is more lively than an area of flat colour.

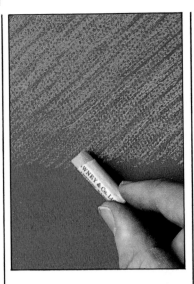

Feathering • Pastel
Use the feathering technique when you want to change the hue of a particular colour subtly. To feather one colour over another, use a hard pastel or pastel pencil. Keeping your wrist loose, make light, feathery, diagonal strokes over the underlying colour.

FLAT WASH

The wash technique is used with fluid paints (including thinned acrylic paints) to deposit colour on an area which is too large to be covered with a single brushstroke. In a flat wash, the aim is to obtain a smooth, even layer of colour, which is achieved by working quickly and confidently. Any hesitation will show when the paint dries and, if applied too slowly, the paint will dry unevenly, causing irregularities which may mar the smoothness of the wash.

Watercolour

Washes are the foundation on which watercolour paintings are produced. A smooth layer of pigment is applied to damp paper, and spreads softly, drying with a delicate translucency unmatched in any other medium.

When laying a flat wash, it helps to first dampen the paper thoroughly with water. This allows the brushstrokes to spread and dissolve on the paper without leaving any hard edges. The paper should not be so wet, however, that it buckles and makes for a bumpy brush action, which can lead to BACKRUNS forming. If necessary, mop up any excess water with a clean sponge.

It is essential to have sufficient colour ready in a deep palette or jar before you begin: mix up more than you think you might need because you cannot stop in the middle of painting to mix a fresh

supply. It also helps to use as large a brush as you can. Generally speaking, the fewer and broader the strokes you use in watercolour, the more successful the flat wash will be.

When applying the wash, keep the brush well loaded with paint and sweep it quickly and decisively across the paper, without hesitation. If you start going back into a wash you risk losing that smooth, even tone you are aiming for.

2 Lifting the paper out by one edge, shake it gently to get rid of any excess water.

4 Cut strips of gummed paper and dampen them with a sponge.

Stretching paper

1 Find the right side of the paper by holding it up to the light — the watermark should read correctly on the right side. Lay the paper right side up on your drawing board and trim a margin of about 5cm (2in) off each side of the paper. Then lay the paper right side up in a tray or bath of clean water and, keeping it flat, soak it for 10 to 20 minutes.

3 Carefully lay the wet paper right side up on the drawing board, making sure that you don't trap any air under the paper, and that the paper is completely flat.

5 Stick all four sides of the paper to the drawing board with the gummed paper. Secure the paper firmly with drawing pins pushed into each corner of the paper, and leave the paper to dry naturally, away from any source of heat.

Flat Wash • Watercolour

1 Mix up a wash of colour in a saucer or jar, making sure that there is more than enough paint, so you won't run out.

2 The first step in laying in a flat wash is to dampen the entire paper to enable the paint to flow more easily. The colour should be fluid, but quite strong, to compensate for the fact that it will dry much lighter on the paper. The drawing board should now be tilted to an angle of 10 to 15 degrees. This allows the wash to flow downwards but at the same time prevents drips. To lay the flat wash, load a large brush (round or flat) and draw a slow, steady stroke across the top of the area. Due to the angle of the board, a narrow rill of paint will form along the bottom edge of the stroke.

4 Repeat these overlapping strokes all the way down the area to be covered, each time picking up the paint from the previous stroke. To encourage a smooth, even flow, work quickly and apply a light pressure only to the brush.

5 At the end of the wash, squeeze the brush until semi-dry and blot up the excess pool of colour that forms at the bottom. The wash should then be allowed to dry in the same tilted position; if left to dry flat, there is a danger of the paint flowing back and causing blotches and 'tide marks' in the wash.

3 Load the brush again and paint a second stroke beneath the first, slightly overlapping it and picking up the rill of paint. The excess paint now rolls down across the second stroke and reforms along the new bottom edge.

Laying a Flat Wash with a Sponge
A small, natural sponge is also useful for laying a flat wash. As before, dampen the paper first to prevent streaks from forming. A sponge allows you to control quite accurately the density of each stroke; for a heavy cover, allow the sponge to absorb plenty of paint. For a paler effect, squeeze the sponge gently until almost dry.

Acrylic
When laying a flat wash in acrylic, in the manner of a watercolour wash, it helps to add a brushload of matt medium to the paint in the palette. This makes the paint just a bit creamier so that it flows more smoothly and gives a more even coverage. Use soft hair brushes rather than bristle brushes because bristle brushes tend to leave faint grooves in the paint, no matter how swiftly you work. To obtain an even coat, run each stroke in one direction only — scrubbing back and forth takes off the paint rather than spreading it.

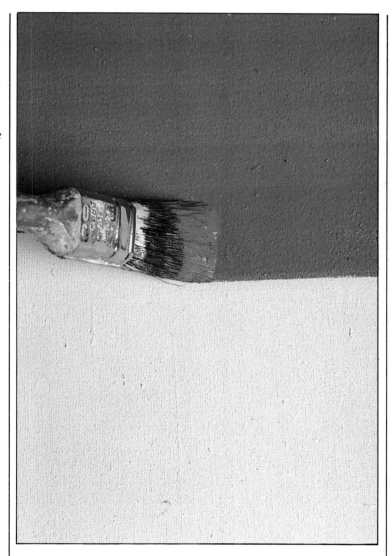

Flat Wash • Acrylic, Oil
To lay a solid, opaque area of colour, be sure to mix up plenty of paint, diluted with the appropriate medium. For an even coat, use a wide, flat brush and run the strokes in one direction only. Each successive stroke should slightly overlap the one before.

FROTTAGE

The word 'frottage' is derived from the French verb *frotter*, meaning to rub.

The term is associated most often with rubbing on paper over a textured surface so that the underlying pattern comes through. This technique can be used in pastel painting, for example, using the side of the stick. In oil painting, however, the term refers to the technique of creating a rich, irregular texture in wet or semi-wet paint by rubbing a sheet of non-absorbent paper onto an area of flat, opaque colour. When the paper is peeled away it drags at the paint, leaving a rough, mottled surface. The paper can be applied to the wet paint either flat or crumpled, the latter producing a stronger pattern.

Frottage is perfect for depicting the rough textures of rock, stone and wood. In addition, it provides a quick, spontaneous way of creating surface interest in broad areas of a painting — in an empty foreground, for example.

The German Surrealist painter Max Ernst (1891-1976) used frottage in his paintings and drawings, often combining it with COLLAGE to create strange, haunting images.

With frottage, the patterns created are absolutely unpredictable, so it is advisable to start by experimenting on a piece of scrap canvas.

Frottage • Flat paper
1 Lay a patch of colour, using rich paint thinned with a little oil and turpentine. The thicker the paint you use, the heavier and more ridged the texture will be.

2 Place a sheet of non-absorbent paper over the paint and press it down gently. Rub lightly over the paper with your fingertips.

3 Peel the paper away. Because the paint is tacky, the paper drags at it, forming a rough, stippled surface. To alter the texture, the paper can be replaced, and moved about or rubbed. Experiment until you get the effect you want. Leave the painting to dry for at least 48 hours.

The finished effect

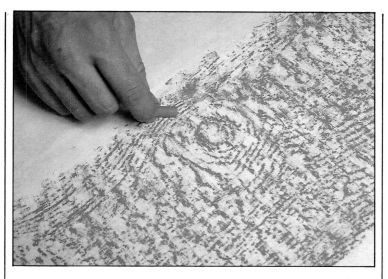

Frottage • Crumpled paper
1 Apply a patch of thick paint as before. Crumple a sheet of non-absorbent paper into a ball, open it out, then press it into the wet paint.

2 Carefully peel the paper back from the paint. This creates a more pronounced texture than that achieved with flat paper. Repeat the process with a clean sheet of paper if desired.

Frottage • Pastel
In pastel painting, rich textural effects are gained by placing a piece of paper over a surface with a pronounced texture — such as grainy wood or rough stone — and rubbing with the side of the crayon so that the texture comes through. Here the artist is making a rubbing of a wooden floorboard. The frottage technique has a lot of creative potential: try placing textured surfaces selectively under certain sections of a drawing to recreate natural textures or patterns. Alternatively, sections of frottage work can be cut up and then re-assembled and glued down to a new support to make a collage. Further images can be superimposed over frottage work to create unusual or disturbing images.

The finished effect

GLAZING

Glazing is a technique most often associated with oil painting, but can also be used with acrylics, egg tempera, watercolour and inks. It is a system in which thin, transparent washes of colour are laid on successive layers of dried colours, like many sheets of coloured tissue paper. Each glaze qualifies earlier ones, and the result is rich, transparent and glowing.

The reason for this is that a glaze, being transparent, allows light to pass through it and be reflected back off the underlying colour. The colours thus combine optically — in the viewer's eye — and take on a resonance impossible to achieve by mixing them physically on the palette.

Glazing requires an understanding of how different colours react with each other; it is worth experimenting on pieces of scrap canvas, board or paper, depending on the medium you are using.

Oil

Paint for glazing should be thinned with a glazing medium which contains special film-forming ingredients that impart a soft lustre to the paint surface. In preference, use a ready-made medium which contains beeswax — linseed oil is not ideal for glazes because it tends to move about after it has been applied.

Do not dilute the paint with turpentine alone — this makes the colour go flat and dull, and sometimes results in a cracked surface. For best results, apply the glaze with a large, flat, soft-haired brush. Position the canvas or board at an angle of about 15 degrees rather than vertically.

Glazing • Oil
1 Mix the colour on your palette, then add an equal quantity of medium. The paint should have a thin but oily consistency. Beware of overthinning!

2 Apply the glaze in a thin layer over a light ground. The colour appears bright because of light reflecting back off the canvas. Lay the canvas flat to prevent drips and runs.

3 Allow each layer to dry fully before adding more glaze. This example shows how the colour underneath glows through the glaze, giving the paint a three-dimensional quality.

Oil • Glazing to modify tone

If you are unhappy with a certain colour or tone, adjust it by glazing over it. A glaze will soften contrast and help to unify disparate tones although it will not obscure the form beneath it. Shadow areas, in particular, appear more luminous when deepened with a dark glaze.

Oil • Glazing over impasto

Glazing can be used to enhance impasto. The thinned colour settles in the crevices, accentuating the craggy texture of the paint.

1 Lay thick paint with a knife or brush, creating a coarse, craggy texture. Leave until the surface has dried out.

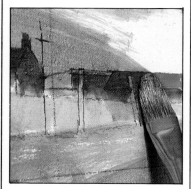

1 Apply the glaze in a thin layer over the dried underpainting so that it forms a transparent film.

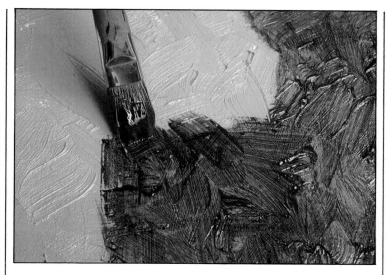

2 Mix a thin glaze, and brush it lightly over the impasto.

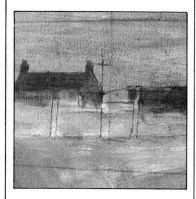

2 The colours underneath glow through the glaze, but the hues are modified.

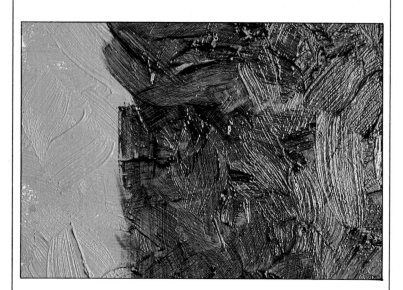

3 Let the impasto settle into the textural surface and leave it to dry before applying the next layer of paint.

Tempera
Egg tempera is ideal for glazing, because like acrylic, it dries quickly and any number of coats can be laid one on top of the other.

In tempera, most glazing is done with egg glair (white of egg) or oil. The glaze is applied in small areas because large areas are difficult to cover evenly with such a fast-drying medium. An entire painting can be glazed, however, if the surface is dampened first by spraying it with water from an atomiser. This delays the drying process, allowing the paint to flow easily and without streaking.

Acrylic
Thinned down with medium, acrylic paints are immensely suitable for the glazing technique. They dry within minutes, and are waterproof when dry, allowing the artist to build up several glazes within a short space of time, with no risk of the colours muddying.

A small amount of acrylic medium is added to the paint on the palette by dripping it into a hollow made in a blob of paint and mixing it thoroughly with a wet brush or palette knife. A little water added in the same way further dilutes the paint. A very watered colour may need some gloss or matt medium added to it to maintain the paint's adhesive properties.

As with oils, glazing in acrylic can be used to modify tones or enhance impastoed passages.

Glazing • Acrylics
1 When applied in transparent glazes, acrylic seems to transmit light from within. To make the glaze, mix a small amount of colour with a lot of medium. Acrylic mediums are white and milky in appearance when wet, but they dry clear. Apply the paint with a soft brush. Allow a few minutes for each glaze to dry before applying the next one. Glazes may be laid in smooth layers over a stained or painted area, but can also be applied thickly, showing brushmarks.

2 A more transparent glaze can be achieved by adding extra matt medium to the pigment.

Watercolour
The glazing technique is used to great effect in watercolour, particularly when conveying the illusion of atmosphere, space and light in landscapes.

Some watercolour pigments are more opaque than others — the earth colours and cadmiums, for example — and these do not work well in glazes. Stick to the truly transparent colours which allow the light to reflect up off the white paper through the colours.

Do not apply more than two or three layers when glazing in watercolour — any more and the delicate, transparent nature of the medium is lessened.

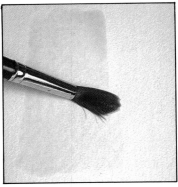

Glazing • Watercolour
1 Lay the palest colour first, so that the light can reflect off the white paper.

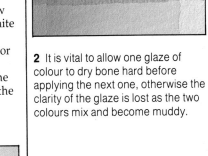

2 It is vital to allow one glaze of colour to dry bone hard before applying the next one, otherwise the clarity of the glaze is lost as the two colours mix and become muddy.

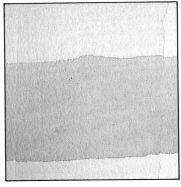

3 Here the artist applies a thin wash of Hooker's green over the first colour. Where the two washes cross over each other, a third hue is produced.

GRADATIONS

Gradations occur wherever there is a gradual transition from light to shadow or from one colour to another. It is important to know how to render subtle gradations, because they occur in most painting subjects — portraits and figures, still lifes (in the rounded forms of vases, fruits, vegetables, and softly folded drapery) and in skies, where one colour fades gradually into another.

In water-based media (ink, watercolour, and acrylic used as watercolour) gradations can be rendered by means of a graded wash. In opaque painting, they are handled by 'knitting' together the various tones or colours, using carefully controlled brushwork.

Watercolour • Inks • Gouache

With water-based media, smooth gradations are achieved by working WET-IN-WET.

Gradations • Watercolour

Here the artist wanted to paint a soft highlight on a metal object. He started by applying two strips of Payne's grey on damp paper, allowing them to almost touch. Then he ran a clean, soft, just-damp brush between the two bands to lift off some colour and soften the edges between them.

Oil

The soft, pliant consistency of oils, and their prolonged drying time, mean that you can brush and re-brush the tones or colours together to achieve almost imperceptible gradations. Examples of wonderfully subtle gradations can be found in the works of Titian (c 1487-1576), Rubens (1577-1640) and Vermeer (1632-75).

Alternatively, colours can be roughly blended together so that the brushstrokes are more evident: this achieves a more lively effect (see BLENDING)

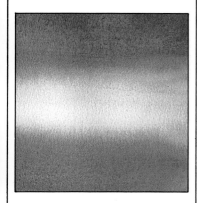

Gradations • Oils

1 Analyse the tones of the gradated area very carefully and prepare on your palette a colour mixture for each change in tone. Begin the gradation by painting the darkest tone. Here the artist uses a mixture of sap green and ivory black, and blocks in the darkest tone with a No. 4 flat bristle brush. The colour is applied beyond the point where the colour turns lighter, so that it can be blended with the next colour.

2 With a clean brush, the artist mixes a slightly lighter colour by adding a touch of titanium white to the first mixture. He applies this tone adjacent to the first one, then fuses the two tones by moving the brush in a zigzag manner. This drags the lighter colour into the darker, and the darker colour into the lighter one, creating an even gradation between the two tones.

3 The artist continues in this manner, adding more white to each successive band of colour until he reaches the lightest tone.

4 The finished effect. Notice the subtle, even gradation from the dark area at the bottom to the light area at the top. Keeping the length and direction of the brushstrokes consistent over the whole area helps to achieve this effect.

Acrylic

Because acrylic dries so much more quickly than oils, subtle gradations are trickier to achieve. If you work quickly, however, you can scumble two colours into one another while they are still wet, using quick, scrubbing brushstrokes (see SCUMBLING). Rather than a smooth, even gradation, scumbling produces a more casual, exciting blend, typical of this medium.

To obtain a smoother gradation, you can add acrylic medium to the paint. This gives it a consistency more like oil, and prolongs the drying time. Adding retarder will slow down the drying process still further.

GRADED WASH

In watercolour and other water-based media, the purpose of a graded wash is to create an area of colour that moves gradually from dark to light, from light to dark, or from one colour to another. The method of application is exactly the same as for a FLAT WASH, except that with each successive stroke, the brush carries more water and less pigment (or vice versa if you are working from light to dark).

It takes a little practice to achieve a smooth transition in tone with no striations; the secret is to apply a sufficient weight of paint and water so that the excess flows, very gently, down the surface of the paper and merges with the next brushstroke. When the bottom of the paper is reached, the excess paint should be lifted off, using a clean, dry brush.

As with all fluid washes, be sure to mix up plenty of paint so that there is no danger of running out of colour halfway through. If you are gradating from dark to light you will also need an ample supply of clean water.

Graded washes are extremely useful, especially when painting landscapes and figures which contain soft edges and gently merging areas. In skies, for example, where the colour is most intense at the zenith and fades gradually towards the horizon, a graded wash will render this effect with great economy of effort.

Acrylic
When heavily diluted with water, acrylic paints can be used in the same way as watercolours can. When laying a graded wash in acrylics, add a little matt medium to your jar of clean water. This will not affect the colour, but it lengthens the drying time of the paint, making the gradation easier to control.

Watercolour
Watercolour washes always dry lighter than they appear when wet, so remember to take this into account when mixing your colours. Only with experience will you be able to judge how light an area will be when dry.

Graded Wash • Watercolour
Be sure to mix up plenty of paint, especially if you are covering a large area. Use a large, soft brush or a sponge to dampen the paper, which should be stretched and taped firmly to the board. Make sure the board is tilted at a slight angle to enable the wash to flow freely down the paper.
Load a brush with paint at full strength and lay a line of colour across the top of the paper, taking care not to lift the brush until you reach the end of the stroke. Allow the colour to spread and even out. Working quickly, before the first stripe dries, add a little more water to the paint on your palette. Then lay a band of this slightly lighter colour directly beneath the first one and slightly overlapping it.
Continue working in broad sweeps of colour. To achieve a graded effect, add water to the paint in increasing quantities with each successive band of colour. Always allow the lines of paint to blend into each other. When you reach the bottom of the paper, use a moist, clean brush to mop up the excess paint that gathers along the base of the wash. The completed wash should be left to dry in the tilted position.

Grading two colours
You can also grade one colour into another, which in effect involves applying two graded washes. Here the artist began with a graded wash of cobalt blue, tapering it down almost to pure water halfway down the paper. When the blue wash was dry, he turned the board upside down and worked a graded wash of lemon yellow down towards the blue wash, again tapering it down almost to pure water.

GRANULATED WASHES

In watercolour painting, certain pigments have a tendency to separate out when mixed with others in a wash and allowed to dry undisturbed. This separation is caused by the different physical qualities of the pigments — the earth colours for example, are coarser by nature than most other colours. As the wash dries, tiny granules of the coarse pigment floating in the water settle on the raised tooth of the paper, and the result is an area of flat colour with a natural granular texture which can be used to great effect in a painting. For example, a mixture of burnt sienna and ultramarine creates a very attractive grey which dries with a subtle granular pattern. This makes it a favourite mixture for painting skies, because this pattern gives hints of the texture within clouds.

Other pigments which granulate in this way when mixed with other colours include yellow ochre, burnt umber, manganese blue, cobalt blue and ultramarine. You could use these colours when painting buildings, allowing the granular texture to indicate the pitted texture of stone. Manganese blue is often used for painting the shadows in snow scenes: the granular nature of this colour resembles the powdery appearance of new-fallen snow.

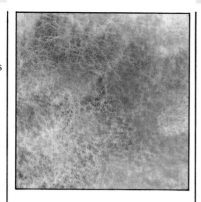

Granulated washes • Watercolour
In this example, a strong, fluid wash of ultramarine was flooded onto a piece of Bockingford 140lb paper, followed by a wash of burnt sienna. The two colours were allowed to merge wet-in-wet and then the paper was left to dry flat. It is important not to disturb the wash while it is drying. In this close-up, you can see the attractive grainy texture which forms; this effect is unique to watercolour, and is highly atmospheric when used in skies and landscapes.

HATCHING

This term refers to the building up of tone and texture with parallel lines — a method traditionally used in tempera painting and pen and ink drawing, though it can also be used in acrylic, pastel and gouache. By varying the width between strokes, a tonal variation from light to dark can be achieved.

Hatching can also be an exciting way of blending different colours. Because the strokes of several colours are not physically smoothed together, each one retains its identity. Seen from the normal viewing distance, the overall effect of the juxtaposed colours is fresh and vibrant (see also CROSSHATCHING).

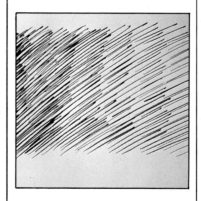

Hatching • Ink
In pen and ink drawings, hatching is the traditional method used to create tonal shading. By altering the direction of the hatched strokes, the shape and volume of objects can be indicated. To achieve crisp, clean lines like these, your technique should be controlled but not rigid — keep the pen well charged with ink and make decisive, fluid strokes.

Hatching • Pastel
1 You can achieve a tremendous variety of tone and texture through hatching in pastel. Here the artist is using soft pastels to intermix different colours, without blending. Hatching in this way builds up striking colour relationships. For strokes with a more linear quality, use a hard pastel sharpened to a blunt point, or the sharp edge of the tip of a new soft pastel stick.

2 Hazy tones can be added to pastel hatching by rubbing the lines with the fingertip to spread the colour. This technique is often used in portrait work; the hatched lines follow the form and rhythm of the figure while indicating the subtle play of light on the skin.

HIGHLIGHTING

Creating highlights in a painting is normally a matter of either adding or removing areas of paint. Highlights are the 'icing on the cake' — when you are close to completing a painting, it is very satisfying to finish off with those few little touches that make the whole thing 'click into focus': the sparkle of sunlight on water, for example, or the bright reflections in the eyes that bring a portrait to life.

Depending on the medium you are using, there are several tools and techniques which you can employ to create highlights.

Oil

In oil painting, the highlights are normally left till last. Some artists use Rembrandt's method of applying the brightest lights with a fairly thick impasto containing plenty of white. Because they stand away from the canvas, these areas catch more light than the rest of the painting, and so appear even brighter.

One pitfall to avoid, however, is painting highlights in pure white. Even the brightest reflection on a glass bottle, for example, will normally contain a hint of green, yellow, and perhaps blue, depending on the prevailing light and the colours of the objects around the bottle. A stark white highlight always spells 'amateur'.

Pastel

In pastel painting, you can either add colour or remove it to create a highlight. If you are working on a dark-toned paper, then the highlights will most likely be added with a light-coloured crayon. The other method is to use a kneaded eraser to lift out some of the colour (see LIFTING OUT)

Pastel • Kneaded eraser
Knead the eraser so that you work it into a point and use the point to lift out colour and lighten the tone in small areas.

Watercolour

Because you cannot add a light colour over a dark one in watercolour, you must first decide where the brightest highlights are to be and either paint around them or mask them off. In this way you preserve the white of the paper (with its brilliant light-reflecting properties) for the highlights, which really 'sing out' when the darks and the mid-tones have been added.

To create highlights in a previously laid wash, you can remove colour with a tissue, blotting paper or a soft brush. When the wash is completely dry, highlights can be scraped out gently, with a scalpel or craft knife (see LIFTING OUT).

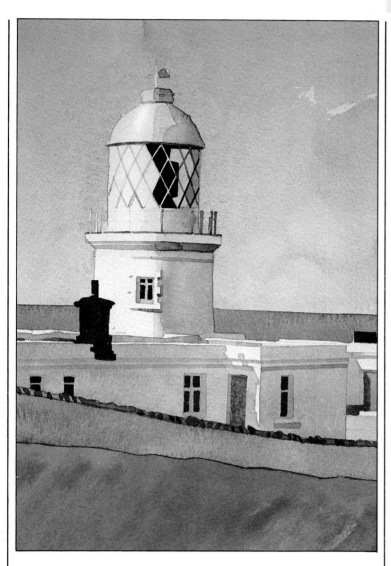

Highlights • Watercolour
In watercolour painting, unpainted paper provides the brightest highlights you could wish for, because it reflects the maximum amount of light. In this lighthouse scene the crisp areas of white paper capture the effect of the intense sunlight on the tower and buildings.

IMPASTO

Thick, opaque paint applied heavily with a brush or knife is called impasto. The paint is laid on thickly, usually with short, staccato movements of the brush, so that it stands away from the support and creates a rugged surface.

Because impasto requires paint of a thick, buttery consistency, its use is limited to oils and acrylics, and, to a certain extent, gouache. An egg tempera painting can be built up of many thin layers, but bold, heavily-loaded strokes are impossible with this medium because the adhesive power in the egg binder is sufficient only to make thin layers stick.

If desired, an entire painting can be built up with heavy impastos to create a lively and energetic surface. For this reason, impasto often goes hand in hand with the ALLA PRIMA method of painting, because thick paint and rapid brushstrokes allow the picture to be built up quickly and in a spontaneous manner.

Van Gogh (1853-90) is perhaps the greatest exponent of the expressive use of impasto; he often squeezed the paint straight from the tube onto the canvas, 'sculpting' it into swirling lines and strokes, which conveyed the intensity of his feeling for his subject.

Impasto can also be used in combination with GLAZING to produce passages of great richness and depth. Titian (c1487-1576) and Rembrandt (1606-69) painted their shadows with thin, dark glazes to make them recede, while modelling the highlights on skin, fabric and jewellery with thick impasto. These small, raised areas catch the light and appear especially brilliant.

When glazing over impasto you must use a drying agent in the impasto, such as a cobalt dryer.

They are not easy to obtain unless you use alkyds or an alkyd-based medium.

Finally, an impastoed passage which is perfectly dry can be painted over with a transparent glaze which sinks into the crevices in the paint and accentuates the rough texture. This technique is useful for rendering a subject such as wood, bark or rough stone.

When building up heavily textured impastos, brushwork is all-important. If the pigment is pushed and prodded too much, the freshness and sparkle of the colours will diminish; think carefully about the position and shape of each stroke beforehand, then apply it with confidence, and leave it alone.

Oil
If thick layers of paint are applied on top of each other, the different speeds of drying out between layers can cause cracking. It is essential that you allow each layer to dry out before applying the next. (A thick stroke of oil paint can take six months to dry unless a drying agent is added to it.)

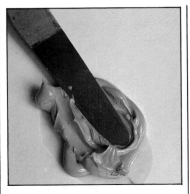

Impasto with a Brush • Oils

1 Some pigments have a higher oil content than others; too much oil makes it difficult to achieve a highly textured brushstroke. To prepare the paint, squeeze it out onto a sheet of blotting paper and leave it for a few minutes. The blotting paper absorbs any excess oil so that the paint has a stiffer consistency which is more suitable for impasto painting.

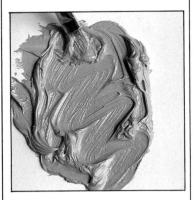

2 Remove the paint from the blotting paper and mix it up on the palette, adding just enough turpentine to make it malleable.

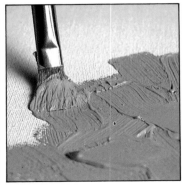

3 Here the artist loads a No. 4 flat bristle brush with paint and applies it thickly to the canvas, using short, heavy strokes applied in different directions. Always resist the temptation to go back over the strokes — apply the paint with deft movements and, once applied, do not touch it again. The paint should be thick enough to retain the marks of the brush. A heavy impasto can take days or even weeks to dry properly, so leave the canvas in a dust-free place. When dry, apply a glaze of a contrasting colour if desired.

Impasto with a Knife

1 A painting knife is an excellent tool for creating a heavy impasto. Here the artist uses the knife to mix the paint on the palette. He then spreads it thickly onto the canvas in broad, textured ridges.

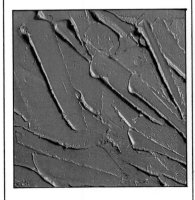

2 The finished effect. With a painting knife, you can 'sculpt' the paint into exciting swirls and ridges. However, do not be tempted to overwork the paint — it will quickly lose its vibrancy and become 'dead'.

Acrylic

Impastos are made more quickly and easily with acrylic paints than with oils — not only do they dry much faster, they also dry without cracking, even when applied very thickly. The pigment can be squeezed directly onto the canvas, or it can be mixed first with an equal amount of gel medium to thicken it.

Texture paste, which is colourless, extremely thick and very fast-drying, can be applied to the surface and then painted over with acrylics. This method is not recommended, however, because texture paste does not handle in the same way as paint and the finished effect lacks spontaneity. However, if the paste is mixed in with the paint the effect will be that of thick oil paint.

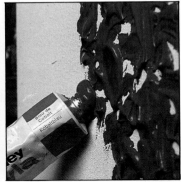

Impasto • Acrylics

1 Acrylic paint can be used straight from the tube, undiluted. Alternatively, mix tube colour and gel medium in equal proportions. The result is a thick, pasty consistency which lends itself to rugged brushwork.

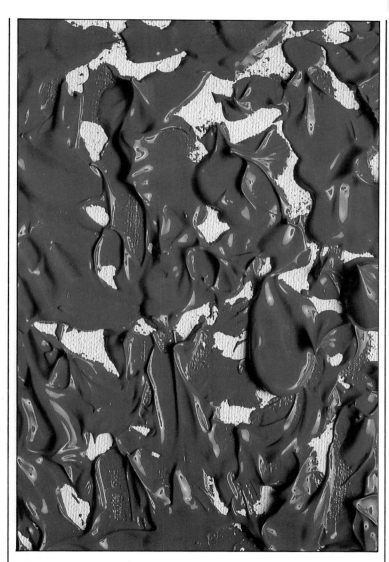

2 Use a knife or a stiff bristle brush to spread the paint on the canvas. The adhesive and quick-drying properties of acrylics mean that they can be used thickly, without fear of cracking, and will dry in a few hours.

IMPRIMATURA

Imprimatura is the classical term for a GLAZE or wash of transparent colour used to create a toned ground for a painting.

An imprimatura serves two purposes: firstly, it softens the stark whiteness of the canvas or paper, making it easier to assess the relative tones of colour mixtures as they are applied (most colours look darker on a white surface than they do when surrounded by other colours).

Secondly, if the imprimatura is allowed to show through the overpainting in places, it acts as a harmonizing element, tying together the colours that are laid over it.

The advantage of an imprimatura over an opaque TONED GROUND is that the white canvas or paper glows through the transparent glaze, sustaining the luminosity of the succeeding colours.

The colour chosen for an imprimatura will depend on the subject you are painting, but it is normally a neutral tone somewhere between the lightest and the darkest colours in the painting. In portrait and figure painting, for example, a wash of diluted yellow ochre or raw sienna provides a subtle mid-tone which ties together the darks and the lights of the skin.

In landscape painting, choose a unifying colour which accentuates the atmosphere of your subject. A sunset or an autumn landscape will benefit from a golden yellow imprimatura, whereas a seascape or a misty mountain scene might require a neutral blue-grey.

The main thing is that the colour should be subtle and unobtrusive — one that does not overwhelm the colours that are applied over it. Choose diluted earthy, subdued colours such as raw sienna, red oxide, or ultramarine with a touch of burnt umber. Avoid 'electric' colours such as phthalo blue and cadmium yellow.

In oil painting, dilute the pigment with turpentine to a very thin consistency. In acrylic painting, use matt medium as a diluent.

The watercolour equivalent of an imprimatura is a FLAT WASH of transparent colour applied to the paper and allowed to dry before overpainting it (leave white shapes in the wash for highlights if desired). In painting skies, for example, an underlayer of burnt sienna, diluted to a pale tint, provides a warm colour which looks most effective when offset by the cool blues and greys of clouds.

Imprimatura
1 For an imprimatura, the paint should have a runny consistency, almost like a watercolour wash. If you are using oil paint, dilute it with copal varnish. Acrylic paint can be diluted with medium.

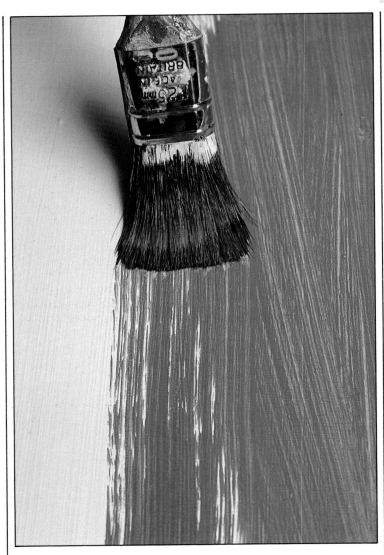

2 Use a large, flat brush and apply the paint to the support as thinly as possible so as not to totally obscure the white gesso or canvas. Brush the paint on with long vertical strokes and without attempting to smooth it out. The streakiness will enliven the colours that go over the imprimatura, and it also encourages you to continue with the same freedom of handling in the later stages.

IMPRINTS

In both transparent and opaque painting, exciting results can be achieved by pressing real objects onto the wet picture surface so that they leave an imprint of their shape or texture.

In oil and acrylic painting, the technique involves simply pressing the object firmly into a layer of thick, fairly tacky paint, then removing it quickly. Objects with a raised or open-weave surface texture work best — try using the side of an old kitchen colander or a potato masher, a fork, a piece of bark, or a chunk of an old bicycle tyre — the possibilities are endless.

When the paint is dry, the imprinted area can be further enhanced with the addition of GLAZING or DRYBRUSH, which emphasize the texture of the paint.

An alternative method of impressing is to coat the actual object with paint and press it onto a dry area, or straight onto the canvas or paper. This works particularly well with gouache, ink and watercolour, because the pattern left behind when the object is removed often has a soft, delicate quality. Natural objects — leaves, feathers and grasses, for example — work well with this method, as do scraps of open-weave fabric and lace.

As with COLLAGE, this technique encourages the artist to look for the creative possibilities in ordinary things — things which might normally be taken for granted. However, the artist must rely on discretion and good taste: the technique should always be a means to an end, not merely a clever trick or device.

Acrylics

Working in acrylics gives you richer textural possibilities than any other medium. Acrylic paint can be thickened with gel medium and built up in thick layers, without any danger of the paint cracking. Alternatively you can simply apply a thick layer of modelling paste and work into that. While the paint or paste is still wet, patterns and textures can be imprinted using virtually any object with a sharp point or a textured surface.

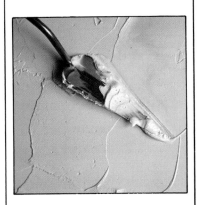

1 A thick layer of acrylic mixed with modelling paste is applied to the panel with a painting knife and smoothed out.

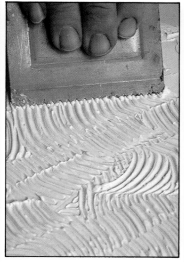

2 A kitchen fork is pressed into the wet paint, leaving a lively pattern of grooves and ridges.

3 Here an adhesive tool is being used. By twisting and turning the imprinting tool you can create endlessly varied patterns. Once the paint is dry, the raised texture can be enhanced by working over it with glazes, scumbles or drybrush. For example, you could imprint a pattern into a layer of dark paint and then drybrush over it with a light colour: the drybrush will pick up the raised points of the paint, leaving the low points untouched, and the result is a colour with an intriguing three-dimensional quality.

Imprints

1 Almost any object, as long as it has one relatively flat side, can be used for the imprinting technique. Here the artist is using a large, soft brush to coat a leaf with a layer of gouache. The paint should be of a fairly stiff consistency, not too runny.

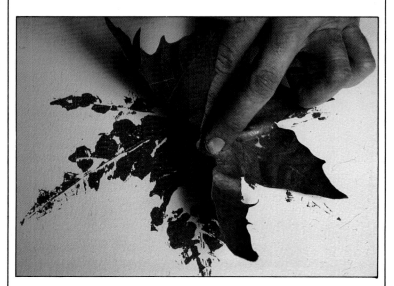

2 The paint-coated leaf is laid carefully onto the paper and pressed down firmly.

3 The leaf is removed, revealing the printed image. A smooth or Hot Pressed paper gives the cleanest print, but a medium-rough paper creates an interesting broken effect because the paint doesn't 'take' so evenly.

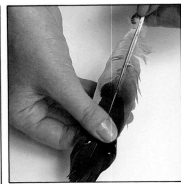

4 The surfaces of some objects — such as feathers — repel water, making them unsuitable for imprinting. This is easily remedied by massaging liquid soap into the object to remove the surface oil. Rinse and pat dry, then brush on a coat of paint in the normal way. To prevent smudging, lay a piece of tissue over the feather when making the imprint. Experiment with various objects, such as pieces of open-weave cloth. Also try pressing unpainted objects into a damp wash to produce interesting negative patterns.

KNIFE PAINTING

A knife may be a less sensitive painting tool than a brush, but it is in fact an exciting and versatile way of applying paint, built up in thick IMPASTOS to produce expressive textural effects, or applied smoothly for soft, subtle passages.

The fauve painter Maurice Vlaminck (1876-1958) often used knife strokes in his skies and foregrounds, achieving exquisite colour effects by partially mixing the pigments on his palette and applying them with broad, sweeping strokes that contained infinite subtleties of tint.

Normally associated with oil and acrylic painting, knives can also be used to create pattern and texture in watercolour, ink and gouache. Even egg tempera can be applied with a knife, so long as the paint is not too thick, and the knife must not be metal — bone or plastic will do.

Painting knives (not to be confused with palette knives) come in many designs and sizes, but generally they are trowel-shaped, made of pliable steel, and often have a cranked handle which keeps the artist's fingers clear of the painting surface.

Oil • Acrylic • Gouache

Oil paints and acrylics are perfectly suited to knife painting, because they have a soft, creamy texture and can be handled without trickling or running. This technique works best on stretched canvas, which has a 'give' in it that responds well to the springy blade of the knife.

Knife painting demands a bold approach. Set the paint on the surface with a decisive movement, lifting the blade away cleanly at the end of the stroke. Avoid going back over the stroke, because this deadens the colour and reduces spontaneity.

Knife painting
1 Apply the paint thickly to the support and spread it with a trowel-shaped painting knife to achieve a variety of interesting textures. One way of moving the paint is to rest the heel of the knife on the support and move it in an arc, spreading the paint with it.

2 Here the artist is partially blending two colours wet-in-wet. Cadmium yellow is first squeezed onto a previously applied layer of ultramarine. Then the knife is used, as if spreading butter, to distribute the paint in different directions. If care is taken not to overblend the colours, attractive subtleties of tint can be achieved.

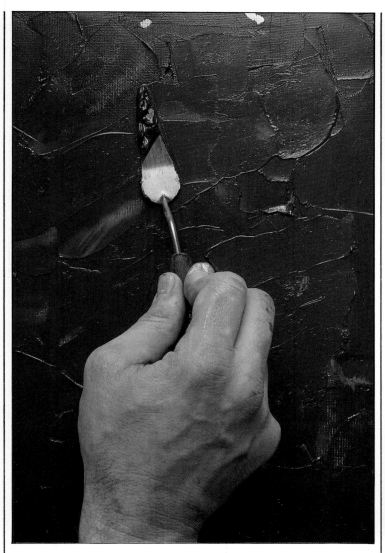

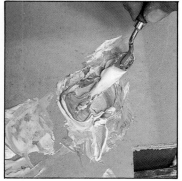

Knife painting • Acrylic
1 Gel medium, a thickening agent, is mixed with acrylic paint on the palette before the paint is applied to the support. The added thickness means that greater texture can be created in the paint with the painting knife.

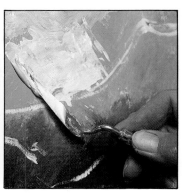

Watercolour
It takes a little practice, but it is possible to paint with a knife in watercolour, using the edge of the blade to apply thin streaks of colour or to scrape out light areas in a wet wash. Always use a knife with a rounded point, which won't dig into the paper, and a cranked handle to prevent your fingers from accidentally touching the paper.

Knife painting • Watercolour
1 If you are using a new knife you must first treat it so that it will accept water. New steel has a slightly greasy surface which repels water and causes it to bead and roll off, as do traces of paint or varnish. In both cases, clean the knife with household cleaning powder. If this doesn't do the trick, stab the knife into a lemon and leave it overnight. The acid will remove any remaining traces of grease.

3 A colour painted with a knife often looks more brilliant than one painted with a brush, since the knife can leave an absolutely smooth stroke of colour which reflects the maximum amount of light. To retain the purity of each colour, always clean the blade of the knife between each application.

2 The paint is then scraped onto the support with the knife. The marks of the knife will remain in the dried paint, but the thick white gel will become transparent as it dries, returning the paint to its original colour.

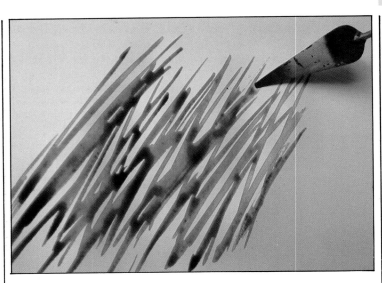

2 Knife painting in watercolour is an unusual technique, so practise knifestrokes on scrap paper first. You will need plenty of paint, but it should not be too watery. Here the artist uses the tip of the knife blade to create thin strokes that represent long grass. Move the knife quickly but with a light pressure so as not to damage the paper's surface. Allow the strokes to taper off naturally.

LIFTING OUT

In watercolour, ink and pastel painting, lifting out simply means removing small areas of colour, using a soft brush, a sponge or a tissue. The technique has several uses to correct mistakes: to lighten a colour; to create a soft, hazy form; to add highlights; and to breathe air into a too-solid area of the painting.

Watercolour

Damp paint can be lifted out quite easily, but dry paint may need to be coaxed off gently with a soft brush. Remember, too, that some watercolour pigments have more staining strength than others — alizarin crimson and sap green, for example, will always leave a residue of colour. Bear this in mind if you wish to lift out colour to regain the white of the paper.

Use the lifting out technique on good quality paper only; soft paper will 'rough up' and by lifting out you may make a hole in your picture.

Tissue paper

When working with lots of wet washes, tissue is useful for wiping areas that have become too wet, and for controlling the flow of paint. Use a blot-and-lift motion with the tissue — rubbing may damage the surface of the paper. Tissue paper can be used to lift out amorphous shapes in a wet wash — when painting clouds, for example. Use this technique judiciously, however; when overdone it looks slick and unconvincing.

Blotting paper

Blotting paper is thicker and more absorbent than tissue and, once dry, it can be re-used. If you wish to lift out a small, precise area, hold the corner of the blotting paper against the surface until the excess paint is absorbed.

LINE AND WASH

Line and wash (or wash and line) is a classic technique of both pen and ink work and watercolour. The combination of finely drawn lines and delicate washes has great visual appeal, and is particularly suited to flower studies. The same combination also evokes a sense of movement and fluidity, and so lends itself to paintings of animals and birds.

In this technique, colour and tone are indicated by fluid washes, and allowed to dry. Fine lines are then drawn in with a pen or a brush. Varying the pressure on the pen or brush will produce subtle variations in the quality of the line. The line and wash drawings of Rembrandt (1606-69) and Hogarth (1697-1764) are worth studying in this respect.

If waterproof ink is used, the process can be reversed: the subject is drawn first and then washes (either monochrome or coloured) are added to create contrasts of light and shadow. Experiment to find out which method you prefer.

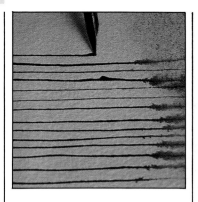

2 Use pen and ink to draw in lines over the washes. The combination of crisp lines and translucent washes is highly attractive.

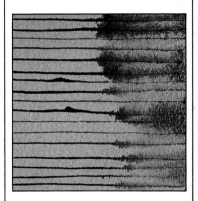

3 A crisp line is obtained where the wash is quite dry. Where the surface is still wet, the lines are soft and feathered. It is also possible to draw the lines first and apply the wash on top; use waterproof ink if you wish to retain the crispness of the lines when the wet wash is applied.

Line and Wash
1 Lay a wash with broad strokes using a soft brush and thin, fluid paint. Make sure the wash is not too wet before applying the lines.

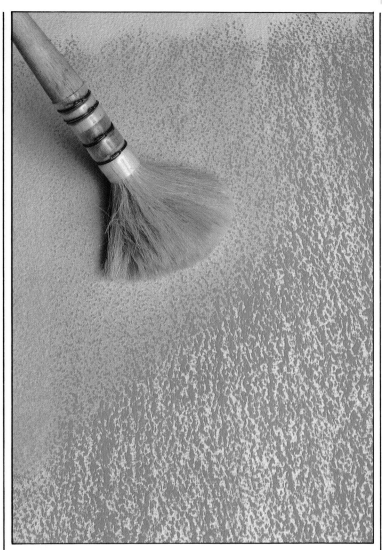

Lifting out • Pastel
To lift off excess colour in pastel, use a delicate scrubbing motion with a soft brush, blowing away the surplus dust as you work.

To lift out colour in small areas, use a kneaded eraser pulled to a point.

MASKING OUT

Masking out means isolating certain areas of a painting by covering them up with a paint-resistant surface, so that they can be freely worked over without marking the surface. This serves two main purposes. Firstly, to protect finished areas of the painting from random splashes of paint while work is still in progress in other areas. For example, if you are using an 'action painting' technique such as SPATTERING in one area of a picture, you would be wise to cover up those areas not to be spattered, since the paint tends to fly in all directions.

Secondly, a mask or resist is used to block off specific areas of shapes in order to retain the colour of the support or the existing surface. Once an area has been safely masked off, you are free to carry on with the rest of the painting, unhampered by having to paint carefully around fiddly shapes, because you can paint right over the mask. When the painting is completed the mask is removed to reveal the areas underneath.

There are various masking devices available to the artist, ranging from a simple sheet of newspaper to film with a slightly adhesive surface, to a more sophisticated latex solution. What you use depends on the medium you are working with, the size and type of support, and the kind of effect you are aiming for.

Masking tape

Masking tape is a strong, self-adhesive tape which attaches firmly to paper, board or canvas, but can be peeled off easily. The tape works well on canvas or dried paint, but can sometimes lift the surface of soft papers off; use it only on strong, well-sized paper.

Masking tape is most often used where a linear or geometric design is desired, as in the hard-edge paintings of Mark Rothko (1903-70) and Bridget Riley (b 1931). Because it always leaves a hard edge, it is unsuitable for masking out soft, organic forms.

Masking with Tape
1 Masking tape gives the best results where a clean, sharp edge is required. Make sure the support is perfectly dry before sticking the tape down firmly in the required position.

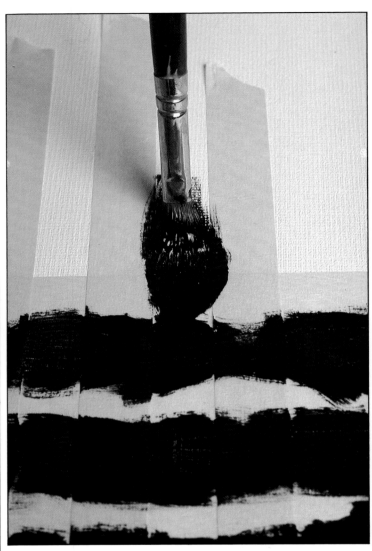

2 Here, acrylic paint is being applied over and away from the edges of the tape. Painting over the tape ensures that there are no ragged edges when the tape is peeled away.

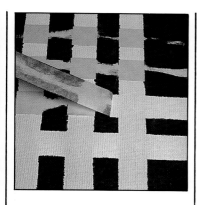

3 Allow the paint to dry thoroughly, then lift one corner of the tape and peel it back carefully.

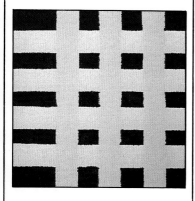

4 The finished result is a pattern of well-defined, clear-cut lines.

Masking fluid

Because of the transparency of watercolour, it is impossible to paint a light colour over a dark one; the artist must plan where the light or white areas are to be and paint round them, which can be a fiddly problem. An effective solution is to paint over the areas to be preserved with masking fluid. This liquid, rubbery solution is applied with a brush, just like paint, and dries within a few seconds to form a water-resistant film which can be painted over without affecting the paper underneath. When the painting is completely dry, the rubbery mask is easily removed by rubbing with the finger.

The advantage of masking fluid is that it can be applied in any shape you desire. It forms a firm, waterproof resist, and doesn't have to be held in place manually on the support. The one disadvantage is that areas treated with masking fluid always have a hard edge, which may not be compatible with the rest of the painting.

Always use an old brush to apply masking fluid, and wash it in warm, soapy water immediately after use, to prevent the rubber solution from drying hard and clogging up the bristles.

Masking with Fluid

1 Using a soft brush, paint in the area you intend to leave white and allow it to dry hard. The fluid must be fresh or it will yellow the paper. Wash the brush out immediately to prevent the fluid from drying on the bristles.

2 When the fluid is dry, you can brush washes freely over the surrounding area without having to be careful to avoid the white shapes.

3 It is essential to let the watercolour dry before continuing.

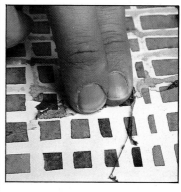

4 Remove the dried masking fluid by gently rubbing with your fingers or a soft putty eraser and peeling it away. If the paint is not dry the colour will smudge.

Wax

An attractive, broken effect is achieved by masking with wax, especially when used on rough paper or canvas. Use either a white candle or a white wax crayon and skim it across the paper so that it touches the high points but not the indents. When the painting is completely dry, the wax can be removed by covering it with absorbent paper and pressing with a warm iron.

The speckled, broken appearance that waxing gives is perfect for suggesting textures such as tree bark, or the sparkle of sunlight on water.

The Wax Resist Method

1 Rub a dry wax candle (or a wax crayon) over the paper as desired.

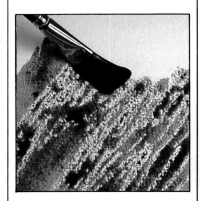

2 Paint over the wax and the surrounding area. The wax will reject the watercolour and protect the paper underneath. Allow the wash to dry thoroughly.

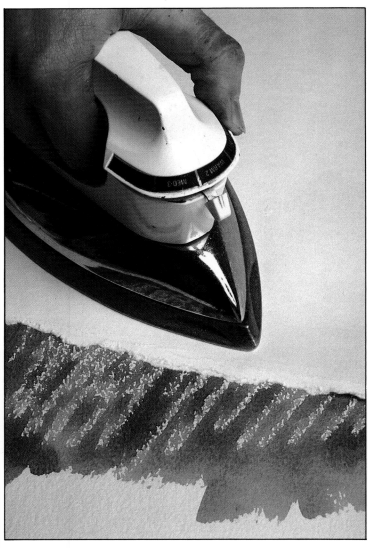

3 To remove the wax, lay a sheet of absorbent paper over the area and press with a cool iron until the wax is absorbed by the paper. You may have to repeat the process two or three times to remove all the wax.

4 Because the wax skips over the raised tooth of the paper and misses the indents, the watercolour is not completely resisted. The resulting shapes give an interesting batik effect with broken, textured edges. For a more pronounced texture, use a rough paper.

Masking with Cotton Wool

The disadvantage with most masking techniques is that the resulting shapes tend to have hard, crisp edges. If you wish to mask off a shape while retaining a slightly softer edge, try using cotton wool as a mask. This method works particularly well in conjunction with the spattering technique.

1 Take a small piece of cotton wool and tease it out until fairly thin. Lay the cotton wool on the paper, pulling and teasing it into the required shape.

2 Holding a stiff brush several centimetres (a few inches) above the surface, spray colour onto the area surrounding the mask by running your finger through the bristles of the brush.

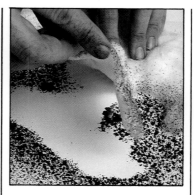

3 Wait until the paint is thoroughly dry before removing the cotton wool.

4 The soft edges of the cotton wool mask have allowed the spattered paint to seep under it in places. The finished shape has a softer, more natural outline than that achieved with other masking techniques. This method could be used in painting natural subjects such as trees and clouds.

Masking with Card

1 A mask can be made from a piece of heavy card. Draw the required shape on the card and cut it out with a craft knife. The mask can be either a positive or a negative shape. Here the artist has cut out a negative shape — a rectangle — and placed the mask over a sheet of paper ready for painting.

2 Hold the mask firmly in place or stick it down with masking tape. Here the artist uses a knife to apply a thick layer of cadmium red acrylic paint inside the cut-out shape. If the paint is too wet it will seep under the edges of the mask. Keep it thick, and work away from the cut edges of the mask.

3 When the paint is completely dry remove the mask to reveal the shape.

MIXED MEDIA

One of the most exciting aspects of painting in the twentieth century is that artists are free to break with as many artistic conventions as they like. By mixing techniques and combining different media in the same painting, it is possible to broaden the range and expressiveness of your work beyond anything you thought possible.

Take pastel, for instance: the greatest pastellist of them all, Edgar Degas (1834-1917) was certainly no purist in the use of this medium. He often combined pastels with distemper paint (made by mixing powdered pigment with animal size), or drew in pastel over a base of oil paint thinned with turpentine. Millet (1814-75), in a study for his oil painting, *Harvesters Resting*, combined pastel, oil, watercolour and black crayon.

Of course, there is enormous satisfaction to be gained from arriving at a particular texture or effect within the limitations of one particular medium. But equally, combining different media can be exciting, surprising and instructive. The different 'personalities' of each medium often complement one another — and sometimes they clash. Only by experimentation will you discover which combination best expresses what you are trying to convey in your painting. In so doing, you will broaden your visual language, develop your confidence in handling paint — and you may even discover hidden qualities in a medium which you had hitherto avoided.

Below are a number of suggestions for mixed media combinations. Having tried a few of these ideas, you may feel encouraged to develop others of your own.

Pastel with watercolour wash
1 The vibrancy of soft pastel colours can be used to enhance the delicate transparency of watercolour washes. Here the artist creates a design with a soft orange pastel.

2 Using a soft watercolour brush, he washes over the pastel with a light toned wash to spread the pastel colour. Any surplus moisture is removed with blotting paper.

3 While the wash is still damp, the artist adds further details with the point of the pastel stick. When the wash dries, more pastel marks and watercolour washes can be added.

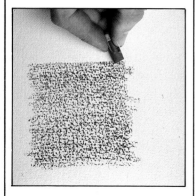

Oil pastel with watercolour wash
1 Oil pastels produce a slightly different effect because they are more resistant to water than soft pastels are. Here the artist rubs blue oil pastel over rough-textured watercolour paper. The pastel catches the raised tooth of the paper and creates a mottled pattern.

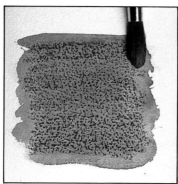

2 A wash of Payne's grey watercolour is applied over the oil pastel. The oil repels the watercolour, which settles into the indents of the paper's texture, which were untouched by the crayon. The wash dries with a granular texture which is effective for depicting stone, rocks and sand.

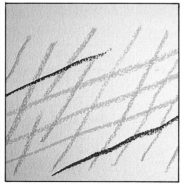

Acrylic and oil crayon
1 The artist begins by drawing a bold design on the canvas with oil crayons. Apply the crayon quite thickly.

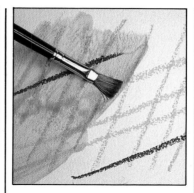

2 Acrylic paint, diluted with plenty of water to a thin, wash-like consistency, is brushed lightly over the crayonned area with a large, soft brush.

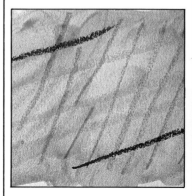

3 The oil crayon resists the watery paint and the design shows up clearly through the coloured wash.

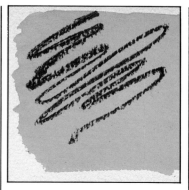

Gouache and charcoal
1 The artist first applies a thick layer of yellow gouache. When this is completely dry he draws a design onto it with charcoal. Note that if the paint is still wet, the charcoal will not take.

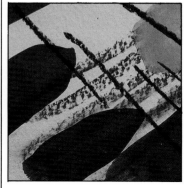

2 Using a No. 4 bristle brush, the artist works into the charcoal drawing with further gouache colours. Interesting variations of tone are achieved by allowing the charcoal to dissolve into the colour in places.

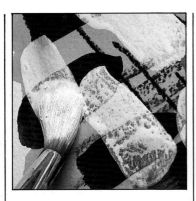

3 When the paint dries, the process can be repeated, adding further charcoal marks and colour washes.

Acrylic and gouache

Acrylic and gouache paints work well together because of their versatility. Acrylic can be used for transparent washes or heavy impasto; it dries quickly and won't lift off, so that further washes of transparent colour can be applied, producing effects of great depth. Gouache, too, can be used thickly or diluted with water to create semi-transparent washes. Here the artist combines the covering power of acrylic with the smooth-flowing, translucent quality of gouache to create an intriguing effect that could be used for painting a stormy sky or a night scene.

1 Working on a sheet of 200lb Not watercolour paper, the artist applies a flat wash of acrylic in a dark colour and allows it to dry. The surface is then re-wetted with water, and the upper edge of the board is tilted up at a slight angle. The artist then floats a dilute wash of white gouache across the top of the paper and allows it to flow downwards gently. Because the acrylic underlayer has dried insoluble, it does not lift off and muddy any succeeding washes.

2 When the first wash of gouache begins to run out, another is applied, again across the top of the paper. As this wash travels downwards, it merges with the first wash. The painting is then allowed to dry.

3 The dark wash of acrylic glows through the translucent wash of white gouache. The finished result is very subtle, and evocative of a rainy sky.

POINTILLISM

Pointillism is a method of painting which relies upon small dots of pure colour to create shapes, tones and colour effects. These dots are placed close to each other, but not overlapping, so that from a distance they appear to merge (see also STIPPLING and BROKEN COLOURS).

This same principle can be seen if you look at a colour photograph in a magazine through a strong magnifying glass: the image is composed of thousands of tiny dots of colour, which the eye forms into recognizable shapes.

Georges Seurat (1859-91) and Paul Signac (1863-1935) are the two painters chiefly associated with Pointillism (which Seurat preferred to call Divisionism). Seurat was greatly influenced by the scientific discoveries about light and colour which had been made by Michel-Eugène Chevreul. He found that a colour becomes more vibrant when placed next to its complementary (the colour which appears opposite it on the colour wheel). In addition, he maintained that adjacent, but separate, colours mix in the eye of the spectator and so produce other colours.

What Pointillism achieves is not so much a colour of greater intensity, but a more luminous colour. This is because the incomplete fusion of the dots produces a flickering optical sensation, known as 'lustre'. As a result, the surface of the picture appears to palpitate with light.

The use of complementary colours adds to this luminous effect, because small areas of complementary colour placed next to each other also set up an optical vibration. If you look closely at a painting by Seurat or Signac, you will notice how, among the blues of a shadow for example, touches of contrasting yellow are often added to depict the warmth of reflected light penetrating the shadow.

Using tiny dots of colour also allows the artist to note even the most minute gradations of tone and hue, and so register all the subtle halftones, shadows and glints of reflected light that are experienced in nature. This amplifies still further the feeling of light and luminosity.

Pointillism is regarded by some artists as too exacting a system of painting, at odds with an artist's need for freedom of expression. It is a method worth experimenting with even so, because it can teach you a lot about the behaviour of colours and about the infinite gradations that occur within a seemingly flat area of colour. Pointillism can be used in any medium, even oil pastel, so long as the pastel stick has a sharp point. It is particularly suited to egg tempera, exploiting to the full the luminous quality of the paint.

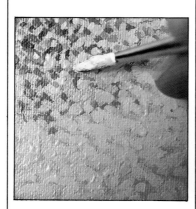

Pointillism • Oils

In this technique, dabs of different colours are laid next to and on top of each other. The colours link up so that forms emerge and develop gradually into solid shapes.

Pastel

Pastel is particularly suited to the pointillist technique because of the vibrancy of its colours and ease of manipulation. Hard or semi-hard crayons work best — soft pastels tend to smudge more easily. The technique doesn't have to be applied methodically — used in a free manner it still produces more sparkle than flat colour does.

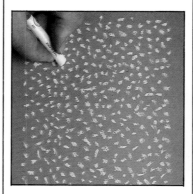

1 Using the sharpened tip of the pastel stick, the artist makes a pattern of yellow dots, evenly spaced, on a dark-toned paper.

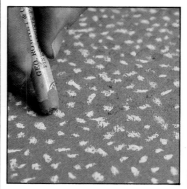

2 He then works over the area with dots of another colour, keeping the dots separate and unblended.

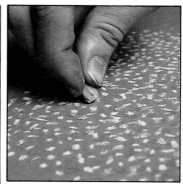

3 Dots of a third colour are now added.

4 The finished effect. Because each dot of colour is separate, this technique makes it possible to exploit the effects of tinted papers. Here you can see how the underlying green tint of the paper acts as a unifying element, against which the vibrant pastel colours appear to scintillate. Alternatively, you may choose to build up the dots more densely so that they overlap each other and create a web of sparkling colour.

SCUMBLING

Scumbling is the rough application of a dry, light, semi-opaque colour over a darker layer of dry, opaque paint. The scumbled layer is applied thinly, creating a delicate 'veil' of colour which partially obscures the underlying colour. Whether you work in oils, watercolour, pastels — in fact any medium — scumbling is a highly versatile and expressive technique.

Scumbles are usually applied by using a circular, scrubbing motion with a brush or crayon, but the effect can also be achieved with streaks, dabs, smudges or stipples. The important thing is that the colour is applied *unevenly*: this produces a lively, unpredictable texture in which the marks of the brush or crayon are evident.

Because scumbled strokes have an irregular quality, if painting, use a bristle brush in preference to a soft brush. Indeed, an old, worn brush is most useful, because the scrubbing action could damage the hairs of your best brush if you scumble frequently. You can also scumble with a rag, a sponge, or even with your fingers or the edge of your hand.

If you have an area of colour which looks flat and dull, scumbling another colour over it will make it appear richer and more vibrant; for example, a dull grey will sparkle if you scumble over it with yellow or red. This is because the two colours mix optically and thus become more resonant. Similarly, colours which are too warm, too cool, or too bright can be modified with a scumble of a suitable colour.

When scumbles are combined with GLAZES, the effect is one of extraordinary depth and mystery. When you apply an underpainting, followed by a scumble, followed by a glaze (allowing each one to dry before the next is applied) the colours seem to glow with an inner light, rather like polished wood. The paints must have drying agents added to them, however, otherwise the waiting time between each layer is impossibly long.

This atmospheric quality can be exploited in many subjects, notably stormy skies and seascapes. The liveliness of scumbled strokes is equally well suited to textures such as animal fur, or the fuzzy skin of a peach, and subjects that contain movement — scudding clouds, tumbling hair, and rushing water.

Oil

With this method applied to oil paints you can achieve subtle gradations of hue while retaining the liveliness of the brushstrokes. Make the strokes short and decisive — don't overblend them or the effect will be lost.

Scumbling • Opaque media
Paint for scumbling should be fairly dry — wipe the brush on blotting paper to remove any excess moisture. Using a bristle brush (a soft brush is less effective) scrub the paint on with free, vigorous strokes. The paint can be worked with a circular motion, with straight back-and-forth strokes, or in various directions. The idea is not to blend the colour but to leave the brushmarks showing. Here, various yellows and greens were scumbled together with short, scrubby strokes. The texture produced closely resembles tree foliage.

In scumbling, the idea is to paint a semi-transparent layer, like a haze of smoke, over another colour which has already dried. The underlayer is covered only partially and shimmers up through the scumble, producing mysterious and atmospheric effects. Generally, a light scumble over a dark colour gives the best results; add a touch of titanium white to the pigment to lighten it and make it semi-opaque. It is important to build up scumbles thinly, in gradual stages — if the paint is applied too heavily the hazy effect will be lost.

Acrylic

Paint for scumbling should be thick, but more fluid than that used in DRYBRUSH. Dilute the pigment with either matt or gloss medium, and add a touch of titanium white to make the colour slightly more opaque.

Conversely, mixing a small amount of colour with plenty of matt medium, or medium and water, produces beautiful, transparent, delicate scumbles. This technique is most effective when painting sunlit waves, for example.

Transparent scumble

In acrylic painting, try mixing a lot of matt medium and water with the tube colour; this combination produces delicate, transparent scumbles. For even greater depth and luminosity, you can glaze one transparent scumble over another.

Blending with scumbles

Scumbling can be used as a means of blending colours. The scumble allows some of the undercolour to show through and the two layers blend in the eye of the viewer. You can also scumble one wet colour into another where they meet, as shown here.

Scumble over sponged texture

Subtle textures are the essence of egg tempera painting and help to give it its characteristic luminosity. Here, a light scumble was applied over a sponged surface to soften the texture and merge the tones. Use an almost dry brush and work with a circular motion.

Watercolour

Scumbling is used less often in watercolour, due to the fluid, transparent nature of the paint. But thick colour, diluted with very little water, can be applied with a light, circular motion so as to pick up the texture of the paper. J.M.W. Turner (1775-1851) often used scumbling when painting stormy scenes or rough terrain.

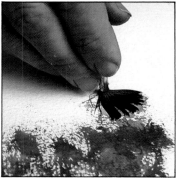

Scumbling • Watercolour

1 Load your brush with fairly stiff paint, or wipe off the excess moisture on a piece of blotting paper. Fan out the bristles of the brush and work over the surface of the paper with a circular motion.

2 Used over washes, scumbling is useful for representing rough textures such as a weathered stone.

Pastel

Colour mixing is not always as easy in pastel as in other media. Scumbling is therefore an invaluable technique, because it allows you to modify any colour.

Hard pastels are best for scumbling, using light strokes with the side of the stick. Soft pastels can be used, but they require a very light touch, or the underlayer will be obscured.

An area of colour can be enlivened — or muted — by scumbling over it with another colour. Practise by laying in a square of thick colour with the side of the crayon. Then, taking a different colour, gently run the *tip* of the crayon in meandering strokes over the area. The original colour still shows through, but is modified by the scumbled strokes. This works especially well with complementary colours: a vibrant green, for example, can be cooled down by scumbling over it with its complementary, red. Be careful not to overdo the scumbled strokes: if they become too dense the effect will be lost. On smooth papers, only a minimum of scumbling is

possible before the surface becomes clogged up. On a rougher surface with more tooth, more scumbling is possible. If you wish to scumble several layers, spray each layer with fixative before applying the next.

2 Here, the process was reversed: a dark tone was worked over a lighter one.

1 A dark tone was laid in first, then a darker tone was scumbled over the area.

3 A dark and a light crayon were scumbled together to produce this vibrant effect.

SGRAFFITO

The word 'sgraffito' is derived from the Italian word *graffiare*, meaning 'to scratch', and refers to a method of scratching or scraping through a layer of paint to expose the colour or colours underneath. In this way, highlights can be added to a painting, and texture is created.

Any sharp instrument can be used for sgraffito — knives, razor blades, scraperboard tools, the end of a brush handle, the edge of an old credit card, or simply your fingernail. In addition, sandpaper is useful for scraping away areas of paint to reveal some of the colour underneath.

Sgraffito can be used with any medium, including pastel, and on wet or dry paint, depending on the effect required. For example, the texture of grass or the grain of wood can be scratched into a layer of dried colour, using a sharp point; while a layer of paint is still wet, you can create soft highlights by scraping into it with a blunt knife or ice lolly stick.

Scratched textures • Opaque media
1 Apply a layer of thick paint, straight from the tube or diluted with just a little medium. While it is still wet, 'draw' lines into the paint with the end of the brush handle or the handle of a knife.

2 Experiment with different scraping tools to discover the variety of textures and patterns that can be achieved. Here, a trowel-shaped painting knife was used to make broad marks.

3 A more delicate texture is obtained by applying a thin layer of paint and then using the edge of a painting knife to scrape off some of the paint right down to the canvas.

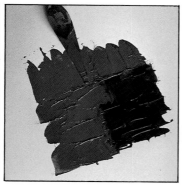

2 Apply a second coat, this time in a different tone or colour, and smooth the paint out.

Scratched texture • Water media
Although the practice should be used with caution, you can create delicate linear effects in a watercolour wash by scratching into dried paint with a sharp point.

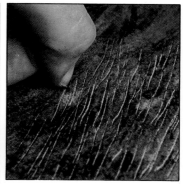

Thumbnail
1 While a wash is still damp you can scratch out delicate lines with your thumbnail, using a quick flicking movement.

Two-tone effects
1 Use a painting knife to apply a textured undercoat of thick, gummy paint, then allow it to dry.

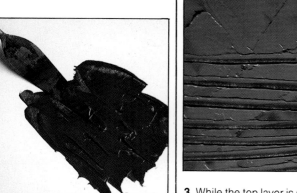

3 While the top layer is still wet, scratch into it to expose the dried underlayer. Use the end of a brush handle, a knife, a stick or any sharp instrument which gives you the effect you want.

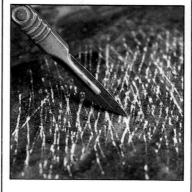

Scratching with a blade
Use a razor blade or scalpel where you want sharp, clean lines. Move the blade in one direction only — scratching back and forth damages the surface of the paper. Use fast, light strokes and do not press too hard.

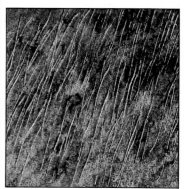

2 This method is useful for indicating the texture of long grass partially lit by the sun.

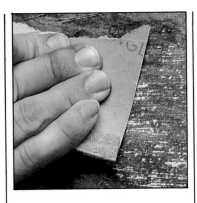

Sandpaper
Where a rugged or weathered texture is needed, try scraping gently with a piece of fine grade sandpaper.

2 When the gouache is dry the whole design is covered in a thick coating of black waterproof ink.

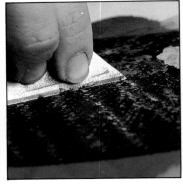

3 When the ink is thoroughly dry, a craft knife blade is used to scrape away some of the ink. Work until part of each layer of the design shows through.

Scraping with mixed media
1 Create an abstract or semi-abstract design by building up layers of contrasting colour with different media and then scratching into the various layers. Here the artist makes a design combining oil pastel and watercolour, finishing with a thick layer of gouache.

4 The finished picture. The marks left by the blade have lifted the design out of the flat plane by giving it texture, and in revealing the underlying bright colours have lent the image life.

SPATTERING

Spattering is similar to STIPPLING, in that colours and tones are built up from small spots of colour. But in spattering the effect is more random and has a greater feeling of movement, because the paint is flicked onto the surface from a brush held above the paper.

Generally, spattering is used in small areas only of a painting, because too much of it can appear mechanical and overbearing. But it is an excellent technique for simulating rough, pitted textures such as stone, cement and rock. When the spattered paint is dry, the shapes can be further worked: apply highlights and shadows with the tip of a small brush to create the illusion of three-dimensionality.

Artists often use a touch of spatter to enliven an empty foreground, because its randomness can suggest stones and weeds while not distracting attention from the centre of interest. Also, a spattered passage has an inherent sense of movement, which can be used to advantage when painting sea spray, or a snowstorm, for example.

There are two basic methods of spattering: one is to dip an old toothbrush into fairly thick paint and, holding it 7.5 to 15cm (3 to 6 inches) above the paper, quickly draw a knife blade, or your thumbnail across it. This action releases a shower of fine droplets onto the paper below.

The second method is to load a stiff bristle brush with thick paint and tap it sharply against the palm of your free hand, or an outstretched finger, or the handle of another brush. This produces a slightly denser spatter, with larger droplets than a toothbrush does.

Spattering can be used successfully in all painting media. It may be an unorthodox painting method, but it has a valid place in picture-making so long as it is used with care and discretion. It is worth experimenting with the technique on pieces of scrap paper. For example, a variety of patterns can be achieved by simply varying the distance between the brush and the paper, so increasing or decreasing the density of the dots; or try spattering onto wet paper, so that the dots become softened and diffused; additionally, spattering with two or more colours produces a more interesting surface than a flat wash of colour.

A final word of caution: spattered paint can travel a surprising distance, so make sure you are wearing old clothes and shoes, and that nearby walls, floor and furniture are covered. Similarly, when applying spatter to a small area of a painting, mask off the areas not to be spattered with sheets of paper fixed with masking tape.

Spattering • Egg tempera
1 Spattering is a popular technique in tempera painting because it produces a stronger, more vibrant surface than a flat wash does. Lay the panel flat on the floor, otherwise the spattered paint may run down the surface. Use newspaper to mask off those parts of the painting which are not to be spattered. This allows you to work with complete freedom within a specific area. The paint should be wet, but not too runny — the consistency of medium cream. Load your brush well, then draw your finger through the bristles to release a shower of small drops onto the surface. Here the artist is using a 3.8cm (1½in) decorating brush, held 15cm (6in) above the panel and at a slight angle to it. Leave the panel on the floor until the paint dries.

2 When the paint is thoroughly dry, remove the mask. Here you can see the edge where the flat wash and the spattered area meet.

3 Spattering from different directions will give a variety of effects. Here the artist holds the brush closer to the surface and slightly to one side. He then hits the handle of the brush sharply against the palm of his free hand. This method produces oblique marks instead of dots, because the paint hits the surface at an angle.

4 Tempera paint dries very quickly, allowing a densely spattered texture to be built up quickly without the colours running together. The drops of spattered paint should not be so thick that they stand up from the surface; if they do, they may crack off. Correct this problem by reducing the amount of paint on your brush. Avoid spattering tones that are much lighter or darker than the colour underneath: subtle shifts in tone help to create the glowing quality characteristic of tempera painting.

Spattering on dry paper
The delicate, fluid nature of watercolour lends itself well to the spattering technique. Use a stiff hog's hair brush or an old toothbrush and draw your thumbnail rapidly through the bristles to release a shower of fine dots onto the paper. The paint should be a stiff mix, like medium cream. Always test the density of the spatter on a scrap of paper before applying it to a painting. Generally, the brush should be held about 15cm (6in) above the paper, but you will discover by trial and error which is the best distance for the effect you want.

Spattering on damp paper
Spattering on damp paper creates a soft, impressionistic effect as the dots of paint blur together. This spontaneous way of painting often produces accidental effects which can be further worked to produce pleasing images. Try spattering with two or more colours and allow them to blur into each other.

SPATTERING • SPECIAL TECHNIQUES

SPECIAL TECHNIQUES

For most artists, one of the greatest pleasures in painting is exploring the thin dividing line between controlled technique and accidental effect. Indeed, some of the most successful paintings are those that contain a happy blend of the two, so that there is an underlying sense of order and structure as well as of naturalness and spontaneity.

Sometimes, though, seemingly spontaneous effects can be engineered by an imaginative artist. Purists may disapprove, but an artist should never be afraid to experiment with a variety of tools and techniques, or to mix different media in one painting if they complement each other. In fact, it requires some ingenuity to manipulate paint, paper, brushes and other tools in such a way as to merely suggest a particular texture or effect, without it looking false or laboured. The examples shown here should serve to whet your appetite for experimentation, and no doubt you will discover many more ideas of your own.

Of course, too much reliance on technical 'tricks' can make a painting look gimmicky. But, when used as a complement to a well-disciplined skill, they can add much to the expressiveness of your work, as well as teaching you a great deal about the potential of your chosen medium.

Plastic wrap
Some artists, instead of setting out to paint specific things, prefer to start out with random shapes which suggest a particular image, and then work on developing that image. This idea is far from new: Leonardo da Vinci often suggested to his students that they look for pictures in the cracks and stains on an old wall, and the Russian-born painter Alexander Cozens (c1717-86) wrote a book on developing images from ink blots (see BLOWN BLOTS).

Watercolour and coloured inks are particularly fluid, spontaneous media; random shapes and patterns often occur, especially when working WET-IN-WET, which can provide the spark of an idea for further development.

An excellent way to try out this idea of painting from random forms is to create patterns and textures in a wet wash of watercolour or coloured ink, using a sheet of thin, plastic food wrap. The plastic is pressed into the paint and then squeezed and prodded with the fingers so that it forms folds and creases. The support is then left to dry in a horizontal position for several hours.

When the plastic sheet is removed, a mottled or striated pattern will have formed in the paint, due to some of the pigment having been trapped in the creases in the plastic. Such patterns might suggest a rocky landscape, a woodland scene, or even the design of a butterfly's wing. Once you have decided on an image, you can then develop and strengthen it further, using other media if you wish to.

Ink and plastic wrap
This process is very simple and produces extraordinary and unpredictable effects. The random patterns created when the ink has dried can be left as they are, or further worked with different colours and media.

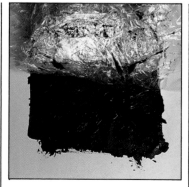

1 Begin by pouring ink onto dry paper in a heavy wash. You can either create a specific shape, or you can tilt the board this way and that to create an entirely random shape.

2 While the ink is still wet (it should not be too thin) lay a sheet of thin plastic, such as clingfilm, over the area. Using the tips of your fingers, press and squeeze the plastic so that it crinkles up and forms ridges. With the plastic still in place, lay the board flat in an undisturbed corner and leave the painting to dry. This may take anything up to a couple of days. When you think the ink looks dry, peel away the plastic wrap.

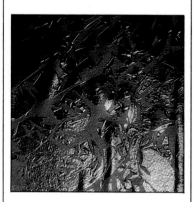

3 The finished result. Where the ink became trapped in the folds of the plastic, it has dried with a hard sheen.

67

Salt

The use of salt sprinkled into a wet wash of watercolour or ink produces exciting textures and effects. The granules of salt soak up the paint where they fall and when the paint is dry the salt is brushed off, and a pattern of pale, crystalline shapes remains. These delicate shapes are very efficient in producing the illusion of falling snow in a winter landscape, or for adding a hint of texture to stone walls and rock forms.

The technique sounds simple, but it takes practice to get the timing of the salt application right. The ideal time to apply salt is when the wash is wet, but not soaking, damp but not too dry. Large, soft shapes are produced by applying salt to a wet wash, whereas smaller, more granular shapes are produced in a wash which is just damp.

If you want to produce a fine, delicate pattern, ordinary table salt can be used. But in general, coarse rock salt works better. Do not sprinkle on too much salt, because this spoils the effect. Once the salt is applied, leave the surface in a horizontal position for 10 to 15 minutes, or until the wash is completely dry, then simply brush off the salt.

It should be remembered that salt will not react on pigment that has previously dried and been re-wetted. Nor will it work on poor quality paper or with inferior paints.

The Salt Technique
1 Apply a flat wash of colour to the paper. Just before the wash loses its shine (you can see this by holding the paper, horizontally, up to the light) sprinkle a few grains of rock salt into it. Leave the surface flat and allow it to dry naturally.

2 When the paint is dry, brush off the salt. Pale, crystalline shapes are left where the salt granules have soaked up the pigment around them.

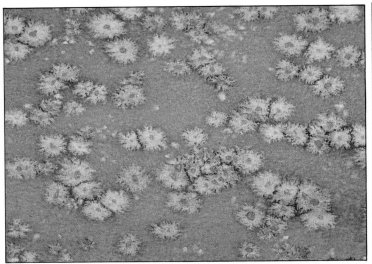

3 Sometimes the textures created by the salt technique will suggest other images which can be developed further. These flowerlike forms were created by dropping salt crystals into a slightly wetter wash.

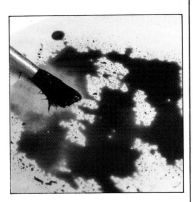

Watercolour on oil
Try painting white spirit over an area of paper and then laying a wash of watercolour over it. Interesting things happen as the paint separates on the oil. The technique is unpredictable, but beautiful marbled effects can be obtained.

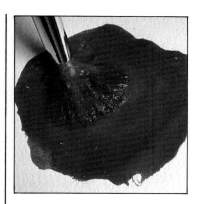

Gum arabic and watercolour
Gum arabic is the medium that binds the pigments in watercolour, and it can also be bought from art shops specifically for adding to the paint. Gum arabic added to watercolour pigment makes it thick and glossy and enriches the colour. Try mixing colours together on the paper to create a rich texture suitable for painting subjects such as animal fur, or stormy skies.

Turpentine
To produce a soft, painterly effect in a pastel painting, try blending the colours by moistening them with turpentine. The finished effect is similar to that achieved by Edgar Degas (1834-1917), when he sprayed boiling water over some areas of his pastel drawings and worked into them with a brush.

2 With a clean brush and turpentine, work into the pastel to dilute the colour and spread it into the grain of the paper. As the pastel mixes with the turpentine it takes on a painterly, washlike quality, and the colour becomes richer and darker.

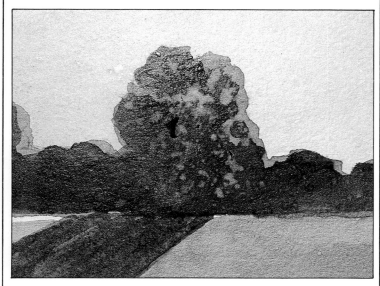

Oil pastel and turpentine wash
1 Using the side of the pastel stick, lay an even area of colour over a rough-textured paper. Apply the pastel lightly so it catches on the upper layer only of the paper's tooth.

Gum water and watercolour
In the painting the hedge was first painted in watercolour. A diluted form of gum arabic known as gum water was then added to the paint to heighten its greenness and create tonal variety.

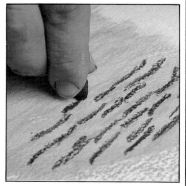

3 If desired, further pastel tones can be added on top of the pastel-turpentine wash. This combination of washes and strokes adds much to the colour brilliance of the final image. Use this technique for blocking in backgrounds, for underpainting, or for any subject with rich colours and textures.

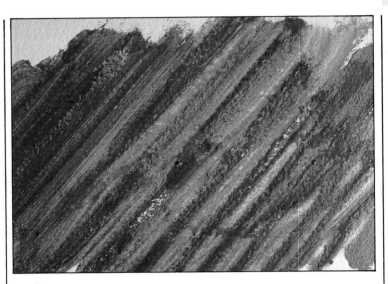

Pastel and acrylic medium
As with the pastel and turpentine wash technique, the combination of pastel and acrylic medium can produce a picture which is somewhere between a drawing and a painting. Here, diagonal strokes of soft pastel were applied to rough paper and then brushed with acrylic medium to soften and blend the strokes.

SPONGE PAINTING

The sponge is a highly versatile painting tool, capable of producing a broad range of effects in any painting medium. Most artists keep two sponges in their painting kit: a synthetic one for laying a flat, even layer of colour in large areas, and a natural sponge for creating patterns and textures. Natural sponges are more expensive than synthetic ones, but they have the advantage of being smoother and more pliable to work with, and their irregular texture produces more interesting patterns in the paint. For example, a mottled pattern is produced by pressing a moistened sponge into fairly thick paint and then dabbing it onto the paper. You can dab one colour over another, or produce a graded tone by dabbing more heavily in one area than another. This technique is successful in rendering foliage on trees, or the pitted surface of weathered stone.

Also, by twisting or stroking with a paint-soaked sponge, subtle gradations of tone can be achieved when painting soft, rounded forms such as clouds, fruit, or perhaps misty hills in the distance.

Natural sponges
Painting with a sponge gives textural effects which are often impossible to render with a brush. The mottled patterns produced by dabbing colour on with a sponge are perfect for simulating the textures of weathered rock and crumbling stone, pebbles and sand on a beach, sea spray, and tree foliage. In addition, you can create lively broken colour effects by sponging different colours over each other.

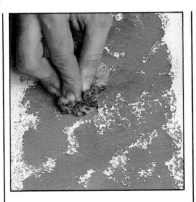

1 Paint for sponging should be diluted with just a little water or medium — if it is too fluid the marks will be blurred. In acrylic painting, diluting the pigment with matt medium gives sharper results than water will. Always use a damp sponge. Soak it in water, squeeze it out until just damp, then dip it into the pool of colour on your palette. Apply the colour with a soft dabbing motion, without pressing too hard.

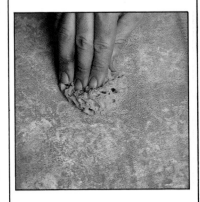

2 You can also press a damp, clean sponge into a wet wash to lift out colour and leave a subtle texture.

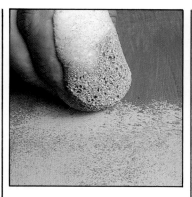

Synthetic sponges

1 Sponging often works better when a light colour is applied over a darker underpainting. Here the artist is sponging over a grey-toned ground with egg tempera — a mixture of titanium white, raw umber and cadmium yellow. A thick, synthetic sponge produces an even, close-textured pattern which is often used in egg tempera painting for building up tones and textures.

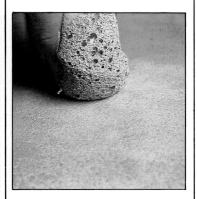

2 When the first coat is dry, a lighter colour, with more white added to it, is sponged over part of the first layer of paint.

3 A delicate, gradated effect is obtained by laying tone over tone. This technique works extremely well in rendering subtle, evanescent textures such as those of clouds and sea foam.

STAINING

In oil and acrylic painting, the canvas can, if desired, be 'stained' with thinned pigment, as an alternative to using thicker, opaque colour.

This approach is used when the artist wishes the weave or 'tooth' of the canvas to remain an intrinsic element of the finished picture. Some artists, notably Morris Louis (1912-62), prefer to stain unprimed canvas, so that the colour is actually absorbed by the canvas weave, although unprimed canvas should not be used by oil painters.

Like GLAZING, staining can produce wonderfully transparent effects, the only difference being that a stain is applied directly onto the canvas, whereas a glaze is applied over an UNDERPAINTING.

Rowney's Flow Formula acrylic paints are especially good for staining large areas, and the addition of water tension breaker to the water helps to retain the intensity of the colour.

Staining Raw Canvas • Oil, Acrylics

1 Mix the tube colour to a thin, fluid consistency, using the appropriate medium. Pour the paint directly onto the canvas.

2 Work the colour into the weave of the canvas, using a sponge.

3 You can aim for a completely smooth, even finish or (as here) you can work the paint in different directions for a more rugged finish.

STIPPLING

Stippling is the technique where colours, tones and textures are built up with a mosaic of fine dots applied with the tip of a small, pointed brush. Stippling can also be used to provide texture or tone in small areas, alongside or on top of a wash. In a beach scene, for instance, a few stippled marks can be used to suggest small stones and pebbles.

Stippling works well with all media, including pastel (when the stick has been sharpened to a point) and is particularly suited to egg tempera painting. It is a fairly demanding technique, requiring plenty of patience, but the results are usually well worth the effort, especially when two or more colours are used together to create scintillating colour effects.

With stippling, you can achieve beautiful, subtle gradations of tone simply by varying the density of the dots: a dense concentration creates a darker or more solid tone, whereas a light tone is the result of leaving bigger spaces between the dots.

Because each dot is separate, the colours appear to shimmer and sparkle when viewed from a distance. This is due to the way in which tiny dots of colour vibrate on the retina of the eye. In addition, the colour of the ground plays a part in the overall effect, serving as a dark, middle or light tone.

Stippling with a brush
1 Shading and texture can be achieved by building up a mosaic of fine dots using a small, well-pointed brush. Hold the brush almost at right-angles to the painting surface and repeatedly touch the tip to the surface without pressing too hard. Try to space the dots evenly and make them about the same size. Paint for stippling should be quite fluid, but not too runny; shake the brush to remove any excess moisture and avoid drips and runs.

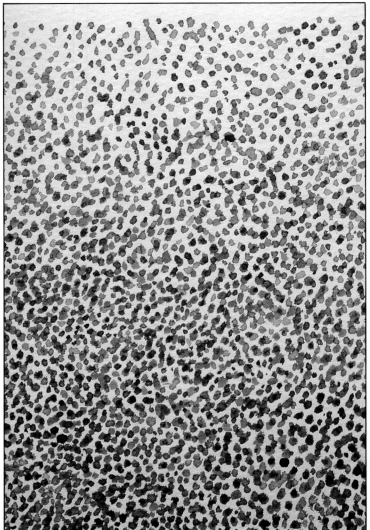

2 Stippling produces an area of colour that appears lighter and brighter than the equivalent colour applied in a flat wash. The overall effect can be extremely soft and subtle, especially when used over a wash of colour. If you wish to increase the density of tone in an area, apply more dots but do not increase their size. Experiment by intermixing two or more colours; graduating from one colour to another; and applying a stipple over different coloured washes.

Stippling with a round bristle brush
Here the artist is using a round stippling brush to apply tempera paint. Each of the stiff hairs leaves a tiny dot of colour on the panel, enabling a large area to be covered fairly quickly.

Stippling with a Sponge
1 You can also stipple with a small, round sponge — synthetic ones will produce a more regular pattern. For small areas, make a stippling tool by wrapping a piece of sponge or foam rubber round the end of a paintbrush. This will give you greater control over the technique.

3 Moisten the sponge and dip it into fairly stiff paint, then apply with a press-and-lift motion — don't scrub.

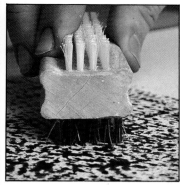

Stippling with a nail brush
Stippling doesn't always have to be done neatly with the tip of the brush. Different types of brush will produce different types of stipple. Here the artist is using an old nail brush and semi-liquid colour; this is faster than the painting brush method, and produces a slightly more ragged stipple, but just as attractive as the traditional method.

Stippling with a decorator's brush
The softer hairs of a decorator's brush produce a slightly blurred, more irregular stipple. A worn, ragged paintbrush with splayed hairs is also useful for stippling.

2 Make sure the wad of sponge is thick enough to prevent the sharp point of the brush handle sticking through, and tape it firmly in position.

4 Keep dabbing and lifting, overlapping the patterns until you achieve the density and texture that you want. Try dabbing one colour into another, or producing graded tones by altering the density of stipple.

TEXTURAL PAINTING

In the early 1900s, the Cubist painters introduced a great many innovations into painting, which have now become commonly accepted. Among them was the idea of creating textures and forms with additions to the paint, rather than by creating the illusion of them with brushstrokes. Certain artists began experimenting by mixing coarse-textured substances into the paint before applying it to the canvas. They added sand, marbledust, sawdust and woodshavings to give extra bulk to the paint and produce interesting textures on the canvas, often resembling bas-relief.

What these artists were striving for was to emphasize the presence of the painting itself, as an object in its own right. Indeed, many of the more heavily textured works by Picasso, Braque and Jean Arp seem to bridge the gap between painting and sculpture.

To explore the tactile qualities of opaque paints such as oil, acrylic and gouache, try adding sand, plaster or sawdust to the paint to give it body and texture. The thickened paint should be applied to the support with a knife, rather than a brush.

In addition, all kinds of textures can be scratched, scraped, incised or imprinted into a layer of thick paint. Experiment with a variety of improvised tools — old kitchen forks, spoons and knives, hair combs, wire brushes, ice lolly sticks — anything that will leave an interesting, irregular texture.

Such experiments may act as a springboard for ideas which you can develop in your paintings. A combed texture might suggest tree bark, for example, or the way the light falls across a stippled texture could suggest a rocky terrain.

Experimenting with paint in this way serves a useful purpose in stretching the imagination and in developing confidence in the handling of the medium. Even so, textural painting should not be used for purely facile or superficial effects. Rather, the textures you create should spring naturally from the textures which you observe in nature.

Mixing sand with paint
1 Almost any granular material can be mixed with oil or acrylic paint to create a textured surface. Here the artist lays out coarse building sand and acrylic paint on his palette and mixes them together well.

2 The textured paint is spread over the canvas with a knife and worked into the weave to make it adhere. The paint should be of a thick consistency, but not too dry.

3 When the first layer is complete, more paint is added using a painting knife. Gradually the surface is built up to a thick impasto. In order to prevent eventual cracking of the paint surface, try not to lay the paint on *too* thickly.

4 This close-up shows the fascinating texture achieved; the impression of the knife strokes is retained, and the ridges of paint cast interesting shadows.

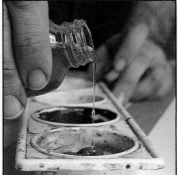

Comb texture
1 A thick layer of gouache can be worked over with a pointed tool which leaves its imprint in the paint and creates textured effects. Here the artist mixes gouache with gum arabic, which thickens the paint and gives it a slight gloss.

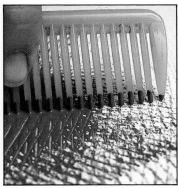

2 The paint is poured onto the paper in a thick layer, and then smoothed out and worked into with a hair comb to produce a three-dimensional texture.

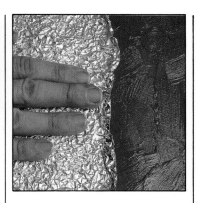

Texturing with silver foil
1 In this adaptation of the frottage technique, a stippled texture can be created in a thick layer of oil, acrylic or gouache. The paint should be of a thick tacky consistency — if it is too runny the texture will be less pronounced.

2 When the foil is peeled away a raised texture is left which, when dry, can be accentuated with glazes or drybrush.

TONED GROUND

In oil and acrylic painting, a toned ground serves exactly the same purpose as an IMPRIMATURA: it tones down the glaring white of the canvas or board, which can be somewhat intimidating, and it unifies the overall colour scheme if small areas are allowed to show through the overpainting.

The only difference between the two methods is that an imprimatura is transparent, whereas a toned ground is made opaque by the addition of white pigment.

The advantage of a transparent ground is that it gives more sparkle to the overlaid colours, because of the light bouncing back off the white support. However, if you wish to leave small patches of the ground showing through the overpainting, the problem is that the colour may fade eventually because it is so thin and diluted.

The advantage of having an opaque ground colour is that large areas of this colour can be left exposed because they will be quite permanent. The ground colour then becomes an integral part of the painting, just as a tinted paper is in a pastel painting.

As with an imprimatura, a toned ground can be a neutral grey or earth colour, or it can give a generalized idea of the overall colour scheme of the subject — a pinkish tone under an evening sky, for example. It can also be a colour which is near-complementary to the finished colour scheme. For example, a warm undertone of burnt sienna will have a vitalizing effect on a cool green landscape.

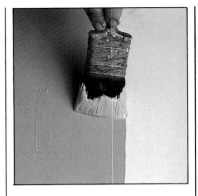

Toned ground
After priming the canvas or board, apply an opaque ground of raw umber. The colour should be softened with a little flake white and diluted with the standard amount of medium. Use a large bristle brush and apply the paint smoothly and unevenly. It is important for the toned ground to be thoroughly dry before you paint over it. This can take up to 48 hours, perhaps longer if a lot of white has been added to the colour. For this reason it is a good idea to have a few canvases or boards in various colours prepared ready for painting at any one time. Alternatively, you can use acrylic paint to tone the canvas. This dries in minutes, making it possible to begin the overpainting in the same session, and can quite happily be overpainted in oils (though acrylics can *not* be painted on top of oils).

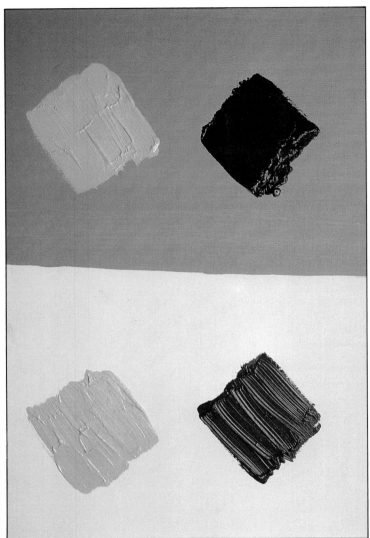

How a toned ground works
A toned canvas helps you to judge the relative intensity of your colour mixtures more accurately than a white canvas. This is because the toned canvas gives you an idea of how the colours will look when surrounded by other colours. To demonstrate this, the illustration above shows a piece of canvas, of which half is painted with a toned ground of raw umber and half is left white. Small squares of ultramarine and cadmium yellow are applied to each half: observe closely and you will see how much more intense the colours appear on the toned ground than they do on the white canvas.

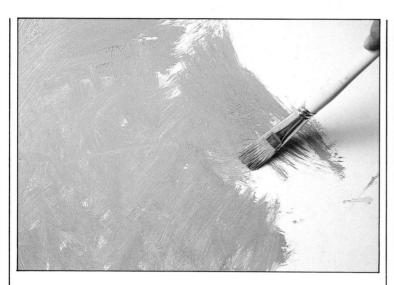

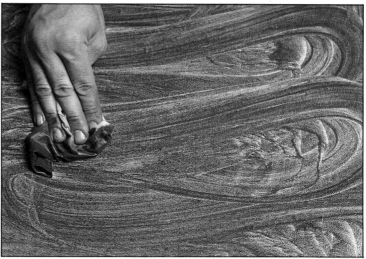

Toned ground • Acrylic

Acrylic paint thinned down with water to a fairly fluid state is ideal for preparing a toned ground because it dries so quickly, allowing you to work on it soon afterwards. But, because of the speed with which it dries, you have to apply it quickly.

Toned ground • Oil

Oil paints can also be used to tone a ground and, like acrylics, have to be thinned down so that they have a liquid consistency. Turpentine is one of the best diluents for this purpose. Here the artist has used a cloth to distribute the umber paint over the canvas. An oil ground usually takes a day to dry thoroughly.

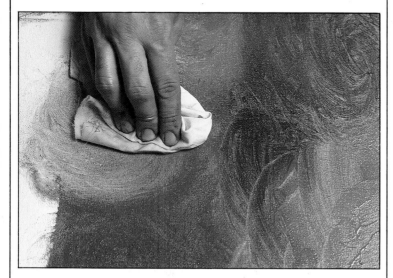

Multicoloured toned ground

More than one colour can be used for the ground, particularly if you already know where you will want warm and cool tones in the finished picture.

TONKING

In oil painting, an overworked area which has become clogged with too much colour can be rescued, when still wet, by the technique of tonking. The process consists of laying a clean sheet of paper over the failed area and smoothing it down with the palm of the hand. The paper is then gently peeled away, lifting with it the excess pigment and producing an overall softening which is, incidentally, very attractive. The artist can then repaint over the area using the 'ghosted' image remaining on the canvas as a guideline. This process is quicker and easier than scraping back the offending passage after it has dried.

2 The artist lays a clean sheet of newspaper over the area and rubs it gently with the palm of his hand.

3 The paper is then peeled away, bringing with it the excess colour.

Tonking
1 An area of a painting has become clogged with too much paint.

4 With very little effort, the colour has been softened and lightened, and is now ready to be painted over. This technique is excellent for producing misty, atmospheric effects in landscape paintings.

UNDERPAINTING

Underpainting is the time-honoured method of laying the foundation for a good painting by blocking in the main shapes and tones with thin paint, prior to the application of detailed colour. The idea is to establish the overall composition and tonal relationships at the outset, thus providing a firm base from which to develop the painting.

The Old Masters often divided the execution of a complex painting into several, more manageable, stages. Firstly, an IMPRIMATURA or TONED GROUND was laid, followed by an underpainting. When the artist was satisfied with the organization of the picture, he then overpainted with thicker colour and, or, transparent glazes.

Some artists favour working directly, or ALLA PRIMA, but there are certain advantages to making a preliminary underpainting. First of all, it helps to overcome the staring white of the canvas or board which comes through a toned ground or imprimatura. This makes it easier to judge the relative tones of the succeeding colours.

Secondly, mapping out the composition in this way gives you an accurate idea of what the final painting will look like. At this stage, you can see at a glance whether or not the picture 'hangs together', and any necessary changes or corrections can be made. Because the paint is used so thinly in underpainting, mistakes at this point are easily corrected by wiping the paint with a rag soaked in turpentine substitute. Corrections should be avoided in the later stages of the painting, because they involve scraping down the paint, and there is a danger that the colours will become clogged and look tired from being overworked.

Thirdly, an underpainting leaves the artist free to concentrate on colour and texture in the later stages of the painting, because all the decisions about light, shade and modelling have already been made.

Always work loosely in the underpainting stage. Use a fairly large brush and work rapidly, blocking in the main shapes and masses only. It is a mistake to put in too much detail at this stage, because it tends to restrict the freedom of brushwork later on. It is essential to keep the painting in a flowing, changeable state and to work from the general to the particular.

Regarding the colours used for underpainting, there are several choices: you may choose to block in the light and dark areas in a rough approximation of their finished colours; you may use neutral greys, blues or earth colours which will help to unify the later layers of colour; or you may choose a colour which contrasts with the final colouring of the subject (a warm red under a stormy grey sky, for example).

Rembrandt (1607-69) often underpainted his subjects in tones of grey, terre verte or brown, overlaid with thin glazes. When painting fleshtones, Rubens (1577-1640) used an underpainting of terre verte; this subdued green complements the pinkish colour of the flesh and, when allowed to shine through in places, lends a delicate coolness to the shadows.

Oil

When underpainting in oil, always use lean paint, diluted with turpentine to a fairly thin consistency (see FAT OVER LEAN). Allow the painting to dry thoroughly — at least 48 hours — before painting over it. A convenient alternative is to use acrylic paint for the underpainting. This dries within minutes, allowing you to begin the overpainting in the same session.

To indicate light areas, use very diluted paint, or wipe off the colour with a rag. An underpainting should consist of a mere stain of colour which dries quickly and doesn't smudge or lift off when overpainted.

Acrylic

Colour for the underpainting stage should be mixed with matt medium, which dries without any shine.

The obvious advantage of acrylic paints is that they dry so quickly, which means that you can complete the underpainting and the overpainting in one session if you wish.

Underpainting
1 Many artists choose to underpaint in tones of one colour — usually a neutral colour: this is called monochrome underpainting. Here the artist is making an underpainting for a still life. The paint is diluted with turpentine to a thin consistency and applied with short, scrubby strokes with a large flat brush. If desired, a toned ground or imprimatura can be applied before the underpainting. It is a matter of personal choice as to how you tackle the underpainting: you can work from light to dark, from dark to light, or you can start with the mid-tones and then establish the lights and darks.

2 Here we see how the basic shapes and areas of tone are beginning to take form. This underpainting is done in tones of cool grey, mixed from Prussian blue and burnt umber — both quick-drying colours. Flake white is added for the lighter tones (never use titanium or zinc white, as these are very slow-drying colours). It is a good idea to blend the edges of the shapes lightly with a soft brush; this will eliminate any hard edges in the paint surface which will spoil the later applications of paint. Try not to create too many extremes of tone — keep the shadows lighter than they will finally appear and the highlights more subdued. The lighter the underpainting, the more vibrant the finished picture will appear.

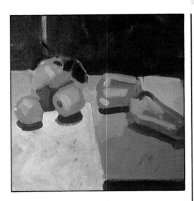

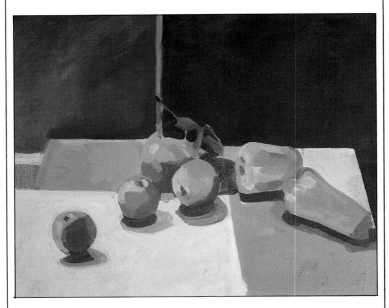

3 When the large masses have been established, use a smaller brush to refine the shapes if desired. Guard against too much detail, however. The underpainting is only a guide and should not be so perfect as to inhibit your freedom of handling in the later stages of the painting. Once the underpainting is thoroughly dry, you have a solid foundation on which to continue the painting in colour.

VARIEGATED WASH

With water-based media — ink, watercolour, and heavily diluted acrylic — exciting and unusual effects can be obtained by laying different coloured washes side by side so that they melt into each other WET-IN-WET. Try using variegated washes when painting misty, atmospheric skies, for example.

Variegated washes are controllable only to a degree; when the colours start to bleed together there is little you can do to control the spread, except by tipping the board or blotting with a sponge. But then in any painting the best results are often achieved by a combination of skill, hope, and the 'happy accident'!

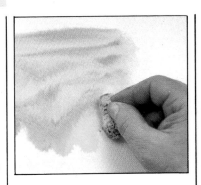

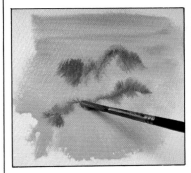

2 While the first wash is still wet wash in another colour with a sponge and let the colours run together.

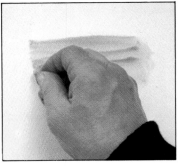

Variegated wash • Sponging
1 Dampen the paper, then mix up a variety of colours and apply them in an irregular shape so that they flow together.

3 A more concentrated mixture of paint can then be drawn across the wash with a paintbrush to strengthen the colours.

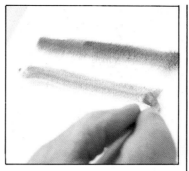

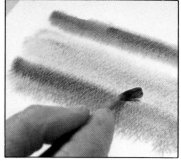

4 Blend in the darker paint lightly and let it run, and then leave the wash to dry. The unpredictability of this technique is one of its most exciting characteristics.

Variegated wash • Blending
1 Laying a wash with a brush is a much easier way of controlling the spread of paint when applying it with a sponge. Having dampened your paper, paint two parallel strips of colour on it, with a space between them, and leave them to dry.

2 Paint another strip of colour parallel to the first two and blend their edges with gentle strokes using a wet brush and allow them to bleed into each other.

WASH-OFF

Ink and gouache wash-off is an exciting technique that produces a textural effect not unlike that of a woodcut or lino print. The process, though quite a lengthy one, is highly satisfying and the results can be spectacular. The secret of success lies in a patient, methodical approach: each stage must be allowed to dry completely before the next stage can be begun.

The basic method is as follows: a design is painted onto paper with white gouache and allowed to dry. The whole paper is then covered with a layer of waterproof black ink. When this is dry the painting is held under running water. The gouache, being soluble, dissolves and is washed off. This causes those areas of dried ink which were covering the gouache to wash off at the same time. Meanwhile, the areas of black ink which covered parts of the design *not* painted with gouache remain intact. The result is a negative image of your original design.

3 Laying a variegated wash in this more controlled way means that you can establish a background knowing more or less what it will look like although the effects are not altogether predictable.

1 Ink wash-off must be done on a good-quality white paper, strong enough to withstand thorough wetting without tearing. The paper should be pre-stretched and taped firmly to the board to prevent it from wrinkling. If it does buckle a little when wet, don't worry — leave it to dry naturally and it will correct itself. The first stage in the wash-off process is to cover the entire paper with a flat wash of watercolour. This makes it easier to distinguish the white gouache design when you come to paint it. Here the artist is laying a diluted wash of raw umber, applied with a large mop brush.

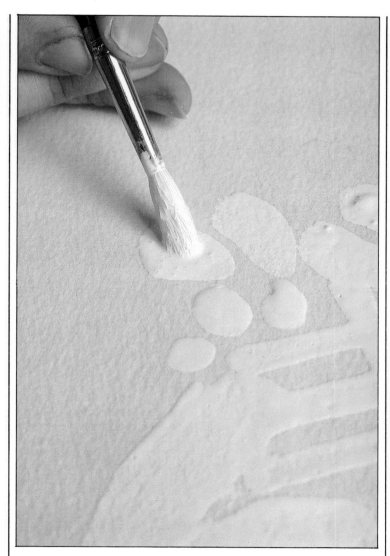

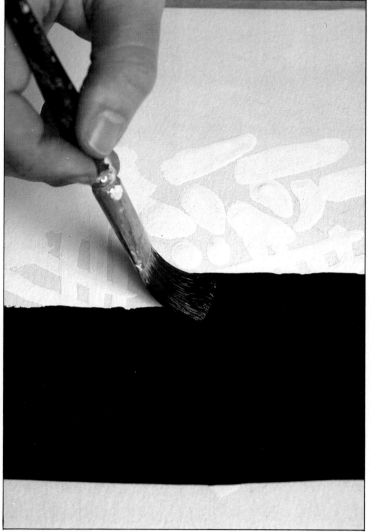

2 When the watercolour wash is completely dry, paint your chosen design in white gouache. If the image is to be an intricate one, you may prefer to make an outline sketch of it on the paper before applying the watercolour wash. The gouache will eventually be washed off, leaving negative shapes on a black background.

3 Allow the gouache to dry thoroughly, then cover the entire painting with black waterproof ink. This is the trickiest part of the process — the effect can be ruined if it is not done properly. Check that you have enough ink to cover the whole paper and shake it well before starting. Always use a large flat brush to apply the ink — here a No. 16 sable is used. Starting from the top, apply the ink in broad horizontal strokes. Make sure your brush is well loaded, because you can only go over each area once — otherwise the white gouache starts to come off and mix with the ink. Leave the ink to dry naturally until it is bone hard.

4 Now the wash-off part begins. Hold the board in a tilted position and pour large quantities of cold water over the paper (or hold the board under a running tap). Eventually the white gouache starts to dissolve and the ink that covers it also breaks up and is washed away. It may take several washings before all the removable ink comes off the board.

5 Use a soft brush to remove any excess gouache. The waterproof black ink that was not painted over gouache stays firmly in place, despite repeated washings.

6 The finished effect is a silhouetted image. This can be left as it is, or it can be developed by adding colour to the white parts of the design. For demonstration purposes, the design shown here has deliberately been kept simple. However, the technique is best suited to a more intricate or textural design such as that used for leaves and flowers. Animals, with their fur texture and markings, are another suitable subject.

Wash-Off

In this example, a wash of burnt sienna was laid over a pencil drawing and, when dry, the shapes of the flowers, the vase, and the table were painted over it with white gouache. When the gouache had dried the whole image was covered with waterproof Indian ink. Once this was dry cold water was poured over the paper and within several minutes the ink on the gouache came away, with the gouache. Excess gouache was removed with a paintbrush, still leaving the waterproof black areas on the paper. A thin background wash of Prussian blue was then applied to lift this decorative image out of the purely monochrome.

WET-IN-WET

In wet-in-wet painting, colours are applied over or into each other while they are wet, leaving them partially mixed on the canvas or paper. It is one of the most satisfying methods to work with, producing both lively colour mixtures and softly blended effects.

Because the colours don't quite blend together, the result is soft and hazy, often with a slight feeling of mystery. In landscape painting, for example, the line where the sky meets the horizon should be blended wet-in-wet. This lends a sense of space and atmosphere, encouraging the eye to sense that there is something yet unseen over the horizon. In contrast, a hard edge along the horizon looks flat and unsympathetic.

Wet-in-wet is also a quick, spontaneous method, often used in ALLA PRIMA painting. The Impressionists — notably Monet (1840-1926), Pissarro (1830-1903) and Sisley (1839-99) — often overpainted or SCUMBLED over a wet underlayer when trying to capture the fleeting effects of light on their subject.

Watercolour

Wet-in-wet is one of the classic techniques of watercolour painting, as exemplified in the wonderfully fresh, lively sketches of outdoor subjects which Constable (1776-1837) executed as studies for his larger oil paintings.

When you're painting delicate or hazy subjects — flowers, mists, skies, water, shapes in the far distance — wet-in-wet allows the colours or tones to blend naturally on the paper without leaving a hard edge.

The results depend on how wet the layer underneath is. If colour is charged into a wet wash, the results are unpredictable — though often very exciting. If you require a greater degree of control, however, it is better to allow the first layer to dry just a little.

Because the results can be so attractive, it is tempting to overdo the wet-in-wet effect, resulting in a painting that looks weak and woolly. Always try to introduce some stronger, sharper details for contrast.

Wet-in-Wet • Watercolour
1 Watercolour's reputation as a spontaneous, unpredictable medium is based largely on the effects produced by working wet-in-wet. For this technique it is best to use a heavy grade paper (200lb or over); lightweight papers are apt to buckle when wet washes are applied. The paper should also be stretched and firmly taped to the board.
Dampen the paper with clear water, using a large brush or sponge. Blot off any excess water with the sponge so that the paper is evenly damp, not wet. The board should be laid flat, or at a very slight incline. Load your brush with pigment and apply it in random strokes on the damp surface. Don't dilute the paint too much beforehand, because this creates a weak, runny result. Because the paper is already wet, you can use quite rich paint — it will soften on the paper but retain its richness. You must also compensate for the fact that the colour will dry much lighter than it appears at first — just as a wet pebble on a beach looks richer in colour than a dry one does.

2 While the first strokes are still damp, further colours can be added so that the strokes spread and blur softly together. It is possible to manipulate the flow of paint by tilting the board to make the colour 'roll' on the paper. Keep a tissue handy for wiping away colour where you don't want it to go.

3 A wet-in-wet passage has a soft, impressionistic feel. The technique is unpredictable but exhilarating, and it is worth experimenting on scrap paper to see what effects you can create with it.

Acrylic

Acrylic may be quick-drying but this property does not rule out the possibility of working with it using the wet-in-wet technique. For example, tube colour heavily diluted with water behaves very like watercolour, creating soft, blurred strokes. If you require a greater degree of control, dilute the paint with matt medium and perhaps some retarder.

Oil

The soft, pliant nature of oil paints means that you can achieve a remarkable range of wet-in-wet effects, while retaining a degree of control over the paint. By slurring the wet colours together — without overblending — subtle gradations of tone and colour are achieved, while the colours themselves remain fresh and lively because each retains its identity.

Another method of painting wet-in-wet involves brushing a light colour sparingly over a darker, still wet colour. The light colour partially blends with the underlayer, creating an attractive 'lost and found' effect. This technique is perfect for rendering wispy white clouds in a blue sky, or the soft highlights on hair.

Wet-in-wet • Oils

Wet-in-wet is a feature of much alla prima painting in oils, where each stroke is painted next to or over another wet stroke to produce softly blended tones.

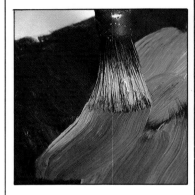

1 Lay a patch of colour. While it is still wet, brush into it with a second colour, using loose, random strokes.

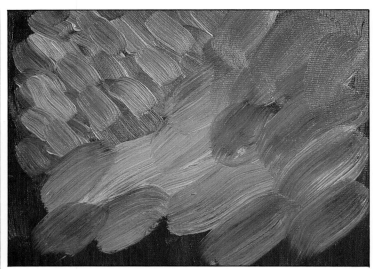

2 Continue building up tones and colours as desired, taking care not to overwork the brushstrokes: a wet-in-wet passage should have a fresh, lively appearance. Here you can see how scumbling strokes leave an interesting texture. The complete passage contains hints of the two separate colours, as well as a subtle range of tones in between.

WET OVER DRY

The opposite approach to WET-IN-WET, painting wet over dry means applying fresh paint over a previously dried colour. This method is used in GLAZING, and for rendering precise or strongly modelled forms.

Oil

Exciting results can be achieved by SCUMBLING or DRYBRUSHING over a dry passage of IMPASTO. Because the wet paint is of a fairly stiff consistency, it catches only the raised points of the dried underlayer, and this lends it a three-dimensional appearance. Similarly, a glaze of diluted colour will settle into the crevices of the dried underlayer, creating a random pattern of dark lines.

Wet over dry is a time-consuming method in oils, because each layer must be completely dry before the next one is applied if cracking is to be prevented. In this case, time can be saved by working on two paintings simultaneously.

Watercolour

In watercolour, a combination of wet-in-wet and wet over dry passages is always effective, especially in flower painting. Wet-in-wet washes capture the delicacy of leaves and petals in the initial stages, and then further washes, applied over the dried underlayer, add form and definition.

Depending on the wetness of the initial wash and the type of paper used, watercolour can take anything up to 15 minutes to dry thoroughly, so the technique does require a little patience; if the overlayer is applied too soon, the colours turn muddy and the crispness and definition are lost.

Wet over dry • Watercolour
1 The artist applies a flat wash of Hooker's green. When this is completely dry he overlaps it with another wash of the same colour to achieve a layered effect. The overlapped wash creates a darker tone. To produce a still darker tone, add a third layer.

2 This simple image shows how building up overlapping washes, from light to dark, creates a convincing impression of aerial perspective; the lighter tones look farther away. It is most important to allow each colour layer to dry before applying the next one, otherwise the characteristic clarity and transparency of the medium is lost. Remember also that the fewer the overlaid washes, the cleaner and brighter the result. Watercolour tends to become 'muddy' with too many superimposed washes.

Acrylic

Painting wet over dry in acrylic presents no problems, because the paint dries so quickly. In addition, the paint is insoluble once dry, even when diluted to the consistency of watercolour. This means that a wet overwash won't dissolve a dry underlayer, as sometimes happens with traditional watercolour.

Wet over dry • Acrylics
If you wish to paint wet-in-wet over a dry underlayer of paint, simply brush water or medium over the dry paint; the next layer of colour can then be softly blended into the wetness.

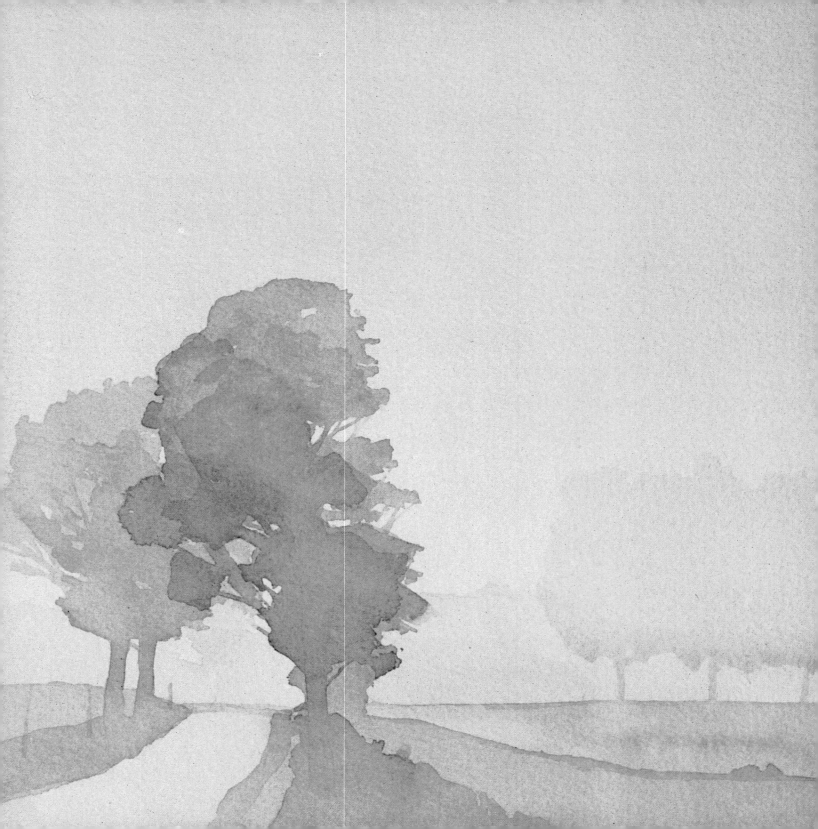

PART TWO

THEMES

I n this second part of the book, the author selects a number of painting subjects, and with step-by-step illustrations, shows how many of the different techniques described earlier can be used in their depiction. She has chosen seven, popular themes in which to demonstrate these techniques: animals, landscapes, portraits, skies and clouds, still life, water and weather effects. The subjects are wide-ranging but are all based on something you can observe for yourself. It is this personal observation that is most important. The techniques are there to enable you to realize your own vision. The author is at pains to point out that the techniques she shows you are not ends in themselves, but ways of achieving a goal — of painting what you see.

Most books on techniques concentrate on subjects such as the chemistry of paint, but few are about techniques as described here. You would probably find it helpful to read through the techniques quite quickly and then go back to work on a particular subject in some detail. You could start with a subject which interests you very much and later move on to subjects with which you have less sympathy. At any rate, here the subjects are so diverse that you will have no difficulty in engaging your interest.

In the 1940s and 1950s art schools did not teach the technique of painting — it was considered that you were either a craftsman or an artist, but that you could not be both. In part this view was due to a feeling that it was essential to break with the past if you were going to experiment with some of the new ideas in painting. Any sort of ability in a technical direction was frowned upon; the spirit, the vision, were all that mattered. With the introduction of acrylics, artists found it necessary to learn something about its technical properties, but a real understanding was slow in coming. The sort of attitude that prevailed was the exact opposite to the Chinese view of teaching, that of endless practice in making a mark until you could do it perfectly without thinking. Today in the 1980s we have come to see that techniques are important in order for artists to realize their ambition.

Though the primary purpose of this book is to introduce you to a series of techniques and to show you how you can use them, the author has much to say about ways of

approaching a subject and offers much helpful advice. For instance, in the section on landscape there is a discussion on whether or not you should put figures in a landscape. Most artists tend to come down firmly on one side or the other. Here the pros and cons are stated, followed by useful information on how to relate a figure to the landscape and what it should do in that landscape. Again, in the section on skies and clouds, while a number of techniques are discussed and you are shown how to achieve different effects, much information is given about the different types of clouds. In the section on portrait painting there is a general introduction as well as essays on aspects you will have to consider: suggestions are made on possible palettes for oil, watercolour and pastel, on how to paint a background, what sort of lighting is best, how to pose your sitter and how to deal with features such as eyes or the mouth. It is good to see the author's insistence that there is no such thing as a 'flesh tone', because skin tones vary and change from sitter to sitter in different lights, even though you can buy a tube of paint labelled 'flesh tint'. Incidentally, there are painters who would never use such a paint when working on a portrait, but find it useful when doing a landscape.

Many artists think that the best way to learn about painting is by working on still lifes. Others think that you must be able to draw well before you start to paint and yet others that you should master one medium before you embark on another. While these attitudes may seem sensible, unless you are able to attend art classes, it is probably more helpful to learn about drawing while you are painting. In addition, the value of one medium over another becomes apparent only when you work in another medium. The same applies to techniques.

Always remember that each painting technique is capable of being used in different ways and for a variety of subjects. Here you are shown some of the possibilities — it is not possible to show all here. Go on to experiment using them in other ways and on other subjects. Once you have understood a technique and how it works, try to master it in one context and then apply it to others. Think of the versatility of techniques and have fun.

ANIMALS

Animals have a reputation for being difficult to paint, mainly because they tend to move most of the time. But capturing the grace and agility of an animal — especially a *moving* animal — is one of the most rewarding experiences an artist can have.

Painting animals does not require a textbook knowledge of their anatomy; intelligent observation, sensitivity, and a basic awareness of form and structure will suffice, plus a willingness to practise, practise, practise! By all means study pictures in books and magazines, but it is generally not a good idea to make a painting by copying from a photograph, because photographs tend to flatten form and reduce detail; invariably the resulting painting lacks life and movement. If you have a pet, then you have endless opportunities for sketching and painting it. If not, try to visit a zoo or wildlife park, where you can observe the characteristic movements and gestures of a wide variety of animals.

Even though they are moving, you will find that most animals tend to repeat certain gestures; a good tactic is to work on several sketches at once, shifting from one to the other as the animal alters and regains certain positions. This may be frustrating at first, but gradually your reflexes will quicken and you will soon learn how to capture the essential character of the animal you are portraying. In addition, making studies of the stuffed animals in museums of natural history will give you an opportunity to examine, at close quarters, the fascinating textures and markings of animals.

The most common mistake seen in animal paintings is that the creature appears to be 'stuck on' to the picture surface, or floating in mid-air. One way to overcome this problem is to establish the tone and colour of the background *first*, working around the approximate outline of the animal. It is always easier to integrate the subject into the background than vice versa. Another way to avoid the 'cut-out' look is by using a variety of hard and soft edges; where the form of the animal is in shadow, the outline will be 'lost' or blurred, and where it meets the light it will be sharp. This combination of hard and soft edges makes the animal appear to blend naturally with its surroundings.

Another point to bear in mind is that too much attention to detail can freeze a rendering of an animal and make it appear stuffed. To convey a sense of life and movement, it is often a good idea to give a high degree of finish to the main features and a sketchy quality to the others. This will give added force to your painting, and also leave something to the viewer's imagination.

FEATHERS

In most birds, the wing and tail feathers are quite smooth and precise in shape, while those on the neck and throat have a downy quality. Begin by painting the bird with a pale underwash. Then use a small, soft brush to delineate the markings of the main feathers, working WET OVER DRY to achieve a precise pattern. The soft, downy feathers should be added last, using light, SCUMBLED strokes.

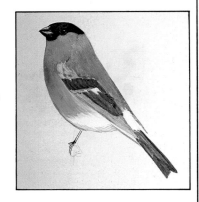

2 The vivid colours of the breast feathers are added in crimson and cadmium red. The texture of the feathers on the back is built up in tones of grey, using a fine sable brush.

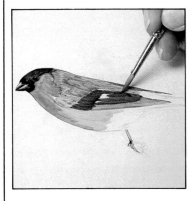

Feathers • Gouache

1 Once the washes of base colour have dried, you can start adding details to the plumage, gradually building up the colour and texture. The artist here has used a very dry brush with the occasional touch of liquid paint to emphasize the changes in tone, and to bring vitality to the image.

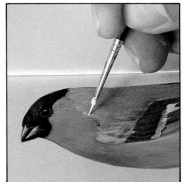

3 Stroke by stroke the artist creates the fine texture of the back feathers. Highlights have been added using white paint, applied with a No. 0 sable brush.

4 Using a very small sable brush the artist paints fine, parallel strokes in dry, undiluted paint to add the final touches to the plumage. This hatching technique is particularly good for conveying the texture of feathers.

5 In this detail, you can see the wide range of tones used, and the careful hatching and cross-hatching of the strokes.

Feathers • Watercolour

In this dramatic study of an owl in flight, the artist uses very loose brushmarks, which not only capture the texture of the feathers but also accentuate the impression of flight.

For obvious reasons it can be difficult to study birds from life, but working from a photograph is not always satisfactory. In this particular case, a high-quality photograph provided a ready-made composition, but the artist also made studies of a dead owl which he had found, so that he could record the colouring and arrangement of the feathers more accurately.

1 Detail from the wing feathers. The artist begins with a fairly accurate outline drawing of the bird, and then blocks in the lightest tones of the wing feathers with a No. 4 sable brush and a very pale wash of yellow ochre.

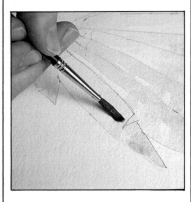

2 When the first wash is dry the artist begins to indicate the patterning on the feathers with a mid-tone of burnt sienna and raw umber.

3 With a dark mixture of burnt sienna and ivory black, the darkest pattern on the feathers is blocked in.

4 The drama of the painting lies in the clear, light shape of the owl against the inky black sky. Here the artist is blocking in the dark background with a very dark wash of Payne's grey. He first cuts carefully around the precise shapes of the feathers using a No. 2 sable brush. Once safely away from the edges of the feathers, he uses a 1.25cm (½in) flat Dalon brush to complete the background.

5 The artist now adds just a hint of texture to some of the feathers by applying hatched lines with a sharp HB pencil.

6 This close-up of the main wing feathers shows how the patterns and shapes have been built up, starting with the lightest tones and working up to the darks in the glazing technique. The process is very simple, but highly effective because it is so direct and to the point.

7 The feathers on the neck and the underside of the wing have a quite different quality from that of the sharply defined wing feathers. To indicate their thick, downy texture, the artist first applies various tones of Payne's grey, ivory black and cadmium yellow with overlapping strokes. When these are dry, white gouache is applied with rapid brushmarks, overlapping the darker feathers in places. This semi-opaque colour has the effect of softening the appearance of the feathers. Finally, white gouache is spattered lightly over the top of the head to give the characteristic markings (the rest of the picture was carefully masked off with newspaper to protect it from any stray droplets of paint).

FUR

Fur — just like human hair — comes in a wide variety of textures. How you render these depends on the type of animal you are portraying, the medium you are working with, and whether the animal is to be seen close-up or in the distance. Below are some examples of suitable techniques, but it is wise to remember that you should always start by defining the outline of the animal, then suggest the pattern of light and shade on its body, and lastly, pay attention to the markings and individual features.

Glossy fur

For animals with a sleek, glossy coat, use a WET-IN-WET technique. Observe the patterns of light and shadow carefully, then paint them with fast, fluid brushstrokes. Use as few strokes as possible, to accentuate the glossiness of the coat.

Shaggy coat

For animals with a fluffy, shaggy or wiry coat, use SCUMBLING or DRYBRUSH with a bristle brush and fairly thick, dry paint. Another method, often used in watercolour and gouache, is to block in the colours and tones of the coat with broad washes; when this is dry, use the tip of the finely pointed brush to tick in tiny lines which follow the pattern of hair growth. This technique is effective for rendering short-haired animals such as dogs and foxes.

Velvety hide

Some animals, such as horses, cows, deer, and smooth-haired dog breeds, have a short, sleek and velvety coat. The muscular structure beneath the coat is much more pronounced than in long-haired animals, so attention must be paid to the subtle modelling of tones. You could start by defining the form with a series of watery washes, and then suggest the lie of the coat with very short strokes using a finely pointed brush.

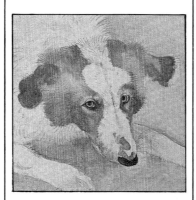

Fur • Oil

1 Layers of pigment have been applied thinly to build up the depth of colour and the details of the hairs are added on top, using a fine brush to smudge in the colour.

2 White hairs are added with a No. 0 sable brush, painting each individual hair slowly and methodically.

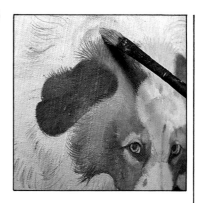

3 The pencil marks of the underdrawing indicate the folds of the dog's flesh and the way the fur stands out. In the final picture, below, the pencil marks are strengthened and flake white is added to pick out the fur against the background.

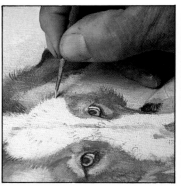

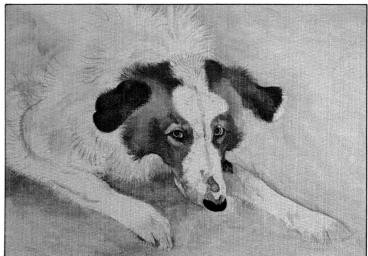

The finished effect

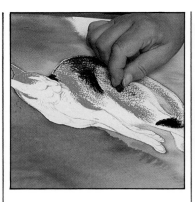

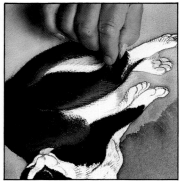

Fur • Watercolour

1 A soft outline was drawn in pencil, using short strokes to convey the fur, and then a light wash was added. Once some of the details of the animal's hair had been drawn, the artist concentrated on the head. Here the artist applies the paint onto wet paper because he wants the edges to remain soft.

Fur • Pastel

1 The background was laid in a watercolour wash because it is easier to apply over a large area than pastel is. A grey pastel is added and black is laid on top, to build up the depth of colour of the cat's coat. The artist used the pastel stick on its side, because the result is more grainy than when the tip is used. The soft but dense colour achieved is just right for the texture of fur.

3 The fine black hairs are added individually using a black pastel stick which has been broken in half to create a sharp drawing edge.

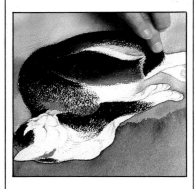

2 To increase the density of colour the artist blends the black and grey pastels, working them into the grain of the paper.

2 Having dried the picture using a hairdrier, the artist begins working on the body colour. A pale mixture of cadmium yellow, cadmium red and white is applied in a thin wash, with shadows added, in washes of black, where necessary. Remember that you can always soften the edges of a wash using a brush loaded with water.

Fur • Watercolour

In this close-up of a tiger's head, a combination of overlaid washes and linear work has been used to render the texture of the fur.

1 Working on a sheet of stretched 200lb Bockingford paper, the artist begins by blocking in the mid-tones of the fur with a No. 4 sable brush and varied mixtures of Payne's grey, ivory black, and burnt sienna. The lighter hairs are indicated by working these tones around negative white shapes.

2 When the mid-tones are completely dry, the tiger's black stripes are added, using a dryish mixture of ivory black and burnt sienna. Again, negative white shapes are left to indicate where lighter hairs cross over the stripes.

3 When the paper is dry, the tiger's golden-yellow fur is painted in. The artist begins by blocking in a pale tone of burnt sienna, once again leaving white spaces for the light hairs. This is allowed to dry. Switching to a well-pointed No. 2 brush, the artist uses burnt sienna, darkened with a touch of ivory black, to tick in individual hairs with long crisp strokes over the dried underwash.

4 Tiny dots or 'whisker holes' are painted on the muzzle, using the ivory black/burnt sienna mix. Here you can see how the negative white shapes now read as whiskers.

5 The hairs on a tiger's nose are very fine, so very little modelling of individual hairs is required. The bridge of the nose is modelled with loose washes in various tones of Payne's grey, glazed wet over dry. Then the tip of the nose is painted with a pale wash of brown madder alizarin.

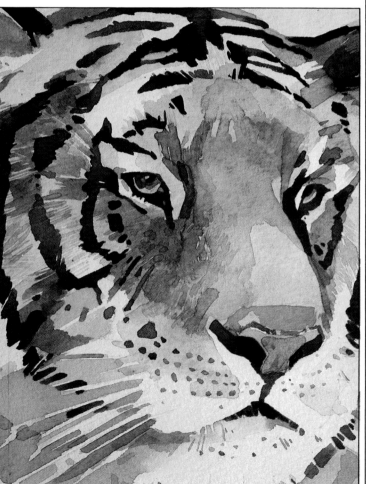

The finished effect

EYES

The eyes are often the most expressive feature of an animal or bird, so they are worthy of some attention. In creatures which are natural predators, for example, the eyes have a hard, watchful, imperious quality which should be emphasized with hard, crisply defined outlines.

Compare this quality to the soft, vulnerable appearance of the eyes of young animals and of non-predatory species such as horses, cows and deer. Pale colours and a smudgy technique will portray the dewy, liquid look of these eyes.

The eyes of animals and birds have a pronounced spherical shape and their surface is glassy and highly reflective. Applying your colours in thin GLAZES is the best way to capture the subtle nuances of light and shade which give the eyes their depth and three-dimensionality. Pay attention also to the shapes of the highlights and shadows, which follow the convex contour of the eyeball.

Eyes • Watercolour

The transparency of watercolour makes it an excellent medium for rendering the subtle nuances of tone and colour that give eyes their unique depth and three-dimensionality.

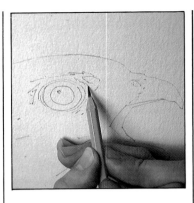

1 Working on a sheet of stretched 90kg (200lb) Bockingford watercolour paper, the artist sketches a simple outline shape for the eye with an HB pencil.

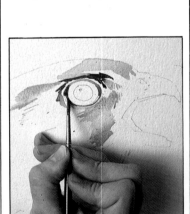

2 The artist begins by painting the area surrounding the eye with pale washes of Payne's grey and cobalt blue mixed with yellow ochre. Using a No. 2 round sable brush, he then defines the outer rim of the eye with ivory black.

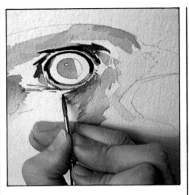

3 The feathers surrounding the eye are built up further with washes of cobalt blue and yellow ochre. Then the pupil of the eye is painted with cobalt blue, leaving a tiny dot of white paper for the brightest highlight.

4 The darks of the pupil are gradually built up with repeated glazes of cobalt blue and Payne's grey. Because each glaze shines up through the next one, the colour has a depth which captures the glassiness of the bird's eye. The darkest part of the pupil is painted with ivory black.

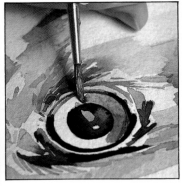

5 When the pupil is completely dry the artist paints the iris with a mixture of brown madder alizarin and cadmium orange. This is allowed to dry thoroughly before adding the next wash.

6 The rounded form of the eye is developed by adding a shadow wash over the iris with a mixture of burnt sienna and cadmium orange. In this close-up, notice how the artist has used a combination of hard and soft edges to define the form of the eye and prevent it from looking too static. The gradual build-up of washes helps to define the convex contour of the eyeball.

7 The clean, sharp, bright highlight of the eagle's eye conveys the fact that this bird is very much a predator.

Tiger's Eyes
The expression in this tiger's eyes is bold and unfaltering, accentuated by the small size of the pupils and the hard, glinting highlight.

Dog's eyes
Using a very fine, No. 0 sable brush, the eyes were painted in layers of the same colour, after each previous one had dried, to build up the density of colour. The paint was laid on thinly to achieve a soft finish, leaving the paper white for the whites of the eyes.

Chimpanzee's Eyes
The eyes of this young chimpanzee — a non-predator — are much softer. There is much more light in the eye, and the outer rim is less sharply defined.

FISH

The silvery, iridescent skin of fish makes them an excellent subject for painting, and they are particularly suited to the delicate, aqueous medium of watercolour. To portray the shiny, wet appearance of the skin, work with broad, loose washes of pale colour on damp paper. Allow the colours to merge WET-IN-WET. While the paper is still damp, indicate the dark markings of the fish with dryish colour, allowing the edges to bleed softly into the underlying wash. Do not attempt to indicate every scale on the fish's skin because the resulting appearance is too tight and stilted and destroys the essentially fluid form of the creature. Simply use a small, well pointed brush to hint at the overlapping scales along the back. When the markings are dry, apply a final, thin wash of colour over the fish's body. This creates a translucent effect, with the dark markings glowing through the final glaze of colour.

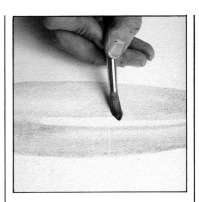

1 Working on a sheet of stretched paper, the artist begins by establishing the shape of the fish. He first dampens the area with water; then, using a round No. 10 sable brush, he applies pale washes of Payne's grey, turquoise and cadmium red. It is best not to outline the shape in pencil, because this can inhibit the spontaneity of the succeeding washes of colour. An outline should always be fluid enough to be altered during the painting process.

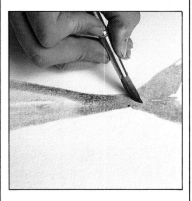

2 The dark shape of the tail is painted with Payne's grey. The artist has mixed gum arabic with the pigment on the palette: this gives a slight sheen to the colour which captures the shiny, lustrous appearance of the fish's skin.

3 Switching to a No. 4 brush, the artist defines the head and spine of the fish with a darker wash of Payne's grey. Notice the broken quality of the line, which lends a sense of movement: a perfectly straight outline would look too static.

4 After allowing the previous colours to dry slightly, the artist starts to add further colours: sap green, turquoise and brown madder alizarin are applied and allowed to bleed together wet-in-wet.

5 At this stage, you can see how the underlying form of the fish has been established using wet washes. In places the colours were lightened by gently lifting out with a clean moist brush, which helps to create the soft lustre of the fish's skin.

6 When the underlying washes are almost dry, the artist indicates the mottled pattern on the back, using a No. 4 sable brush and a dark, dryish mixture of Payne's grey and sap green. The bottom edge of the pattern is then flooded with water using a clean brush to make it bleed into the body of the fish.

7 The mouth and eye are defined with a dark mixture of Payne's grey and burnt umber and a pale mixture of Payne's grey and sap green is used to paint the gills. You can see also where small, spontaneous strokes have been applied here and there over the dried underlayer, giving depth and luminosity to the colours.

8 When the painting is dry, the artist adds a final touch: the highlights on the eye are painted with processed white.

Fish • Scales

1 The artist paints uneven washes of lemon yellow and black in the background to create the effect of ripples in the water. After each layer dries she adds another to strengthen the colour and to help define the shape of the fish. The fish scales are painted onto a weak wash of cadmium red and cadmium yellow pale with a No. 00 sable brush.

9 In developing this picture, the artist has exploited the fluidity and transparency of watercolour to the full, and the completed image captures the essence of the subject perfectly. It is the harmonious balance of loose, wet washes and darker, sharper details which gives freshness and vitality to the painting.

2 The subtle blending of tones is achieved by applying the paint wet-into-wet. Around the gills and fins this is enriched by adding cadmium red and orange, giving the fish an iridescent quality.

BUILDINGS

Buildings and other man-made structures such as bridges, fences and walls, attract the attention of painters because of their fascinating shapes, textures and patterns. In the countryside these features provide a good foil to the surrounding trees and fields; in the city or town the variety of architecture can suggest interesting contrasts, allowing the artist to play with shapes, moods and tensions. In addition, the size and position of these structures within a composition lend a sense of scale to the scene, and add an element of human interest.

It goes without saying that buildings should always be accurately rendered in terms of scale and perspective, and be given a sense of volume and solidity. But the way they are treated depends on the picture being painted; for example, the flat tones and ruled lines of an architect's draft are inappropriate for a landscape painting but may be suitable for a cityscape. When painting a landscape the artist must approach man-made structures in exactly the same way as trees or clouds, using soft, flowing lines and a sensitive touch, so that they blend in with the surrounding elements of the image.

In rendering the solid, three-dimensional appearance of buildings, it helps if you can find an angle which takes a corner view and creates strong diagonals. Buildings viewed straight-on look much less interesting and more two-dimensional, rather like a flat piece of stage scenery. Remember also that strong contrasts of light and shadow accentuate the form and volume of buildings — long shadows cast in the late afternoon, for example, are particularly useful in this respect.

In order to simplify the process of painting buildings — particularly complex ones such as churches and castles — always start by reducing them to basic geometric shapes and paint these as flat areas of tone. Having laid the foundation, so to speak, you can work up gradually to the more specific details — but avoid overloading your painting with too much factual detail. Suggestion is the key: by giving an indication of texture or pattern here and there, you allow viewers to participate in the painting by filling in the rest of the detail themselves.

BRICKWORK

When you look closely at the walls of a building, you can see every brick and tile; but when you take in the overall look of a building you don't see individual bricks — although you know they are there. This is the effect you should convey in your painting: by describing a few bricks here and there, you will suggest them all, without burdening your viewer with too much tiresome detail.

Always begin by indicating the overall tone of the wall or roof, and the pattern of light and shade. Then add a suggestion of texture.

Beware of painting bricks and tiles too bright a colour, and notice how the colour can vary from brick to brick. Use warm, muted reds, plus greens, blues and earth colours to describe them.

2 Notice the irregular shapes of the bricks, and the variety of colours and tones used. It is a good idea to have your colours mixed up ready on the palette rather than mixing them haphazardly as you go along. This facilitates speed of handling, and you can be sure your colours will be clean and fresh. Wash the brush thoroughly between each application of colour. The colours used here were raw umber, raw sienna, burnt sienna and Payne's grey, used in varying strengths.

Brick wall
1 The artist begins painting the wall by laying in a pale wash of raw sienna to provide a background tone. When this is dry, a No. 6 chisel brush is used to paint the bricks, leaving uneven white spaces between the bricks to indicate light-coloured mortar.

3 When the first colours are dry the artist adds shadow washes, wet over dry, with a weak solution of Payne's grey. This gives form and texture to the bricks.

4 The shadows are developed further with washes and glazes to achieve a crisp, rugged look. Finally, a weak solution of Payne's grey and raw umber is mixed on the palette and then lightly spattered over the picture surface to accentuate the pitted, weathered character of the bricks.

STONE

Walls and buildings made of stone are always an attractive feature, because of their hues and the interesting colours they take on as a result of the effects of weathering and the growth of moss and lichen on their surface.

Start with a pale wash of colour to define the overall tone of the wall and then imply the texture of the stone's surface with DRYBRUSH strokes and, or, SGRAFFITO techniques, as shown below. Watercolourists frequently use SPATTERING to indicate the pitted nature of stone, while the addition of a few granules of salt while the paint is still wet adds an interesting weathered appearance.

When painting the drystone walls often found on farms, it is usually best to begin by painting the wall as one mass rather than defining the individual stones. When the light and shadow planes have been established, you can then suggest individual stones — but without giving emphasis to every one. Use neutral tones — never black — to paint the cracks between the stones and the shadows cast by some stones protruding over the ones below.

Dry stone wall • Watercolour

The dry stone walls often seen in the countryside have a special character resulting from prolonged exposure to the elements. The stones lie unevenly, some protruding over the ones below and some indented, and their surface is pitted and cracked with age.

1 The first stage in painting the wall is to apply an all-over wash of raw umber, on a sheet of rough textured paper. When this is dry, a chisel brush is used to indicate the rough shapes of the stones. The colours used here were raw umber, Payne's grey and yellow ochre, mixed in various quantities to create a variety of sludgy tones and colours.

2 Just before the paint dries the artist sprinkles a few granules of rock salt over the painting and then leaves it to dry in a horizontal position.

4 A strong mixture of Payne's grey and sap green is used to render the dark cracks between the stones. Introduce variety by making the cracks lighter in some places.

6 The same colours used in step 5 are lightly spattered over the picture surface. Here you can see how washes and glazes, spatter, and salt texture have been combined to give a suitably weathered look to the wall. The stones jutting out into the sunlight are sharply defined, whereas those farther back are blurred into the shadows.

3 When the painting is dry the salt is brushed off. The salt granules have soaked up the paint where they landed, leaving tiny pale shapes which effectively simulate the pitted texture of the stones.

5 The painting is allowed to dry, then pale washes of raw sienna and Payne's grey mixed with sap green are used to add glazes that darken the wall in places.

Dry stone wall • Oil

1 Thick oil is applied to a surface that has already been painted on, which means that it sticks to the raised parts of the surface and allows the undercolour to show through the hollows, creating a sparkling result.

Stone houses

The warm yellows and greys of stone houses often found in villages in Europe and the British Isles make these buildings an attractive subject to paint, particularly if they are set against a stunning landscape.

1 The artist first establishes the outines of his composition in charcoal, which he then traces over with fine lines of black paint diluted with turpentine.

3 The short stabbing brushstrokes have given the walls texture. They allow the ochres on the sunny wall and the greens on the shaded wall to show through the overlying greys, and convey the subtle tonal variations of the stone.

2 In the final painting the artist has succeeded in capturing the bleakness of the landscape accurately. The picture has a unity, which the artist achieved by keeping a fixed image in mind, and by developing every part of the picture simultaneously.

2 He then starts to block in areas of colour in such a way that he can judge the effect of each colour on those adjacent to it.

4 Ultramarine, green and black have been used for the thick stone slabs on the roof, to which the artist adds detail with diluted black paint.

105

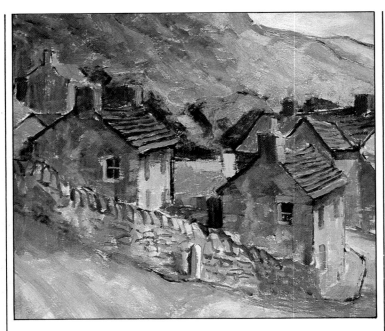

The finished effect

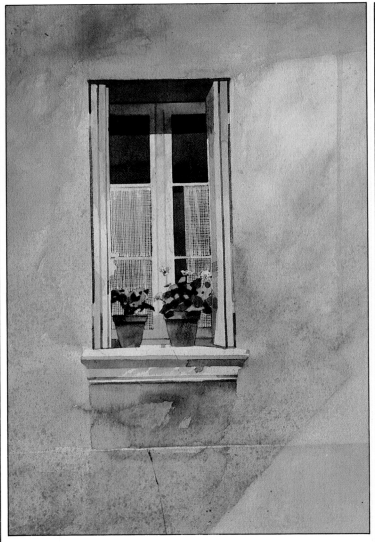

Stone walls

In this close-up we see how shadows and a hint of texture are used to add life and a feeling of light to a potentially static subject like a stone building. The long, slanting shadow offsets the verticality of the window and lends a sense of atmosphere. The pitted texture of the stone is rendered with washes and glazes, overlaid with a hint of spatter in a similar tone. To prevent shadows on buildings from looking too harsh, keep some edges crisp and others soft and diffused.

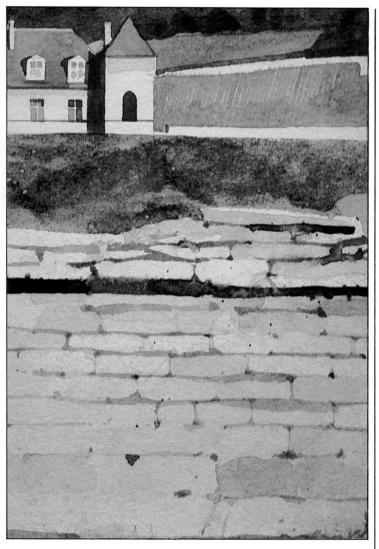

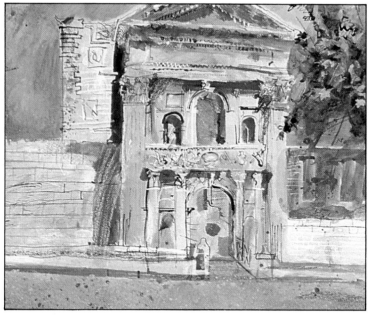

Stonework • Line and wash

Line and wash with pen and ink capture perfectly the intricate carvings on old buildings without meaning that you have to render each detail painstakingly. In this example, a dip pen and sepia ink were used to convey the shadows and forms of carvings in a stone façade.

Weathered stone

A painted stone wall might at first glance seem to be lacking in tonal variety, but closer examination will reveal a vast range of colours and textures which result from the effects of the climate. The pitted surface can be rendered with cool shadows to contrast with the warmth of the paler tones and can be textured with a combination of hard and soft edges.

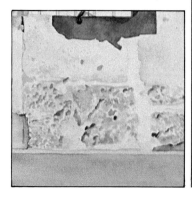

Stone Wall

This detail from a landscape painting shows a wall made of new smooth stone. Notice how only some of the stones are picked out in detail; a wall in the foreground should never be too sharply rendered as this sets up a 'barrier' instead of inviting the viewer into the picture. The artist began with an overall tone of watered down raw sienna, then picked out the stones with glazes of raw sienna, Payne's grey and burnt umber to give life and warmth to the stone.

WEATHERED WOOD

Wooden doors, fences and gates which have been exposed to the effects of the weather make attractive painting subjects: heat and cold cause the wood and paint to crack, split and blister, or to become warped and twisted; the sun bleaches the colour, and rusty nails there leave huge red-brown stains.

Once again, do not be tempted to overdo the surface texture. After defining the overall tone and shadows, you could just suggest pattern and texture with DRYBRUSH strokes and/or SGRAFFITO techniques.

WHITE BUILDINGS

White houses and buildings look especially striking in bright sunlight, or when the setting sun casts long shadows across their walls. Capturing the quality of light on such buildings is simply a question of looking for the subtle nuances of colour in the lights and the shadows.

Shadows on white objects are not always neutral grey , as is often thought. On a sunny day, for example, they tend towards a cool blue, because white reflects the blue of the sky. In addition, the colours of both the shadows and the bright areas may be affected by colour reflected from the surroundings. In particular, look for warm reflected light which is thrown up from the ground onto overhanging eaves and windowsills. The juxtaposition of warm and cool reflections sets up a translucent 'glow' which effectively captures the feeling of sunlight.

The ability to render the effects of reflected light is a major factor in creating atmosphere and luminosity in your paintings. This illustration shows a detail from a painting of an old building in Spain, rendered in watercolour. Although the tiny balcony is attractive in itself, what makes the picture come alive is the interplay of cool shadows and the warm reflected light on the building. Even from this tiny detail, we can sense the atmosphere of intense heat and light so characteristic of early afternoon in a hot country. In a high-key, sunny situation like this it is important to keep your colour mixtures clean and simple. Here, the artist has suggested the brilliant light on the wall by leaving it as pure white paper — which reflects the maximum amount of light. The warm colour reflected onto the stone balustrade from the ground below is rendered in pale tones of raw sienna, while the cool shadows cast on the wall are painted with Payne's grey, which has a blue cast. In the large shadow on the right, the artist lifted out some colour to soften the shape and convey the bleaching effect of the bright sunlight.

WINDOWS

Painting glass in windows is like painting reflections in water — glass is colourless, but reflects its surroundings. But because windows tend to be vertical, rather than horizontal, they reflect an even greater variety of things, and often look dark if they are not reflecting any of the sky. You can also see through glass, making the reflections even more complex. When painting glass windows, always use simple, flat areas of cool lights and darks.

Windows • Watercolour

1 Working on a sheet of stretched 200lb Bockingford paper, the artist begins by lightly sketching the main shapes of the windows and shutters. The surrounding wall is then painted with a pale wash of raw sienna, lightly drybrushed and spattered with Payne's grey to give it some texture.

2 The window frame is painted with ultramarine blue. To ensure that the lines of the frame are perfectly straight, the artist uses the brushruling technique: holding the ruler at an angle to the paper, he carefully draws the brush along with the ferrule of the brush held firmly against the edge of the ruler.

3 The cast shadow of the window frame is painted with Payne's grey. The wooden shutters are textured with glazes and scumbled strokes of cobalt blue and ultramarine. Notice how the colours granulate on the paper's surface: this texture provides the basis for the old and weatherbeaten appearance of the shutters.

White buildings

Weathered white buildings are an appealing subject to paint — whether they are East Coast weatherboard houses, or Mediterranean whitewashed cottages. They are, however, quite difficult to depict because to make them look interesting, you must be aware of and able to portray the subtleties of colour in the white surface. These tonal variations are not easy to see, particularly in harsh sunlight, and are difficult to depict with a limited palette. By accentuating the contrasts between the cool and hot areas you can convey the sense of bright light while breaking up the limited colour, and by heightening texture and pattern you can add variety and interest to the image, as in the watercolour shown above.

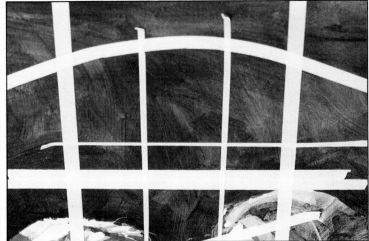

4 Now the artist paints the view through the window. A pale wash of cobalt blue is washed in for the sky, followed by washes of sap green and Payne's grey for the landscape. The landscape shapes are kept very simple, indicating their distance from the window. When this is dry a shadow wash of Payne's grey is blocked in around the window and behind the shutters. Finally, detail is added to the shutters with Payne's grey and a small, well-pointed brush.

Windows • Acrylic

1 Trying to paint straight edge is very difficult without the help of masking tape. In order to paint the window panes in this picture, the artist has used strips of masking tape.

2 If the tape is pressed down firmly and the paint is used quite thickly, clean edges should result. When the paint is dry, remove the tape carefully.

Windows ● Inside looking out
Windows are a useful compositional
device because they create
intriguing 'frames within a frame'.
This detail from a painting of a
domestic interior makes an
interesting composition in itself: the
geometric shapes of the white
window frame create a foil for the
organic shapes of the plant and tree.
There are fascinating echoes, too,
between the leaves of the plant on
the inside and the silhouetted foliage
on the outside. This painting was
executed in acrylics, the perfect
medium for sharp-edged effects.

LANDSCAPES

Surprisingly, the landscape *per se* was never taken seriously
as a painting subject until the seventeenth century; yet
since then it has acquired a wider appeal than any other
form of painting, for artists and for people who simply
enjoy looking at paintings.

As a source of visual stimulation, the landscape is
inexhaustible — and ironically, this is what presents the
landscape painter with the first problem: faced with the
enormous complexity of shapes, colours and textures
present in nature, it is difficult to decide what to paint.
Very often, the solution lies in asking yourself what aspect
of nature moves you more than any other. Is it the sky? the
rugged texture of coastal or mountain scenery? or are you
fascinated by the play of light on the landscape? Once
you've found a subject that elicits an emotional response in
you, it will be easier to communicate that response to the
viewer.

Ideally, landscapes should be painted on location rather
than in the studio or from photographs. The benefits of on-
the-spot painting are obvious: standing in the middle of a
field or on a riverbank, you are acutely aware of the
colours, forms and textures around you. There is a sense of
immediacy, and you are sensitive to the fleeting, often
dramatic effects of the light. All this sensory stimulus is
important in helping you to produce a painting which is
fresh and alive.

Having chosen the scene you wish to paint, the next step
is to sit down and calmly analyze it in terms of pictorial
design. Nature is bountiful, but a scene which looks breath-
taking in reality does not necessarily make a good painting.
Trees, rocks or buildings might be scattered over too wide
an area, or might perhaps be too uniform in shape; the sky
may be full of small clouds which would compete for atten-
tion with the complex shapes on the ground which are the
real subject of your painting. Experienced artists know how
to spot the potential of such a scene and rearrange the
elements within it to suit their compositional requirements.
Never feel duty-bound to represent a scene exactly as it is
— a camera can do this far more easily. Your aim is to
capture a mood, and to present a balanced and harmonious
picture. In so doing, you may have to bend reality a little,
grouping trees together to form a strong focal point, or

getting rid of clouds if they threaten to overcrowd your composition.

Similarly the arrangement of lights, darks and mid-tones within the scene is of vital importance. Try to envisage the landscape as if it were a black and white photograph: does it contain a strong and cohesive pattern of lights and darks? or are the tones scattered and spotted throughout? Once again, you are free to 'orchestrate' the tones in order to create a stronger image. For example, if your centre of interest is a farmhouse in the middle distance, make sure there is a strong contrast of light and dark at that point: if the building is light in tone, darken the surrounding trees or sky, and vice versa.

As you can see, the success of your landscape painting depends on careful preparation before you begin painting. You must know what you are aiming for and be aware of such aspects as colour, composition, light and tones. As far as composition is concerned, there should always be a centre of interest — a part of the picture to which the eye is drawn and which forms the theme of the painting. If there are two large trees in the scene, either group them together or diminish the size of one of them. Never put two objects of equal importance in the same painting.

In addition, try to compose the secondary elements — fences, hedges, paths, rivers, even the cloud patterns in the sky — so that they lead the viewer's eye pleasurably through the composition and to the focal point.

Be on the lookout for interesting contrasts, too. A landscape which is overwhelmingly horizontal in format will benefit from the addition of a vertical accent such as a tree, a building, even a figure, to avoid monotony. Shapes and forms which 'echo' each other provide a pleasing harmony, which is accentuated by the addition of a contrasting shape. The geometric form of a building, for example, provides a foil for the curving shapes of hills, trees and clouds.

Try to include busy areas and restful areas in the same painting, to provide a change of pace; if the sky is the subject of your painting because of its lovely cloud formations, then keep the landscape fairly simple and open. Finally, exploit to the full the contrasting textures of clouds, foliage, rocks and water.

The most important consideration in any landscape painting is creating a sense of depth and space, so that viewers feel that they could actually 'step into the picture'. The most common way of achieving this sense is to create the illusion of the landscape receding towards the horizon and there are several ways of doing this. The most obvious is that of linear perspective — making objects appear to diminish in size from the foreground to the background, but linear perspective alone is not enough. The most important means of establishing a sense of space and atmosphere in your painting is through aerial perspective. As your eye travels from the foreground to the horizon, you will notice certain changes in the appearance of the various landscape elements: those objects which are nearest to you look darkest in tone; in the middle distance they appear somewhat lighter; and objects on the horizon seem the lightest of all. Colours also change, from warm and bright in the foreground to a cool, subdued blue on the horizon. Finally, contrast and detail diminish with distance. All these changes occur because of the water vapour and tiny particles of dust present in the air which partly obscure colours and forms in the distance (this effect is not so apparent in countries in the southern hemisphere, where the light is much brighter).

Apart from linear and aerial perspective, there are other, subtle ways of creating a sense of depth: overlapping the shapes of hills and trees, for example; or depicting the S-shaped curves of roads and rivers winding into the distance; if there is a fence or hedge in the foreground, either eliminate it altogether or 'invent' an open gate in it. Always lead the viewer into the painting — never put up a barrier in the foreground.

All the above points sound like a pretty tall order, but with frequent practice you will know instinctively what to look out for. Painting landscapes is largely a matter of observation and analysis, and it is enormously helpful to make several preliminary sketches before starting to paint. In this way you become acquainted with the scene, and you have a 'blueprint' of the composition and tonal arrangement to which you can refer as you paint.

Having established the composition, you can at last begin to paint. The best procedure to adopt is to work from soft focus to sharp focus, as follows. Using your biggest

brushes, paint the broad masses of the scene, ignoring detail completely. Start with the overall tone of the sky and the ground, then block in the shapes of the trees and other objects. Already you have dispensed with the stark white glare of the paper or canvas, and the bones of the painting are now apparent — you have created order out of apparent chaos.

Confidence renewed, you can now move on to indicate the broad pattern of lights and shadows that gives form to the objects in the composition. Only in the final stages of the painting should textural details be added, and even then it is important to know when to stop. A subtle combination of sharp detail and softer, less distinct forms creates a sense of atmosphere; the skilful artist knows how to suggest more detail than is actually painted.

As you work, it is important to bring along every part of the painting at the same rate of development. Don't put all your energy into getting one area 'just right' before moving on to the next. Work WET-IN-WET, alternating between sky and land, trees and hills, to build up an all-over 'skin' of colour. This way the picture becomes a unified whole, with everything linking together naturally.

Aerial perspective • Watercolour
One of the basic rules of landscape painting is that cool, pale tones appear to recede into the distance, whereas darker or warmer tones appear to come forward. Always remember this principle when painting distant landscapes — it is your best means of creating the illusion of three-dimensional space on a flat piece of paper or canvas.

Generally it is advisable to start your painting from the farthest distance, gradually strengthening the tones and colours as you progress towards the foreground. This appies particularly to watercolour, which is a medium that requires that you always paint from light to dark.

FIELDS

When painting open fields and meadows, be sure to introduce a variety of colours, shapes and contours to avoid a monotonous, 'billiard table' effect. Rather than painting the field in one flat, even tone, it is far better to brush several different greens onto the paper or canvas and mix them very loosely: the different shades and tones will suggest the rolling contours of the land. In addition, take the opportunity to introduce cloud shadows and shadows cast by nearby trees. Vary the style and the direction of your brushstrokes to indicate how the grass is ruffled by the breeze, much as the wind ruffles water — there are many ways of introducing variety into an apparently flat piece of land.

In winter, the linear patterns of ploughed fields can be used as a strong design element in your paintings; their converging lines lend a sense of space and perspective to the composition.

Another means of lending depth and space to a landscape with fields is by keeping crisp detail to the foreground and treating the background more loosely.

Summer Cornfields

In this refreshingly simple oil painting the artist has captured the atmosphere of brightness and warmth that pervades a summer landscape, with cornfields stretching as far as the eye can see.

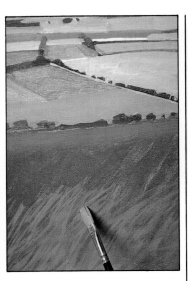

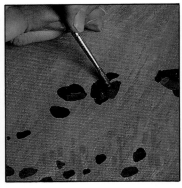

1 The artist begins by applying a transparent imprimatura over the entire canvas, using yellow ochre heavily diluted to a wash-like consistency that allows the white of the canvas to shine through. This colour will in turn shine through the succeeding layers of thin colour, tying the whole composition together and imbuing the scene with warmth and light.

2 The artist gradually builds up a patchwork of fields in the distance with flat washes of yellow ochre, Turner's yellow and cadmium oxide green, lightened with titanium white in places. The paint is applied thinly, allowing the imprimatura to show through. The field in the foreground is painted with a mixture of cadmium oxide green and titanium white, applied with diagonal scumbled strokes which do not completely cover the yellow underlayer. The artist then loads a flat No. 4 brush with a light mixture of cadmium oxide green and titanium white and suggests long blades of grass in the immediate foreground with sweeping diagonal strokes.

3 Finally, the brightly coloured heads of the poppies are painted using various tones of cadmium red dabbed on thickly. The red flowers take on a particular brilliance because they are surrounded by their complementary colour, green.

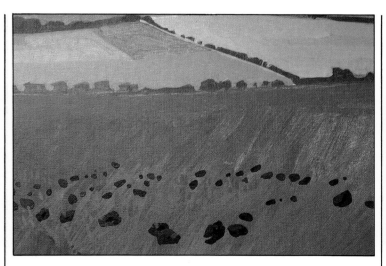

4 In the completed picture the sense of distance is enhanced by the warm colours of the poppies in the foreground and the lively brushstrokes which contrast with the flat areas of colour in the distance.

Summer fields

Inexperienced painters sometimes make the mistake of painting landscape subjects in colours that are too bright and look unnatural. In temperate regions, landscape greens tend to be on the cool side, and even in hot, sunny climates the colours are not always as brilliant as is sometimes supposed.

Make a point of looking for other colours besides green when you are painting a landscape with trees and grass. In this oil painting, a range of yellows, browns, pinks, greys and grey-greens has been used to create a composition which is harmonious, yet full of variety and interest.

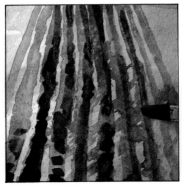

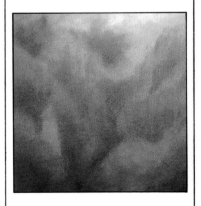

2 This detail shows the artist using a chisel brush to model the lights and shadows of the furrows. He does this by dragging the brush on the still wet lines in short, scrubby strokes between the furrows. The underwash is a pale mixture of burnt sienna and ivory black, applied with loosely scumbled strokes to give a suitably rugged texture to the field. Fields in winter are much darker in colour than at other times of the time, because they are wet most of the year, so the artist has added plenty of ivory black to his paint mixture for painting the straight lines of the furrows.

Dense foliage
1 Staining a canvas is a good way of establishing the background colour. Canvas can be stained with oil paint in the same way. It is better to use a primed canvas and to select colours with a strong tinting power such as chrome green, Prussian blue, sap green and viridian, as used in this example.

Winter fields
1 This deceptively simple watercolour conveys the atmosphere of a stark, chilly day in winter, and the way in which the picture is composed creates stresses and tensions which amplify this mood. The converging lines of the ploughed furrows in the foreground lead the eye forcefully back in the picture plane, to where the furrows of the distant fields suddenly change to a diagonal direction. This regular, repeated pattern of the ploughed fields is contrasted with the organic forms of the clouds and trees, themselves painted in cool greys.

2 The colours were gradated over the whole canvas and in some areas were wiped with a turps-soaked rag to lighten the tone.

3 Using a No. 7 flat brush, the artist paints in the leaves using tones of cadmium yellow, sap green, viridian and white.

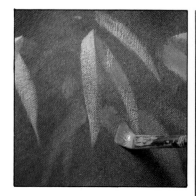

4 He has carried the patterns of spiky leaves throughout most of the canvas, not copying exactly what he sees, but exaggerating the motifs to create a decorative effect.

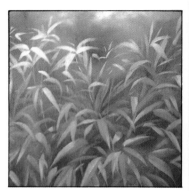

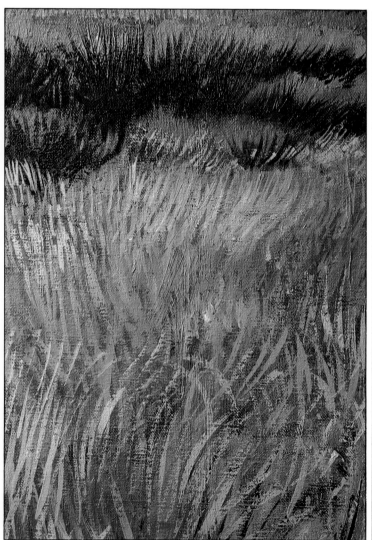

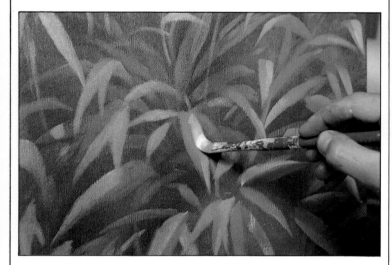

5 Reflected sunlight is implied by the addition of streaks of white to some of the leaves.

Grass

This is a detail from an oil painting of a summer meadow, which shows the variety of subtle greens, yellows, greys and earth colours that go to make up 'green' grass. The artist began by covering the canvas with soft umbers and ochres, scumbled together wet-in-wet to suggest areas of light and shadow. Then, with a small pointed brush and lighter colours, he worked back into the wet colour to suggest individual stems and blades of grass.

The underpainting provides a soft focus background for the precise strokes of grass in the foreground and helps to give a sense of depth. Notice also how the curving, rhythmical strokes of the grass lead the eye back in the picture, creating a sense of receding space.

HILLS

With the soft contours of rolling hills it is more difficult to distinguish the main masses of light and shade which emphasize solidity. It helps to look at the subject through half-closed eyes, thereby reducing the colours and making the lights and darks more apparent. Watch out also for fleeting cloud shadows, and use them to enliven the forms of the hills.

In contrast to the sharp angularity of mountains, most hills have soft, slightly blurred edges because they are covered with trees and vegetation. Use rapid, fluid brushstrokes which follow the undulations of the hills, and allow a variety of greens and earth colours to blur into each other WET-IN-WET.

If the hills are covered by trees, it is enough merely to suggest the texture of the foliage with short, scrubby strokes, rather than trying to paint each individual tree.

Hills • Acrylic

The artist was attracted by the wild, lonely atmosphere surrounding these ancient Welsh hills which brooded uder a blustery sky. To convey their ruggedness, he applies acrylic paint in the direct, alla prima manner.

1 The artist begins by applying a toned ground of Hooker's green over the entire canvas. This tone is painted with a 2.5 cm (1 in) flat decorator's brush, leaving obvious brushstrokes that will soon be covered with opaque colour. When the toned ground is completely dry, a No. 8 bristle brush is used to paint the sky with cobalt blue.

2 A mixture of titanium white and a touch of cobalt blue is scumbled over most of the sky area, leaving a small patch of blue sky on the right. When this is dry the artist begins to block in the far distant hills with a No. 2 sable brush. The farthest range is a pale tone of Hooker's green, cobalt blue and titanium white. This mixture is darkened slightly with more Hooker's green and a second, closer range of hills is painted in front of the first one.

3 The peak of the hill in the middle ground is now painted in a dark green made by adding a little ivory black to the mixture. The distinct range of tones, becoming paler in the distance, gives a feeling of atmosphere and deep space. The artist now starts working on the immediate foreground, brushing in a light tone (mixed from sap green and yellow ochre) to indicate patches of grass lit by the sun.

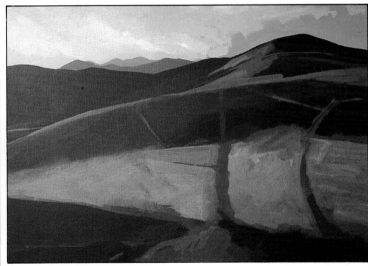

4 The bumps and curves of the hillside are broadly modelled with warm and cool greens applied with vigorous strokes that move in different directions. The footpaths that criss-cross the hillside are indicated with thin paint. These pathways accentuate the contours of the hills and help to lead the eye into the picture. In the completed picture, the rugged quality of the handled paint is in perfect keeping with the nature of the subject. The opposition of warm and cool greens gives an impression of how the cloud shadows travel across the landscape as the clouds are blown by the wind.

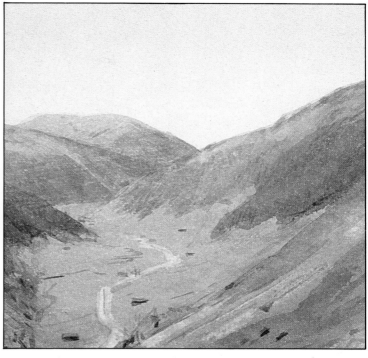

Hills • Watercolour

Watercolour is an exciting medium to use for landscape painting because it is so flexible and adaptable. You can use all sorts of unorthodox techniques with watercolour and it responds by producing wonderfully descriptive textures.

In this detail from a hilly landscape in Italy, for example, the artist has created a subtle range of textures to suggest foliage and vegetation. He has added gum arabic to the paint to make the colour denser and give it a slight sheen. He has then spattered clear water onto dry areas of paint and lifted off the colour to create light patches that suggest the play of sunlight on the leaves.

Hills • Watercolour

The artist has used aerial perspective to create a marvellous sense of distance in this landscape. The overlapping planes of the hills recede to the hazy, blue horizon. The colour range is limited and the tones have been built up from washes laid over each other. Where the washes are thin, the white paper gives a luminous quality to the paint.

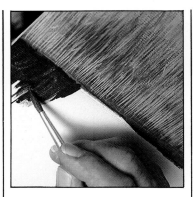

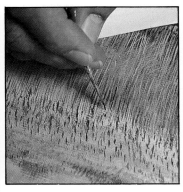

Marshland

1 This gouache landscape shows how the surface texture of the support and the paint can be used to great effect. The background colour has been laid in broad strokes with a large bristle brush, the paint catching on the surface of the canvas, breaking up the colour.

3 The artist has smeared the dry paint in some areas to create a sense of movement.

5 Black, chromium oxide and burnt umber are used to paint in the water with thin streaks of paint for the reflections of the reeds.

7 The foreground is worked up further with dark streaks, to give it more depth.

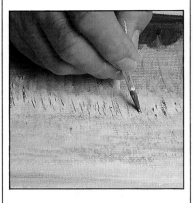

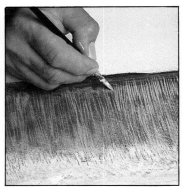

2 On top of the background the artist uses a fine brush dipped in dry, undiluted paint, to draw in the reeds.

4 Thin streaks of white are painted on the stalks of the reeds to give them definition.

6 Feathery brushstrokes take the water's edge up to the reeds, and light coloured paint is flicked onto the darker paint to break up the edge.

8 In the final painting it is obvious that the artist has concentrated on detail in the foreground, leaving the elements of the background less defined. Nonetheless they are given texture and direction by the brushstrokes and the surface of the canvas.

Moorland
1 Over a pencil sketch the artist paints in the sky in ultramarine and white, and the ground in dilute burnt umber. A mixture of permanent violet and white is added to suggest the colour and texture of heather. The artist applies it loosely with a No. 4 bristle brush for a scrubby effect.

2 The rocks are painted grey (mixed from black and white) with a stippled motion to give them texture.

3 A strong band of cadmium yellow is painted into the middle ground and violet and yellow are mixed in the foreground. The loose strokes around the rocks indicate the vegetal growth.

MOUNTAINS

When you're painting mountains, once again the trick is to look for the basic geometric forms and emphasize the lights, and shadows.

Mountains are always impressive, but they look particularly dramatic under certain lighting conditions. Notice, for example, how late afternoon sunlight emphasizes the three-dimensional quality of the form. The light strikes some of the planes of jagged rock, leaving others in shadow. Solidity is achieved in your painting by building up the planes of light and shadow, using warm colours in the lights and cool colours for the shadows. It is a good idea, when painting outdoors, to block in quickly the light and shadow planes with a neutral underpainting before you add colour, to ensure that there is consistency in the lighting.

The amount of textural detail you give to a mountain depends on its distance. The blocklike forms of foreground rocks can be painted with bold, horizontal or vertical strokes, using a knife or a flat bristle brush. Rock forms appear less distinct on more distant mountains, so use soft, scrubby brushstrokes to describe them.

The effects of aerial perspective are often strongly apparent in mountain scenes. Begin by painting the most distant mountains with soft, indistinct strokes and cool blues. Gradually work forward to the foreground, adding more detail, stronger colour and darker tones.

Mountains • Acrylic

Used straight from the tube or diluted with medium to a creamy consistency, acrylic paint has enormous covering power and a strength and directness which is ideally suited to a scene such as this one. Acrylic also dries quickly, and the artist uses this quality to advantage in building up a strong pattern of light and dark shapes, which gives form and solidity to the subject.

1 Working on a sheet of illustration board, the artist begins by defining the main shapes with simple pencil outlines. He also records the intricate pattern of light and shadow shapes so that it can easily be followed by the brush. The main shadow planes are then blocked in with a mixture of cerulean blue and titanium white, diluted with water to a thin consistency. Note how the direction of the brushstrokes helps to establish a feeling of form. Between these strokes, patches of bare canvas are left to suggest the light-struck areas. Switching to a No. 7 sable brush, the artist then indicates smaller shadows within these light areas.

2 The artist continues to build up the shadow planes with broad strokes that follow the contours of the mountainside. The dark shape of a mountain ridge is painted in the foreground, using a mixture of Payne's grey, cerulean blue and titanium white.

3 With the main shapes and forms roughly established, the artist now sets about consolidating them with thicker, darker paint. The pigment is diluted with water, mixed with a little gloss medium to a creamy consistency and applied with a flat brush in smooth strokes. In this detail, paint is being applied by 'rolling' the brush to create strokes rather like drybrush: this gives a suitably craggy texture to the mountainside.

4 Finally, the sunlit patches of snow are filled in with titanium white which is applied with a round sable brush.

5 In the completed painting, the shadowy foreground heightens the impact of the dramatic lights and darks on the distant mountain, rather like throwing a spotlight on a stage.

ROCKS

The most common mistake when painting rocks is to make them appear too soft and formless. Rocks are solid, three-dimensional, and heavy. The way to portray these qualities is by emphasizing the contrasts of light and shade that play on them.

The first thing to consider is the overall structure. Some rocks are rounded in shape, some are jagged and some are a combination of both. Begin by picking out the broadest areas of tone and colour and brushing them in freely. Next, look for smaller planes of tone and colour within the large planes and indicate them with short, stabbing strokes. For angular rocks, leave the edges between these planes quite sharp and distinct; for rounded forms, you could produce a graded effect by softening and blending the edges of the different planes.

Finally, when the overall structure is completed, indicate the main cracks and fissures on the rock surface. These act as contour lines which move across and around the form and strengthen its three-dimensional appearance.

Rocks are a fascinating subject whatever medium you use, because they offer an ideal opportunity to try out different kinds of brushwork. In oils and acrylics, short strokes of IMPASTOED paint, applied with a knife, will describe the jagged edges of rocks. In watercolour, too, a blunt knife can be used to scrape out wet paint to create jagged highlights. In egg tempera, highly realistic effects are achieved by using tiny strokes, hatched and crosshatched, to describe every minute change of colour and tone.

In most media, rough surfaces can be implied by dragging and SCUMBLING with fairly dry paint, or by SPATTERING with wet paint.

Mottled patterns caused by the presence of lichen or moss can be described very effectively by dabbing colour on with a sponge. The possibilities are endless, but take care not to get carried away by technique, to the detriment of what you are trying to express.

Rocks • Oil
1 In a painting of a rocky headland with crumbling cliffs and striated patterns, the artist used a variety of techniques to depict the different textures. He first drew on a fine-textured board with a pencil and then applied several washes of diluted oil paint. Each diluted layer was applied after the one before it had dried (Liquin was added to the paint to speed up its drying time). The striations in the rock were painted in with vertical strokes.

2 To emphasize the vertical fissures in the rock the artist used a soft (3B) pencil sharpened to a point to draw into the paint. He also used a scalpel to scratch back into it.

3 The painting was allowed to dry before the next layer of colour was applied. The pale washy nature of the rock and grass is balanced by the starkness of the trees at the top of the headland.

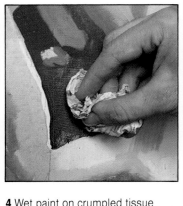

4 Wet paint on crumpled tissue paper was dabbed onto the grassy area to create texture and deepen the colour.

5 The artist then used a stiff brush to splatter diluted paint onto the rock to enhance the textural effect further.

6 A scalpel was used to scratch the paint surface to reveal the underlying white of the canvas.

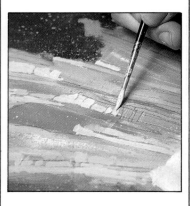

7 Highlights were applied with a brush, using a mixture of Payne's grey and white.

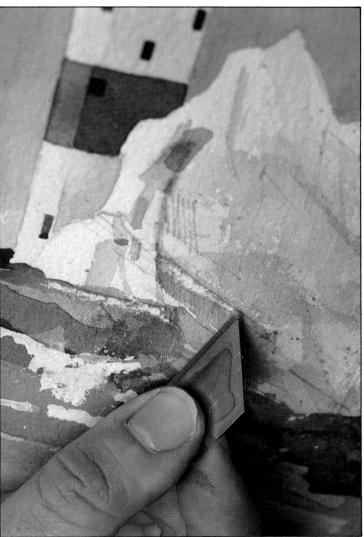

8 In the final stage of the painting the artist smudged the highlights with his finger to blend them in slightly.

Rocks • Watercolour
In this detail from a coastal landscape in watercolour, the artist is scratching out paint with a sharp blade to create an impression of the cracks and striations in the face of the sunlit rock. This technique is known as sgraffito.

SAND

The texture of sand, whether on beaches or in the desert, should be treated as simply as possible.

Start by indicating the patterns of light and shade on the sand, using warm and cool colours and working in broad washes of thin paint. In the foreground, use DRYBRUSH or SPATTER to suggest the granular texture of the sand and any small stones or pebbles. In watercolour, this texture is suggested most efficiently by using colours which separate, or GRANULATE, on the paper; try using cerulean or manganese blue with a touch of burnt sienna for the shadows.

The colours of sand vary enormously from one part of the world to another, so there are no hard and fast rules about colour mixtures. In general, though, sand is not as yellow as beginners often paint it. It is usually a pale yellow-grey in hue, particularly in the shadowed parts of sand dunes.

Sand Dunes • Watercolour

When painting sand dunes, what you leave out of the picture is as important as what you put in: use understated colour and a minimum of brushstrokes to capture their pale, silvery tones and softly curving forms. In this watercolour painting, the white of the paper does much of the work in conveying the bleaching effect of bright sunlight on the sand.

1 After making an initial pencil outline of the scene, the artist begins by painting the sea and sky area with a pale wash of cobalt blue, leaving a little white at the top of the sky to indicate clouds. Then the lightest tones (apart from white) in the sand are brushed in, using a mixture of yellow ochre and lemon yellow. Next the mid-tones are added, using the same mixture but with a touch of Payne's grey added to darken it. Finally the curves of the dunes are strengthened with more shadows, this time darkened still further with a touch of burnt sienna. A large round sable brush is used throughout.

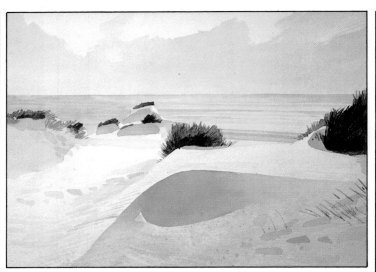

2 When the painting is dry, a very light spatter is applied in the immediate foreground to give a granular texture to the sand. The beach grasses are painted next, using dark mixtures of Hooker's green and burnt sienna, applied with short, scrubby brushstrokes. These accents of vivid green make a perfect foil for the pale, delicate tones of the sand. Finally, a few blades of beach grass sticking up through the sand are suggested by slender drybrush strokes made with the tip of the brush.

In the completed painting, notice how the hollows in the sand dunes have sharp edges which become softer as they move out into the light: this is what gives the sand its soft, sculpted appearance.

Sandy beach • Watercolour

1 The artist begins by applying the first underwashes of colour to define the areas of sand and water. Starting at the top of the paper, he lays a flat wash of cobalt blue for the water. Leaving narrow areas of white paper (which will later indicate ripples in the water) he then applies a dilute wash of yellow ochre and ivory black in the middle ground, to imply wet sand. This wash is warmed with more yellow ochre in the immediate foreground. The gradation from warm yellow in the foreground to cool blue in the background creates a sense of deep space.

2 When the first washes are dry, the artist begins texturing the rough sand in the foreground. He carefully masks off the rest of the painting with a large sheet of paper, then spatters a dilute mixture of yellow ochre and Payne's grey across the bottom third of the picture. This is done by running a finger through the bristles of a stencilling brush held several centimetres/inches above the surface.

3 This picture shows how the spattered colour has dried to a subtle tint which looks entirely natural.

4 When the first layer of spatter is completely dry the artist moves the paper mask down a few inches and spatters again, this time using a slightly darker tone with more Payne's grey added to it. When the mask is removed, the spattered area has a gradated appearance which strengthens the sense of perspective.

5 When the spattering is completed, the artist paints the large pebbles in the foreground. He uses a dark but fluid mixture of ivory black and a touch of yellow ochre, applied with a No. 10 sable brush, and varies the density of colour to give tonal variation among the pebbles.

6 Finally, the ripples in the water are indicated by brushing in darker strokes of cobalt blue over the initial wash.

127

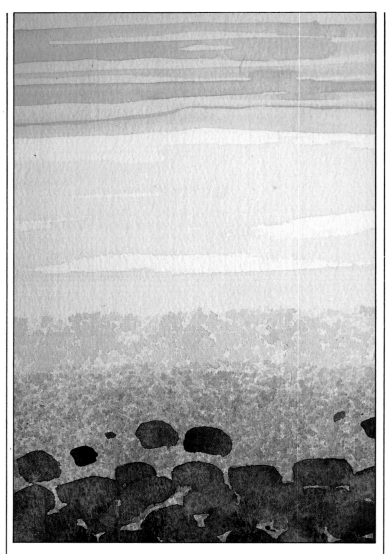

7 In the completed painting you can see how these simple techniques combine very effectively to create a convincing impression of a sandy beach. Notice how the texture of the pebbles in the foreground is created in a delightfully accidental fashion: the transparency of the paint used for the pebbles allows the spattered underlayer to show through, creating a suitably mottled texture. This is the beauty of watercolour painting — textures sometimes seem almost to paint themselves!

TREES

Trees are an important theme of so many landscapes, and the serious artist should study them as closely as a portrait painter studies the human face and figure.

Observation is the key to painting trees convincingly; not only does each species have a particular shape and growth pattern, but each tree within this species has a unique character. It will help your painting enormously if you take the trouble to go out and sketch trees, in all seasons, and learn to look at them analytically.

Deciduous trees lose their leaves in winter, which is a good time to study their characteristic 'skeletons' without the distraction of their leaves. Compare the height of the tree to the spread of its branches and try to get the proportions right; note how some of the branches grow almost horizontally, whereas others are almost vertical; try to define the silhouette and 'gesture' of various tree species and compare their differences. An oak tree, for example, has a squat, rounded silhouette, with a heavy trunk and gnarled branches. The elm, on the other hand, has a tall, slender, graceful silhouette.

When it comes to actually painting trees, don't allow yourself to become overwhelmed by the apparent complexity of branches, twigs and leaves. Trying to paint every leaf is not only frustrating, it also makes the tree look stilted like a paper cut-out. But, making do with a generalized version of a tree — a shapeless mass of green punctuated with a few dark branches — is equally undesirable.

The best approach is to look for the large shapes and masses which characterize that particular tree and which give it volume, and to paint them as broadly and directly as possible. Begin by reducing the outline or silhouette of the tree to its simplest form and blocking in the shape as a solid mass of tone (remembering to leave gaps between the branches, particularly around the outer edges). Next, indicate the main foliage masses within this overall shape. Notice how each mass is modelled by light and shade, and that each casts its own shadow on nearby masses of foliage. Finally, use a smaller brush to add the most important branches and twigs, and a suggestion of foliage.

This procedure is, of course, a very simplified one, to give you the general idea of how to work from the general to the particular. At the same time, there are certain points which you should look out for as you are painting. For example, a poorly painted tree often looks as if it has been stuck to the ground instead of growing up out of the soil. Avoid this by indicating the roots that spread out at the base of the tree and stabilize it. Also, by darkening the tone of the tree trunk as it nears the ground and by softening the edges of the trunk near its base, you will give it the appearance of being linked naturally to the ground.

Pay attention to the limbs of the tree as well. A common mistake is to make all the branches grow sideways, ignoring the fact that some will extend towards and away from you. Notice also how the limbs taper gradually from thick to thin as they reach outwards, and become lighter in tone near the top of the tree, where they receive more light.

One very important factor which is often overlooked is the gaps between the branches. Even when a tree is in full foliage, there are plenty of 'sky holes', particularly around the outer edges of the branches. By

introducing them your tree will look natural and graceful; ignore them, and it will take on a solid and heavy appearance.

Trees and foliage give you an ideal opportunity to experiment with brushstroke techniques. In oils and acrylics, the gnarled branches of an old apple tree might be best treated with strokes of thick IMPASTO. In watercolour, a few delicate DRYBRUSH strokes will render the papery bark of a birch tree; a whole mass of foliage can be represented by short dabs of BROKEN COLOUR, whereas long, graceful strokes of thin colour can suggest the wispy growth of a willow tree. The most important point, however, is to express the idea of the tree as a living thing. To achieve atmosphere and a sense of the tree moving in the breeze, keep the edges of the foliage soft and feathery by merging them into the sky colour, WET-IN-WET.

Trees • Knife Painting
In this painting of an elm tree in high summer, the artist uses a painting knife to apply colour in a thick impasto, which captures an impression of lush, heavy foliage.

1 Working on a toned ground of pale raw umber, the artist first blocks in the sky colour with a mix of cerulean blue and titanium white. When this is dry, he uses a No. 4 flat bristle brush to rough in the basic silhouette of the tree with sap green.

2 Sap green, ivory black and yellow ochre are squeezed onto the palette and the artist mixes a variety of light and dark greens from these three colours, adding just enough medium to make the paint pliable. The colours are applied thickly to the support, using the flat blade of the painting knife.

3 Here you can see how the ridges of the knifestrokes catch the light, forming highlights and shadows which create a three-dimensional impression of thick clumps of foliage. The greens are lighter at the top of the tree, which catches the most light, graduating to a deep blue-green at the base, mixed from yellow ochre and ivory black.

4 Having established the main shapes and areas of tone, the artist now begins to refine the details. Here, he is applying small strokes of the sky colour with the edge of the knife, to create the appearance of large gaps between the branches through which the sky can be seen.

5 With the sharp edge of a smaller painting knife, he scratches away small areas of green paint while it is still wet to suggest both highlights on the foliage and smaller gaps between the branches.

Summer trees • Sponge painting

1 The soft, irregular texture of a sponge makes it a highly versatile tool particularly suited to rendering the texture of tree foliage. In this first stage of the painting the artist begins by loosely washing in the shapes of the trees with pale tones of sap green.

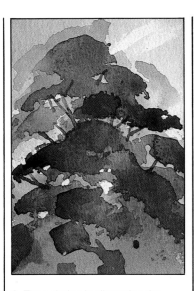

3 The painting is allowed to dry, after which slightly darker tones of Payne's grey and sap greens are sponged onto the tree shapes and a few slender branches are indicated with a rigger brush.

6 In the completed picture you can see how thick paint, freely applied, creates a natural sense of movement in the foliage. It is important to note how, even in high summer, trees are rarely bright green in colour: the greens of the surrounding landscape are much lighter because they reflect more light from the sky.

2 The artist mixes up a more intense wash of sap green and Payne's grey for the mid-tones of the foliage. A rounded sponge is dipped in clear water, squeezed out until it is just damp, and pressed into the pool of colour on the palette. The sponge is then used to deposit a mottled, irregular pattern of dark tones over the dried underlayer.

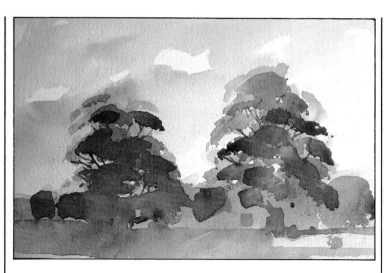

4 The completed painting has a refreshing spontaneity and feeling of light, and the sponged texture gives a convincing interpretation of heavy summer foliage.

Winter Trees • Watercolour

When painting the bare trees of winter, don't make the mistake of trying to portray every twig and branch, because this can look rather stilted. It is far better to convey an impression of massed twigs and branches, particularly where trees are grouped together. In this impression of a winter landscape the artist depicts the distant trees as a soft blurred tone against the sky, accented by a brief suggestion of branches.

1 The artist dispenses with an underdrawing, preferring to allow the spontaneity of watercolour to have free rein. A pale wash of cerulean blue is washed in for the sky, followed by a loose wash of diluted sap green for the foreground. While the paint is still damp the artist creates a deliberate backrun on the right of the painting by flooding the area with clear water applied with a soft brush. The loosened colour is allowed to bleed into the foreground: this shape will eventually be developed into a small group of trees enveloped in mist.

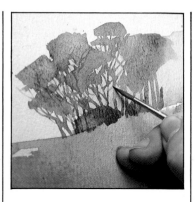

2 The artist uses a No. 2 sable brush and a mixture of Payne's grey and raw umber to draw in the delicate shapes of the trees on the right. A small soft brush is used to lift out colour here and there to suggest swirls of mist.

3 The trees farther back in the distance are painted loosely with a wash of sap green darkened with a touch of Payne's grey.

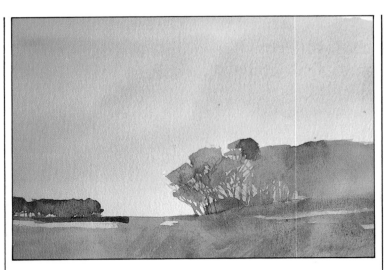

4 The completed picture captures perfectly the cold stillness of a frosty morning in the country. What started as a backrun in step 1 is now a tiny copse still half enveloped in early morning mist. The mood of quiet stillness is also conveyed by the way the artist has composed the picture: the low horizon line emphasizes the calm, open sky.

Palm trees

Palm trees are always a favourite painting subject, with their tall, graceful trunks topped with luxuriant foliage. Here the artist has used watercolour — an excellent medium for rendering the crisp, clean outlines of a palm tree. Using a No. 4 sable brush, he painted the trunk with a pale underwash of raw umber, graduating to Payne's grey near the base. When this was dry the shaded half of the trunk was strengthened with ivory black and Payne's grey. What is particularly interesting here is the use of lively, scribbled, 'shorthand' marks to indicate the jagged texture of the trunk, caused by palm fronds breaking off.

The exuberant shapes of the fronds are painted with the point of a slender sable brush, using sap green and Payne's grey. The feeling of bright sunlight is conveyed by using just three clear, distinct tones to indicate light and shade.

This picture shows a different species of palm tree, with softer, more feathery foliage. These forms are much more complex, especially since the nearest fronds are foreshortened as they curve towards us. The secret is to capture the essential characteristics of the foliage without overworking the painting. Sap green and Payne's grey are used here to create a few simple tones, laid down in overlapping washes and blotted with a tissue to create texture. Form and volume are preserved by concentrating darker washes in the 'inner core' of the foliage, while the lightest tones are found at the outer edges, painted with feathery drybrush strokes.

FIGURES

The question of whether or not to include figures and animals in a landscape depends on the mood you are trying to convey. If you wish to project a feeling of peace and seclusion, the addition of figures may be inappropriate. But in many cases an element of active involvement in the scene helps to bring it to life. A group of cows in a distant field, a fisherman by a riverbank, or an old man strolling down a country lane, all provide a narrative element, as well as giving life, movement and scale to the scene. A tiny figure on the shore helps to convey the vastness of the sea; a grand doorway becomes even more imposing with a small figure standing before it.

Having said all this, it is most important that figures are included in the scene for a purpose, and not just to fill up a space. Generally, they should be placed in the middle or far distance, acting as a supporting feature of the landscape; if a figure is placed too centrally, the picture is in danger of becoming a portrait with a landscape in the background.

It is also essential that animals and people are rendered in correct proportion to their surroundings, otherwise a perfectly good painting may be ruined. One way to overcome this problem is to draw the figure on a small piece of tracing paper and lay it on the painting (so long as it is dry). This way you can check that the relative scale of the figure is correct, and you can try the figure out in different positions in the composition. If the result is successful, you can go ahead and paint the figure.

Many amateur artists exclude figures from their landscapes because they feel that they are not competent enough at figure painting. But for the purposes of a landscape painting, a detailed figure study is less important than the attitude and activity of the figure. In fact, the less detail you include the better, because it allows the figure to blend naturally with the surroundings. For tiny figures in the distance, a well-placed stroke for the body and a dot for the head may be all that is required. For figures in the middle distance, the best technique is to start with a silhouette of the figures and gradually introduce lights and shadows into them to lend weight and solidity to the forms. The most important thing is to get an interesting shape and a sense of movement. Make sure the figure is engaged in some sort of activity and not just hanging about aimlessly!

The best way to practise figures in landscapes is to make rapid sketches in soft pencil each time you go out on a sketching or painting trip. Keep the sketches small, and aim to capture the gesture and silhouette of the figure or animal. These sketches will be an invaluable source of reference to you when painting landscapes in the studio.

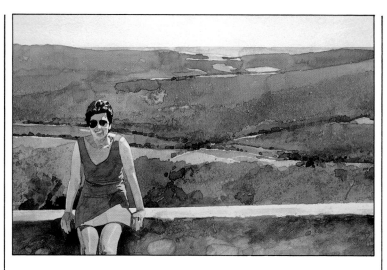

Figures in the landscape
The inclusion of a figure or figures can provide a focal point in a landscape and give an indication of the scale of the other features. In this painting, the figure of the girl in the foreground accentuates the vastness of the mountainous landscape behind her. Think carefully about the positioning of figures in your landscapes — they should be an integral part of the overall design. For example, they can be used to stress the importance of the centre of interest, or to lead the eye into the picture.

Figures in a landscape
1 In painting the figures in the landscape the artist has decided that they are too small to be painted in detail. With simple broad brushstrokes he applies the basic skin tones, laid on top of the background colour.

2 Then he adds the darker tones for the hair and the modelling of the figures.

3 In the final picture everything falls into place. The figures, which looked like blobs of paint close up, now look very lifelike.

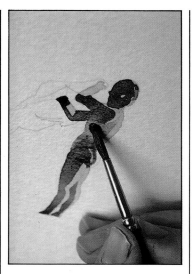

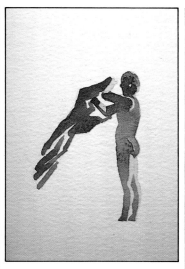

Figure sketches

Here are a few examples of simple figure sketches, drawn with a small brush and ink. Take every opportunity to make rapid sketches of people in parks, cafés, train stations etc. Keep the sketches small so that they can be drawn rapidly, and look for interesting shapes which convey a sense of movement. These sketches can be used later as reference when you are painting a landscape in the studio; having drawn your figures from real life, they will have a greater sense of authenticity.

Figures on the beach

1 No matter how simple your rendering of the figure is, it is important to get the proportions right. The most common mistake is in making the head too big in relation to the body. It is useful to remember that the length of the head is roughly one seventh of the figure's total height. Generally the legs are a little longer than the trunk, and the arms extend to roughly halfway down the thighs.

Here the artist is making a rapid watercolour sketch of a woman on a beach, shaking out a towel. After making an initial pencil sketch to get the proportions right, the artist blocks in the lightest tone on the figure with a pale wash of cadmium red light.

2 The form of the figure is modelled very simply, using raw umber and burnt umber for the areas in shadow. The bathing costume is then painted with ultramarine.

3 Even though this figure is rendered freely and with very little detail, there is a marvellous sense of the way strong sunlight falls on the figure, from the right. The impression of movement and action is reinforced by the way the towel is caught by the wind.

PORTRAITS

Of all the subjects which an artist is likely to tackle, the human face is without doubt the most challenging. Even experienced painters feel a twinge of anxiety every time they begin a new portrait, because each one tackled is unique and presents a fresh set of problems.

The main difficulty faced by the artist is in creating a portrait which not only looks lifelike, but is also recognizable as the person who is the subject of the painting. You must capture the essential characteristics and features of the subject, while at the same time injecting life into the features and conveying the idea of a living, breathing person.

Before attempting your first portrait, you will find it helpful to make sketches of faces at every opportunity. Sitting on a train or bus, you can sketch faces and individual features such as eyes and mouths. Studying your own face in the mirror is also a good idea; this gives you the chance to study features and try out various expressions at leisure, without the pressures of producing a flattering likeness which come when painting friends or relatives.

Another way to develop your confidence is to start by painting a portrait from a photograph — this is less inhibiting than painting a real person who is capable of criticizing your efforts. However, once you have gained some experience, it is best to avoid painting from photographs. It is difficult to create a convincing three-dimensional image from a two-dimensional source, and your painting may well end up looking somewhat lifeless and tightly rendered. Also, the delicate nuances of tone and colour in skin and hair are invariably lost in a photograph.

Probably the best way to practise portrait painting is to start by asking friends and relatives to pose for you and, because you are familiar with their personality traits, you will find it easy to put these across in your painting.

Assuming that you have found a model and are ready to begin painting his or her portrait, there are quite a few preliminary steps to consider before you actually put brush to canvas. The most important step of all is establishing a rapport with your sitters and helping them to relax. Even a sitter you know well may suddenly be overcome with nerves and self-consciousness, so treat the whole thing in a relaxed, informal way. Engage your sitters in conversation as you paint, and provide some background music if you like. Make sure they are comfortable, with plenty of support for their back, if they are seated, and allow them to move and stretch if they feel the need.

The pose

The most important thing to remember is that the pose should look natural, as well as feeling comfortable to the sitter: if he or she feels ill at ease, their tense expression will come through in the painting. The simplest poses are best, so don't fuss about the pose and ask your sitters to move an arm to the left, or to incline their head this way or that. Simply ask them to relax, and they will instinctively take up a pose which is both comfortable and which perhaps demonstrates something of their character and personality.

In general, a sitting pose is better than a standing pose, because it allows the model to relax and hold the pose indefinitely. A standing pose tends to look formal, and is much more demanding of the model's stamina. Whether standing or seated, though, it is important to allow your model frequent breaks.

Background

Backgrounds play a secondary role in most portraits, but they do nevertheless require a good deal of thought and attention. You may choose to paint the interior scene in which the sitter is placed, or to treat the background as a simple colour area with no detail; in either case, try to choose colours that provide pleasing contrasts with the face or figure. The cool tone of a green wall or drape will heighten the warmth of the model's skin; a dark background tone will accentuate strong light falling on the model, whereas a pale background provides a good contrast for a model wearing dark clothing.

Keep the background more subdued than the figure, both in colour and in the overall treatment. Cool, neutral colours accentuate the warmth and luminosity of the model's skin, whereas bright colours detract from it. Similarly, avoid any distracting details or patterns that might divert attention from the subject. If these are present in the background, subdue them by painting them loosely and broadly.

Having sorted out all the preliminaries and made some rough sketches, you are now ready to embark on the paint-

ing. The approach you adopt should be exactly the same as that used in painting a landscape or still life: begin by resolving everything down to basic shapes and tones, and build up gradually from there. Don't make the mistake of drawing a detailed outline of the face and then filling it in with colour. By all means indicate the overall shape with loose strokes as a rough guideline, but a hard, rigid outline inhibits and stultifies the painting process. You should always be free to alter the painting as it progresses.

So, begin by using large brushes to indicate the main masses, lights and shadows with broad washes of colour. Having established the three-dimensionality of the form, proceed in a natural sequence from broad, sweeping strokes to smaller, more precise ones, indicating the angles, curves and contours of the face. Even at this stage, don't become too involved with details such as the eyes and mouth — the form of the face as a whole is what's important. Getting a good likeness is not simply a matter of accurately painting the eyes, mouth and nose. The shapes, sizes and relative proportions of the face differ from one individual to another. Observe these surface shapes closely, because these are what give your sitter his or her particular identity.

At this stage it is a good time to take a break from the painting for twenty minutes or so. When you come back to it, any faults will be more readily apparent and can be corrected before it is too late.

When painting the features, work from the inside to the outside of the face. Some artists like to start with the eyes, others prefer to start with the nose and work up to the eyes and down to the mouth. Whichever method you choose, always work from one feature to another, keeping the paint wet, rather than treating each feature as a separate entity. Then, when the painting is almost finished, take another break from it. After making any necessary adjustments, add the final highlights to complete the portrait.

Lighting
In most cases, portraits are painted indoors, which gives you a choice of using natural or artificial light. There is no doubt that natural daylight is preferable, especially when it comes from a fixed source such as a window or skylight. If you are working with artificial lighting, choose 'warm white' fluorescent tubes, which are the best substitute for natural daylight.

Whether working with natural or artificial light, it is best to illuminate the subject from a single source only. Soft, diffused light coming from one side of the head is flattering to the model and brings out the form of the model's features. Light falling just in front and to one side of the model — referred to as 'three-quarter lighting' — is probably the easiest to paint. The light illuminates one side of the face and part of the front, throwing the other side into shadow. This makes the lights, half-tones and shadows readily distinguishable and helps to solidify the form. If you notice that the shadows on the figure look too dense, this can be remedied by placing a reflective white board on the shadow side to provide some fill-in light.

If you are painting a portrait outdoors, bear in mind the same guidelines. Position your model so that the sun strikes him or her from one side and slightly to the front. Early morning and mid to late afternoon will give the best results.

Clothing
The clothes which your sitter is to wear in the portrait must be selected with care. They should reflect the personality of the sitter and be in tune with the overall mood of the painting. Generally, quiet colours and restrained patterns are best, and if the clothing is darker than the face, all the better. Remember, the subject of the painting is the face; bright colours and patterns will divert attention from the face and reduce the impact of the portrait.

EYES

The eyes are often referred to as 'the windows of the soul', because they convey so much about a person's character and mood. As such, they are a vital element of any portrait, and it is important to get them right.

In shape, size and character, eyes may differ enormously from one person to another, but the basic anatomical structure remains the same. The eye is a convex form in a concave socket, but all too often it is rendered in a schematic way, as an almond shape with a circle in it. The upper and lower lids are never the same shape — the lower lid is much flatter. In addition, the upper lid covers a third to half of the iris, depending on the individual, and the iris 'sits' inside the lower lid, not on its edge.

Conveying the illusion of the spherical nature of the eye, as with any rounded object, involves working with light-dark modulations of tone, as demonstrated below. Notice how the lights and shadows emphasize the curving shape of the eye: even the white of the eye can be brighter on one side of the iris, curving gradually into shadow on the other side. Also, the band of shadow below the eyelid helps to give the effect of the lid curving over the ball of the eye.

When light coming from one side strikes the glassy, moist surface of the cornea, a bright highlight is produced which gives light and sparkle to the eyes (bear this in mind when lighting your sitter). The transparency of the eye allows some light to travel on inside the eyeball, creating a softer reflection on the opposite side which gives a wonderful glow and luminosity to the eye. Paint the main highlight crisply, and the secondary one softly, paying attention to their subtle colouring — highlights are not always white. GLAZING also helps to convey the reflectivity of eyes.

Generally, the eyes should have a soft, 'melting' appearance, and this is achieved by avoiding too many crisp hard edges, painting WET-IN-WET. Even the blackness of the pupil should be softened at the edges where it meets the iris, to avoid an unnatural, 'staring' look.

Finally, never paint individual eyelashes — nothing looks more amateurish. Use a curving, irregular dark line to give an impression of the eyelashes.

Eyes • Oil

1 Having drawn the face in pencil, the artist starts to lay in the paint working down from the hair. He interrupts his method to paint in the irises and eyelids separately, to relate them to the skin colour already painted, and so that he can work outwards from the eyes towards the broader areas of skin tone.

2 The eyes have been integrated into the completed face with a subtle blending of colours around the lids. They also reflect the direction of the light source in that the white of the left eye is brighter than that of the right.

Eyes • Watercolour

Of all the facial features, eyes are the most complex and difficult to paint — and watercolour can be a particularly tricky medium to use because the fluid nature of the medium is not easily controlled. However, this is more than compensated for by watercolour's unique transparency and delicacy. In this demonstration, the artist shows how to build up a series of subtle washes and glazes which emphasize the form and three-dimensionality of the eye, as well as the 'glassy' surface appearance.

1 After making an outline sketch of the eyes in pencil, the artist defines the shape of the eye rim and the shadow on the inside corner of the eye with a mixture of ivory black and brown madder alizarin and a No. 2 sable brush.

2 When the first wash is completely dry a thin, transparent wash of burnt sienna is used to block in the mid-tones around the eye. Then, with a delicate wash of cobalt blue and Payne's grey, he paints in the iris, leaving a tiny dot of untouched white paper for the main highlight.

3 The artist now applies a thin wash of Payne's grey to the eye: in one stroke he delineates the pupil and the shadow cast by the upper lid, being careful to work around the white shape of the highlight. With a clean, damp brush, he then carries a little of this colour up towards the outer corner of the eye to create a subtle shadow which emphasizes the curve of the eyeball. Checking first that the flesh tones around the eye are dry, the artist now paints the lightest tones of the face with a heavily diluted wash of burnt sienna.

4 When this wash is dry, the flesh tones are now strengthened with further washes, mixed from cadmium orange, brown madder alizarin and burnt sienna, and the artist begins to paint the various tones of the hair with burnt umber and cadmium orange. The shape of the eyebrow is then strengthened with a mixture of burnt sienna and cobalt blue. When these washes are dry, the colour of the iris is developed further with strokes of cobalt blue, leaving some subtle highlights of paler blue. Then the pupil is darkened with a wash of ivory black. Notice how the two colours bleed into each other very slightly where they meet, creating a soft, 'watery' feel which is much more lifelike than a hard, unsympathetic edge. Next the 'white' of the eyeball is toned down with a very pale mix of yellow ochre and Payne's grey, which is slightly darker in the inner corner where there is more shadow.

It is important to work continually back and forth between the eye and the surrounding features, so that the eye becomes an integral part of the face.

5 With the basic tones and shapes now establishd, all that remains to be done is to sharpen up the details in the eye to strengthen the 'glassy' appearance. Finally, tiny upward strokes of paint are lifted out just above the eyelid; viewed from a distance these pale shapes give an impression of blond eyelashes.

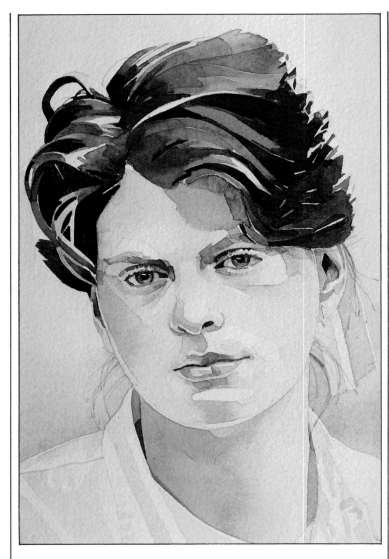

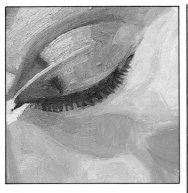

6 The completed painting. Delicate washes and glazes have been used throughout, to create a subtle and lifelike portrait of a young girl.

Closed eyes
1 Having sketched in the head and the features of the face, the artist works on the eyes.

2 In this detail you can see the various skin tones — the lightest areas are made up of yellows, pinks and oranges, whereas the shadows contain tinges of blue, green and purple.

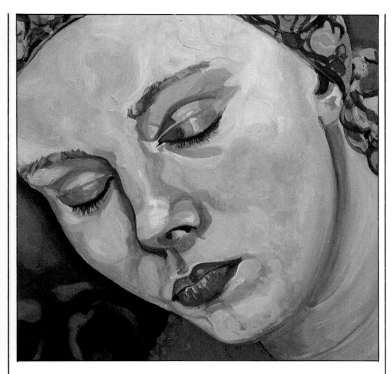

3 In the final picture, the various tones merge together. The tones of the eyelids are purple in comparison with the colours of the cheeks.

MOUTHS

The mouth is the most mobile part of the face, and capable of many expressions (Leonardo's *Mona Lisa* is the most eloquent example of the subtlety of expression which the mouth can lend to a portrait).

The most common mistake when painting mouths is in 'drawing' the final outline first and then filling it in with colour. This linear approach is inappropriate for a painting, and gives the mouth a flat, pasted-on appearance. The correct technique is to model the mouth in a sculptural way, in terms of light and dark tones and hard and soft edges.

Assuming that we are looking at a closed mouth, in repose, there are various points to be noted. Firstly, the mouth is not flat, but stretches around the sphere of the head, swelling out towards the middle of the face and narrowing again towards the corners. The upper and lower lips have distinct features: the upper lip may be thin, well defined and dark in tone compared to the lower lip, which is usually fuller and softer, and lighter in tone because, being more prominent, it catches more light.

To emphasize the curvature of the lips, begin at the corners and work inwards. Put in the darkest tones first — the underside of the upper lip, and the shadow beneath the lower lip. Then apply the mid-tones, blending them softly into the darks. Finally, add the highlights.

So that the mouth appears integrated with the surrounding skin, introduce a variety of hard areas and soft areas into it. The top line of the upper lip, for example, may be much crisper than that of the soft, lower lip.

Finally, don't make the mistake of painting the lips too red. Use the same colour mixtures as you would for the skin, with the addition of just a touch more red.

Mouths • Acrylic
1 A mouth is not a flat shape but rounded, requiring different shades to describe its form. Begin by painting the mid-tones with a No. 2 brush. The basic mix of colours is white, cadmium red, cadmium orange and cobalt blue.

2 Add the highlights where the light catches the moisture and the raised muscles on the lips.

3 Finally, touch in the shadows on the lips themselves and on the surrounding skin.

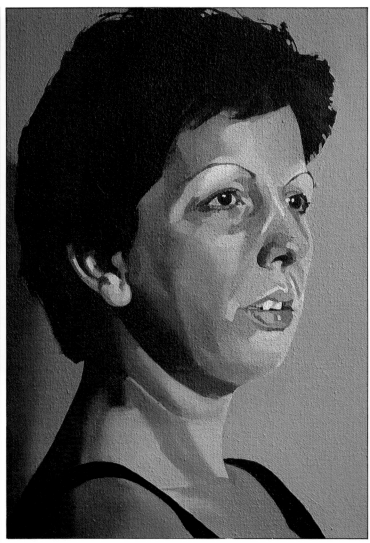

Mouths • Oil

Painting a portrait from a three-quarter view can often yield more interesting results than the conventional full-face portrait, but care must be taken to get the shape and positioning of the features right. Here the artist uses oils to paint a mouth from a three-quarter view. The slow drying time of oils allows for the soft blending of colours in a way that is not possible with other media, and any necessary alterations can easily be made while the paint is still wet.

1 The artist begins with a brief sketch to outline the shape of the mouth, and then blocks in the darkest tones with burnt and raw sienna and a No. 4 sable brush.

3 The artist now blocks in the lights and mid-tones around the mouth, blending them smoothly together. With a touch of cadmium yellow and ivory black, the tones of the teeth are darkened very slightly.

2 Here the lighter tones have been blocked with cadmium red, burnt sienna and titanium white. A mixture of burnt umber and white is used to define the darkest shadows around the mouth.

4 Using a very limited palette, the artist has succeeded in rendering a bold, direct impression of the mouth.

Mouths • Watercolour

A smiling mouth is more difficult to paint than a mouth in repose, since any undue exaggeration of the smile results in a caricature rather than a portrait. The essential thing to remember is that we smile not only with our mouths but with our entire faces. Cover up the mouth in this portrait and you will see that the girl is still smiling. This is valuable proof that all the features of the head are interlinked and supportive of one another.

Obviously it would be difficult for a sitter to hold a smiling pose for a long period without the smile becoming somewhat 'fixed'. In this case, it might be helpful to take snapshots of your sitter and use these as reference during the painting of the portrait.

1 In this sequence, the artist demonstrates how he uses straightforward watercolour washes to render the important shadow patterns formed by the creases around a smiling mouth. After sketching in light pencil lines to establish the facial features and main shadow patterns, the artist begins painting the mouth. The dark line between the upper and lower teeth is painted with a light wash of ivory black, using the tip of a No. 2 sable brush. Then the upper gums are painted with a delicate tone of brown madder alizarin and cadmium orange. The same colour is used on the lips, except for a small section of untouched paper on the lower lip which serves as a highlight.

2 When the first washes have dried the artist blocks in the lightest tones around the mouth with a delicate wash of cadmium orange. A large area of white paper is left to indicate the light-struck area on the left side of the chin.

3 Next, the darker tones of the upper lip and the right side of the lower lip are painted with brown madder alizarin. When the light skin tone around the mouth has dried, the artist indicates the mid-toned shadow shapes with cadmium orange and a touch of burnt sienna. Already we can see the smile beginning to form.

4 When the mid-tones are completely dry, the artist continues to build up the darker shadows by glazing with a mixture of cadmium orange and burnt sienna. The darkest shadows — under the nose and in the cleft of the chin — are painted with a mixture of burnt sienna and Payne's grey. It is important that each layer of colour is perfectly dry before the next one can be applied, so that the shadows remain clear and luminous.

5 The colour on the shadow side of the face is darkened with further washes which accentuate the light-struck planes of the left side of the face. Finally a light mix of ivory black and yellow ochre is brushed onto most of the upper teeth, leaving one or two white highlights. This is another important point about painting mouths — always make them slightly darker in tone.

FLESH TONES

It is possible to buy tubes of pigment labelled 'flesh tint', but in fact there is no such colour. Human skin contains an infinite variety of hues, and flesh tones vary in colour from person to person, from one sex to another, and between people of different ages. In addition, skin is a reflective surface, and is therefore affected by the quality of the prevailing light and by the colours of nearby objects. And yet, so often, one sees portraits in which the skin of the unfortunate sitter looks more like that of a porcelain doll than a human being; the artist has decided that flesh is always 'pink and rosy', and failed to notice the subtle nuances of tone and colour which give the skin its marvellous, translucent appearance.

The best way to practise painting flesh tones is to make studies of your own hand under different lighting conditions. At first you may see pinks and reds only, but closer observation will soon reveal touches of yellow, grey, blue, brown, and even green.

To render flesh tones well, you must discard all preconceived notions about the colour of flesh, and paint what you actually see. For example, you will notice how skin looks lighter and warmer in the prominent, light-struck parts than it does in the receding or shadowy areas. In a painting, warm colours appear to advance, while cool colours appear to recede. By juxtaposing warm and cool colours, the artist is able to define the shape and volume of the face, creating a visual 'push-pull' sensation, rather as a sculptor pushes and pulls the clay to model the 'hills and valleys' of the face.

Thus, you will find cool blues and yellow-greys used in the receding parts of the face: the eye, under the chin, behind the ear, and at the corners of the mouth. Advancing parts, such as the forehead, nose, chin and cheeks, will contain more warm reds and yellows.

Basically, the overall colour of flesh comprises various mixtures of the three primary colours — red, yellow and blue. So the 'core' of your palette should consist of six colours — a warm and a cool version of each of the three primaries. Bearing in mind that warm flesh tones tend towards yellow, and cool ones towards blue, a suggested palette might be as follows: cadmium red light or vermilion (warm); alizarin crimson (cool); cadmium yellow (warm); lemon yellow (cool); cobalt blue (warm); ultramarine (cool).

Of course, this is only a starting point. You will also need white (except in watercolour), perhaps some black, and touches of other colours, depending on the particular skin type of your sitter. Other useful colours include burnt sienna and burnt umber (good for shadow areas and for highlights in dark hair), yellow ochre, Venetian red (useful for mouths) and viridian (again for shadow areas).

For the pastellist, additional colours might include burnt umber, burnt sienna, yellow ochre, blue violet, grey blue and olive green.

There is no single, all-embracing formula for painting flesh tones, and almost every artist has his or her own favourite palette of colours. The combinations given here are intended only as suggestions, and you are advised to try these out alongside other mixtures and decide for yourself which colours are best suited to your style.

Some artists prefer a fairly restricted palette, but if you wish to use more colours, feel free to do so. The main thing is that not more than three or four colours should be used in any one mixture: any more than this and the colours begin to cancel each other out and turn muddy.

Clarity of colour is vitally important if you wish to convey delicate, translucent skin tones. Use a palette with a large mixing area which won't become clogged with colour too quickly, and arrange your colours systematically.

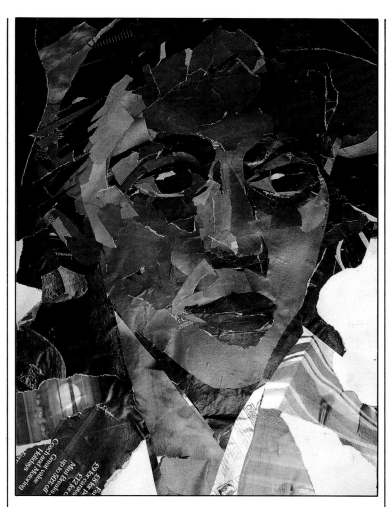

Flesh tones • Collage
Magazines and colour supplements provide an endless source of colours and patterns for collage work. This portrait, for example, was created from small pieces of torn paper, fitted together almost like a jigsaw. An exercise like this is great fun to do, will teach you a lot about judging skin tones accurately, and can produce very striking results — as this picture proves.

Flesh tones • Line and wash
This portrait study in watercolour
and ink demonstrates how washes
and lines can work beautifully in
tandem to produce an image which
is strong and yet subtle. The artist
has used bold calligraphic lines with
brush and ink, which give definition
to the profile and rhythm to the hair.
The skin, in contrast, is rendered
with soft washes of delicate colour
applied wet-in-wet. The resulting
portrait has an immediacy and a
lifelike quality which is special to the
watercolour medium.

Flesh tones • Oil
In complete contrast to the delicate
transparency of watercolour, oil
paints can be laid on with thick
impasto to produce a heavily
textured result. In this striking
portrait, the artist worked alla prima,
applying all the paint in the same
stage and working wet-in-wet over a
beige ground. The paint was applied
rapidly in large blocks of colour
which describe the planes of the
figure in a bold, uncompromising
manner. The painting has an almost
sculptural form, accentuated by the
strong side light which throws the
figure into distinct planes of light ad
shadow.

Flesh tones • Oil
1 The artist starts the portrait with an underpainting of ultramarine oil paint, thinned with turpentine. The strong lights and darks of the model's face, created by shining a light onto it from one direction, can be portrayed easily with one colour.

3 A thin layer of colour is scumbled over the impasto and, by blending with it, modifies the underlying colour slightly to create an exciting effect.

5 Using colour only again, he paints the mouth, using light tones where the lower lip is struck by light, and darker tones where the lips are in shadow.

7 The variety of techniques used in the image can be seen in this detail — thin scumbles which reveal the underpainting and the texture of the canvas, and thick impasto and blending where the texture of the canvas is obscured.

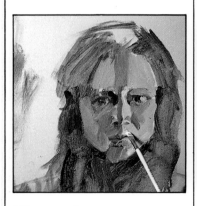

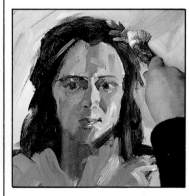

2 The warm flesh tones are laid on in a thick impasto. Their warmth is heightened by their contrast with the cool colour of the underpainting.

4 In painting the eye, the artist brushes in only tone and colour — the reflected light that he sees rather than the form of an eye.

6 With a decorator's brush the artist applies white with touches of other colours for the background and the blouse. His scrubbing brushstrokes suggest the folds and frills of the blouse.

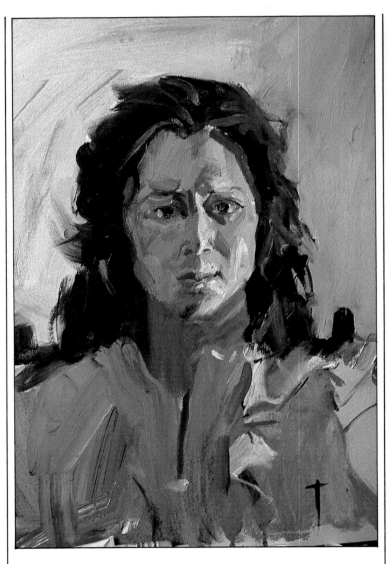

8 A sense of vitality comes across in the final painting, conveyed by the vigorous brushstrokes and the marvellous balance between the warm and cool tones.

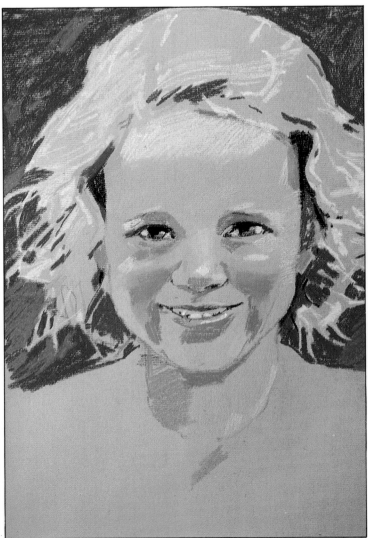

Flesh tones • Pastel

Pastel is the perfect medium with which to express the appealing sensitivity of a child's face. A pastel stick is easy to manipulate, allowing you to catch even the most fleeting expression, and the fresh, clear colours are well suited to the delicate luminosity of a child's complexion.

In this portrait, the artist has used strokes of pure colour in a loose, sketchy style which perfectly complements the engaging warmth of the child's expression.

The artist has chosen to work on a flesh-tinted Canson Mi-Teintes paper. The neutral colour of the paper is used freely as an underlying tone which helps to emphasize the fresh colours of the child's face.

2 The artist continues to model the tones of the face with warm and cool colours. In order to maintain the freshness and vitality of skin tones, it is important not to overwork the drawing. Here the artist is applying hatched strokes of white over madder brown to highlight the side of the face.

4 In contrast to the thinner skin on the forehead, the cheeks are plump and soft. Here the artist uses a torchon to blend the skin tones together to create a smooth, velvety texture.

1 The artist begins by establishing the outline of the girl's face and hair, using hard pastels in shades of pink, brown and yellow. The strokes are kept deliberately loose and sketchy, serving only as a guide to proportion and colour. Next the artist begins to block in the eyes, nose, mouth and cheeks, making sure that the proportions are correct and trying to get a feel for the likeness. The broad, friendly grin of the child is an important feature of the portrait, so the artist ensures that the area around the cheeks and mouth is well established in the early stages. The cheeks and mouth are modelled with cadmium red light, while the eye sockets and planes of shadow around the mouth area are painted with cool tones of raw umber. The eyes are outlined in black, with small dashes of cobalt blue for the irises. Finally, touches of cadmium lemon are touched in on the high points of the face to give an impression of light flickering across the face.

6 Here you can see how the artist has used a minimum of blending, relying on directional strokes of pure colour to convey an impression of the light on the child's face. The tone of the paper also plays a vital part, serving as a mid-tone so that only the highlights and shadows are needed to complete the painting. Thus, with great economy of means, the artist has created a portrait full of freshness and vitality.

5 Movement and texture in the hair are represented by scribbled strokes of cadmium lemon, lightly blended here and there with a torchon.

3 This detail shows the artist modelling the forehead with light, feathered strokes of madder brown which allow the neutral undertone of the paper to shine through. Seen from the appropriate viewing distance, these tones blend together in the viewer's eye without losing any of their sparkle or freshness.

7 The portrait is now nearing completion, requiring only a few final white highlights to bring out the youthful shine on the child's skin. Here, the artist is using the sharpened point of a white pastel to flick in a highlight on the lower lip. Notice how the teeth are indicated with just a couple of strokes of white: the viewer 'fills in' the rest of the teeth quite happily.

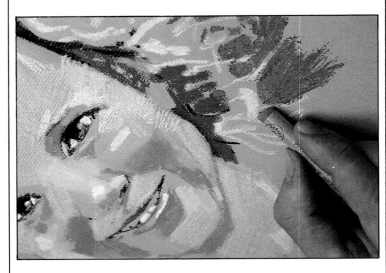

8 Finally, some background colour is indicated with loose strokes of Hooker's green and cadmium yellow. This cool dark tone has the effect of emphasizing the warmth and brightness of the skin tones.

Flesh Tones • Watercolour

When it comes to painting delicate skin tones, no other medium can quite match up to watercolour. In this portrait, the white of the paper plays a vital role in creating an impression of bright sunlight shining on the model's face. The essence of this technique is to use a limited palette of fresh, bright colours and to keep the shapes and colour washes as simple and uncluttered as possible.

1 The artist makes a very simple outline sketch of the head and then establishes the main shadow planes with washes of brown madder alizarin and Payne's grey. The hair is painted next, with a pale wash of raw umber and loose strokes, which capture a sense of movement.

2 The artist continues to model the planes of the face with touches of brown madder alizarin, and cadmium red light. Notice the use of both hard and soft edges, which give form and structure to the features.

3 The dark tones of the hair are brushed in with Payne's grey, raw sienna and burnt umber, leaving some pale streaks. The dark tones of the mouth are then strengthened with brown madder alizarin. The portrait is almost finished, yet almost half of the depicted face comprises white paper.

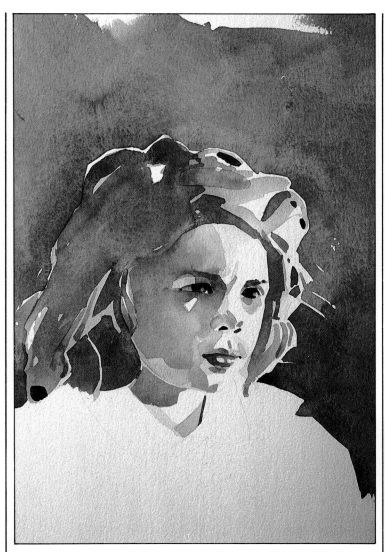

Flesh tones • Brown skin

1 Working from a painted sketch rather than a preliminary drawing the artist begins to block in the basic colours loosely with gouache paint.

2 The artist begins work on the position of the eyes. The freedom of his approach allows him to move and change the tonal planes until he is satisfied with their arrangement.

3 Because brown skin reflects light more than pale skin does, strong highlights and shadows have been used. The colours used by the artist included cadmium red, cadmium orange, cadmium yellow, yellow ochre, raw umber, ivory black and Payne's grey.

Because gouache is opaque it is possible to add light tones over much darker ones, as the artist has done here, adding highlights to the flesh over the darker base colours. When painting light over dark the paint should not be too diluted and take care not to disturb the dried colour beneath.

4 To complete the painting, the artist brushes in a loose wash of Hooker's green in the background, working carefully around the outline shape of the hair. This has a dramatic effect on the portrait, throwing the face into sharp relief. The finished painting is refreshingly simple and direct, because the artist has edited out all unnecessary detail and included the large, important masses of light and shadow only.

SKIN TEXTURE

Rendering the actual texture of skin will depend very much on your own painting style, your chosen medium, and the particular character of your sitter. Oil paint is probably the medium most suited to portrait painting, having a richness and depth of tone which gives strength and solidity to the subject. There are a number of ways of using oils to interpret skin tones: you can start with a thin underpainting to establish form and bulk, overlaid with delicate GLAZES and SCUMBLES to give sheen and translucency to the skin. The slow drying time of oils allows for subtle modulations of tone and colour, achieved by BLENDING with a fan brush. For a more direct, dynamic effect, try painting with bold slashes of BROKEN COLOUR.

Watercolour has a reputation for being difficult to control when painting portraits and figures, but frequent practice will give you increasing confidence. You may choose to build up the flesh tones using glazes WET OVER DRY, or you may prefer the more exciting method of applying pure colours and letting them blend WET-IN-WET.

For the pastellist, the choices lie between smooth blending for a soft, dewy effect, broken colour for a vibrant effect, and building up for a dynamic effect — or even a mixture of all three.

HAIR

The average head contains around 100,000 separate hairs, but, as far as the artist is concerned, hair should be rendered as one solid form, with planes of light and shadow. The volume of the head is defined by the hair, so it is important to begin by defining the hair in terms of shape and mass before thinking about texture. Search out those areas that catch the light and those that are in shadow and indicate them with broad washes of colour. Having established the underlying form, indicate the direction of the hair growth: long, flowing strokes for long hair, short, SCUMBLED strokes for curly hair. Again, think in terms of mass — don't paint individual strands that seem unconnected to the rest of the hair.

To portray the essentially soft, pliant nature of hair, it is best to work WET-IN-WET, so that the edges between the hair and the face, and the hair and the background, flow into one another. One of the most common errors made by beginners is in making the hairline too hard. The hair and face should flow together as one entity; this is achieved by running some of the skin colour into the hairline to soften the division between hair and face. Similarly, the outer edge of the hair should melt into the background colour: soft edges here will give an impression of air and atmosphere around the sitter.

The colour of hair should also look soft and natural, and should not attract attention away from the face. Even if your sitter has raven black hair, do not paint it black. Hair picks up reflected colour from its surroundings: look for subtle hints of blue and brown in black hair, blonde and red in brown hair and brown, gold and grey in blonde hair.

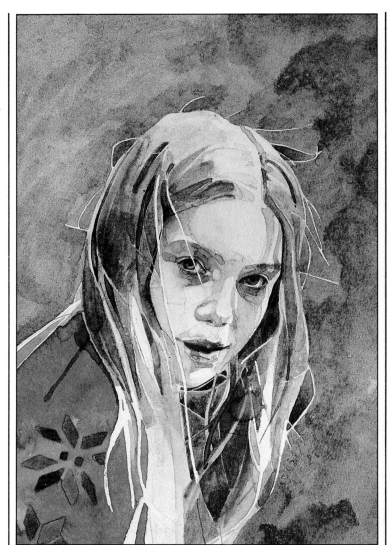

Hair • Watercolour
In this outdoor portrait, the artist achieves a lively impression of light and movement in the girl's hair. The essence of this technique is to keep the tonal masses strong and simple, allowing a few telling highlights to describe the movement in the hair.

1 Working on a sheet of pre-stretched 200lb Bockingford paper, the artist begins by making a light outline sketch of the head in pencil. The facial tones are established first; this makes it easier to assess the relationship between the tones of the hair and the face (notice how the artist has carefully worked around the thin strands of hair blowing across the face). Using a No. 2 sable brush, the artist now blocks in the overall shape of the hair with a dilute wash of yellow ochre.

3 With a still darker mixture of raw umber and yellow ochre, the artist begins to block in the mid-tones of the hair, again working around the highlighted areas.

5 The artist now pours gum arabic onto the palette. This will be added to all subsequent colours used in the painting because it gives an extra gloss and sheen to the paint. The addition of gum arabic also makes it easier to lift out colour with a brush and clear water, enabling the artist to create very fine highlights in the later stages of the painting.

7 When the hair is dry the background colour is washed in, again working carefully around the loose strands of hair blowing around the head. The artist uses a mixture of sap green, ivory black and gum arabic, working with loose strokes so as to create interesting tonal variations within the colour.

2 When the first wash is dry a slightly stronger wash of yellow ochre and raw umber is brushed in, leaving a few strands of pale hair untouched.

4 Here you can see how the patient build-up of transparent glazes, from light to dark, gives a fresh, translucent appearance to the skin and hair.

6 With a mixture of raw umber, ivory black and gum arabic, the artist now blocks in the dark tones and shadows within the hair, carefully working around the lighter strands.

8 Finally, a few further highlights are created by lifting out colour with the tip of a No. 2 sable brush dampened with clear water.

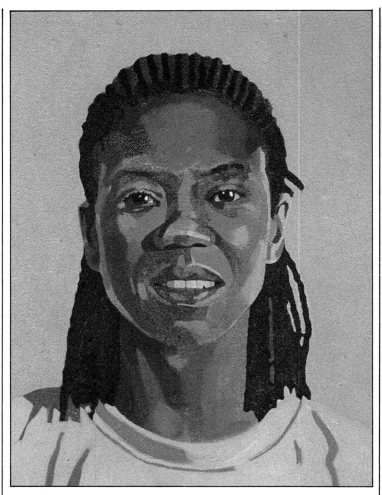

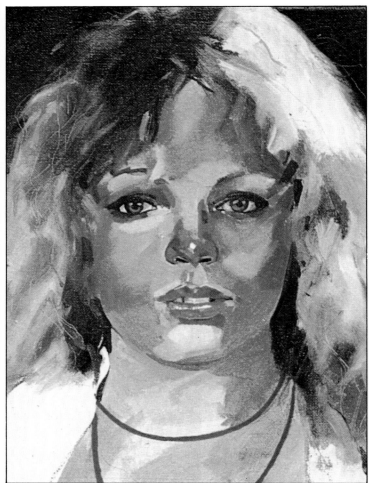

Hair • Oil
The hair was painted in a mixture of black, raw umber and cobalt blue with a No. 4 round synthetic brush. The contrast of light and dark tones on the top of the head capture the ridged effect of the closely plaited tresses. The hanging hair is almost solid with only a slight variation in tone.

Hair • Acrylic, oil
The artist began the painting in acrylic and then progressed to oils using several different methods to apply the paint, such as with a painting knife and straight from the tube. In the final picture, the bright colours of the subject contrast with the bland background, and the highlights in the hair are strengthened by the yellow of the dress.

SKIES AND CLOUDS

The sky is one of the most challenging and exhilarating subjects to paint. Indeed, many artists have made a special study of skies, among them two of the greatest landscape painters, John Constable (1776-1837) and J.M.W. Turner (1775-1851). Throughout their lives, both artists made literally hundreds of studies, in oil and watercolour, which capture the sky in all its moods.

In most landscapes and seascapes, it is the sky which determines the overall mood: in Constable's own words, 'The sky is the source of light and governs everything.' It is important to think of the sky as an integral part of the landscape, and not merely as a backdrop. Rather than painting the sky and the land separately, work continuously on all areas of the picture; this will make you more aware of how sky and land are integrated. On a sunny day, for instance, clouds cast shadows on the land, and where there are gaps in the clouds, the fields below are sometimes lit as if by a spotlight. When details like this are overlooked, the finished painting lacks credibility.

Another way to achieve a sense of unity is to harmonize the colours used in the sky and the ground; include touches of the blues used in the sky when mixing your shadow colours, for example, and hints of the reds, yellows and ochres of the landscape in the darker clouds. It also helps if you begin with a TONED GROUND or IMPRIMATURA of a very light grey or earth colour; when small patches of this undercolour are allowed to 'grin through' the overpainting, they serve to unify the scene.

In order to paint skies convincingly, you need a working knowledge of the various cloud types and their characteristics. Take every opportunity to observe cloud patterns, and fill your sketchbook with rapid, on-the-spot sketches. These sketches will help you to paint skies quickly and decisively — an important asset, because skies and clouds are constantly moving. In addition, they will form valuable reference material which you can use in future paintings.

CIRRUS CLOUDS

Feathery streaks of white cloud, high in the sky, are associated with hot summer days. Handle these clouds with restraint, blending them slightly into the sky colour so that they don't appear to be 'pasted on'. SCUMBLING and DRYBRUSH are perfect techniques for rendering this type of cloud.

Cirrus Cloud

1 Oil paint is an excellent medium for rendering skies and atmospheric effects. In this painting the artist works wet-in-wet with thin veils of colour to recreate the soft, vaporous nature of cirrus clouds. If you are working outdoors, the drying time of oil paints can be reduced by mixing alkyd white or gel medium with your colours.

The artist begins by laying in the sky colour with a mixture of cerulean blue and titanium white. When this is almost dry, the shapes of the cirrus clouds are blocked in roughly with a lighter version of the sky colour, diluted to a thin consistency. Following the upward sweep of the clouds, the artist applies rapid drybrush strokes with a flat bristle brush. To create these semi-opaque veils of colour, the artist keeps the brush starved of paint and works with a very light touch. The larger sunlit areas of cloud are then painted with titanium white, applied a little more thickly.

2 The artist now refines the shapes he has created. With a brush dipped in turpentine, he softens and blends the feathery clouds so that they merge with the sky tone to create a hazy appearance. Then the thicker, brighter areas of cloud are painted with opaque layers of titanium white.

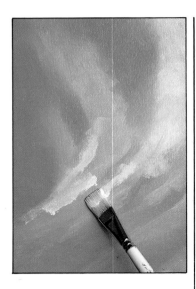

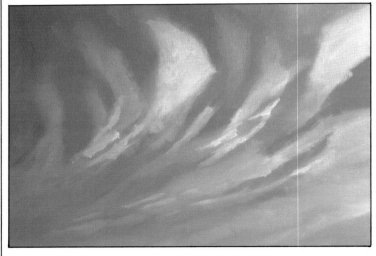

3 The completed study shows how softly blended passages create the effect of thin, vaporous clouds, whereas thicker strokes of colour bring some clouds forward. The clouds appear as part of the sky, rather than painted on it. Cirrus clouds often have a powerful diagonal pattern which can be exploited to great effect in a painting.

CLEAR SKY

The sky always looks clearer and brighter overhead than at the horizon. This is because, looking straight up, we perceive the sky directly through a thin veil of atmosphere; towards the horizon, this veil becomes thicker and affects the tone and colour of both sky and landscape. Thus it follows that painting the sky with a single tone of blue is inadequate. To achieve a sense of aerial atmosphere, introduce a note of warmth to the foreground sky, gradually cooling it until, near the horizon, it becomes a pearly grey or a pale yellow.

Variety of brushwork is important, too. Overblending to create a smooth, flat tone leads to monotony, whereas lively brushstrokes lend an impression of vibrating light. Avoid horizontal brushmarks, which will lead the viewer's eye off the edges of the picture and use, instead, strokes which go in different directions, to give textural interest and a sense of movement to the image.

When painting a clear blue sky it is important to get the tones and colours right, in order to achieve a feeling of recession. Think of the sky as a dome, stretching over the landscape, rather than a flat wall of colour. In this oil painting, the artist began at the top of the canvas with a mixture of cerulean blue, titanium white and a hint of alizarin crimson to give a warm tint to the foregound sky. Towards the horizon the blue becomes progressively cooler, with a hint of yellow ochre added to the colour just above the distant hills.

Clear sky • Pastel

1 Once the pencil outline has been drawn the artist begins to block in the sky colour. He is using a pale blue pastel, on its side, and is applying the colour thickly.

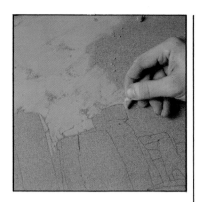

3 The white pastel of the clouds is smudged so that it does not stand out quite so much. In this second detail you can see how the artist has highlighted stone in fine lines, which he has then flicked with a cloth to reduce the sharpness of the line.

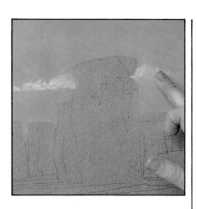

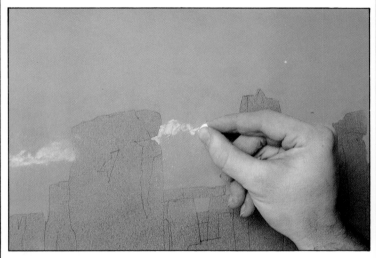

2 The artist then draws in the fluffy white clouds just above the horizon with a white pastel.

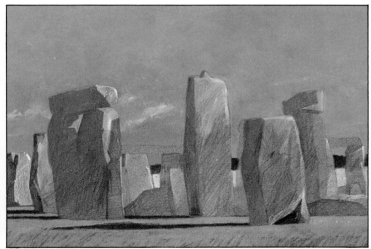

4 In the completed picture you can seen how smoothly the blue pastel was applied. The sky contrasts with the texture of the grass and the strongly modelled shapes of the standing stones.

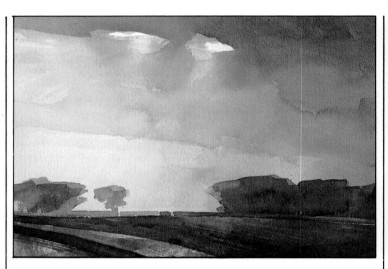

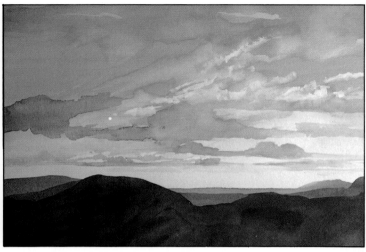

Cloud Composition

In a landscape where the sky plays a dominant role, it is important to create a main centre of interest within it — somewhere for the eye to focus on. In this watercolour, the centre of interest is created by the breaks in the clouds near the top of the painting, through which shafts of sunlight pour down on the landscape. The eye is drawn to this spot because it is here that the lightest and darkest tones in the sky meet in dramatic opposition.

To create the effect of the pale, misty shafts of sunlight the artist lifted out the sky colour with a soft, moist brush and gently blotted the area with a tissue.

Cloud Perspective

The laws of perspective apply to the sky just as much as to the landscape. On a cloudy day, you will notice that clouds seem to get smaller and closer together as they recede towards the horizon. They also become cooler and greyer in colour, due to the presence of dust particles in the air. Taking note of these points will enable you to create an exciting impression of the vastness of the sky.

In this painting, notice how the tonal gradation from light to dark in the landscape is echoed in the sky. The warm background blue of the sky becomes a pale, cool tone close to the horizon, and the streaks of cloud appear thinner, paler and closer together. To heighten the sense of deep space even further, the artist has introduced clouds subtly placed on the diagonal, near the top of the picture.

CUMULUS CLOUDS

Those heaped, white clouds that often herald rain are called cumulus. Such clouds are wonderful to look at, and much can be learned by observing them closely and making sketches before attempting to paint them.

Cumulus cloud formations are usually well defined, with distinct planes of light and shadow. During the day, the upper part of the cloud is bright and luminous, with a definite scalloped edge, whereas the underside is flatter and darker (at sunset the clouds are lit from below, so that they glow underneath while being dark on top).

The three-dimensional appearance of clouds can be emphasized by modelling them with warm and cool colours. The lit planes of clouds are rarely a stark white; they may contain subtle hints of yellow, pink and blue, depending on the weather and the time of day. Similarly, the shadows on clouds are not battleship grey, but contain a variety of blues, reds, browns and violets.

Pay careful attention to the edges of the clouds, making sure that they appear to blend naturally into the atmosphere; this can be achieved by blending WET-IN-WET, or by SCUMBLING the cloud colours over the sky colour, so that they melt softly together. Include a few hard edges for definition, otherwise the clouds tend to look like balls of cotton wool.

Another important point to remember is that the laws of perspective apply to clouds, just as they do to landscapes. Clouds appear to become smaller and closer together as they disappear towards the horizon; they also become cooler and more neutral in colour, and their forms soften.

Cumulus • Oil
This close-up shows the subtle range of hues to be found in 'white' clouds. The sky contains delicate hints of mauve, while the clouds are modelled with colourful greys mixed from pale blues, reds and yellows.

Cumulus • Pastel

Soft pastels are excellent for making quick sketches of fleeting cloud effects, thanks to their speed and readiness of handling. They also come in a wide range of delicate colours which need no pre-mixing, as with other media. In addition, tinted pastel paper serves as a useful middle tone, so that only the shadows and highlights are needed to create a full range of tones.

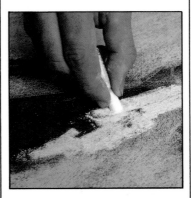

1 For this rapid study of rain clouds, the artist works on a dark-toned paper which provides a suitable undertone. The sky tone is blocked in first with cobalt blue, followed by clouds which are rendered in white, leaving the dark paper showing through in places.

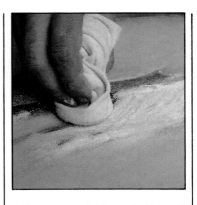

2 The sky area is blended with a soft rag to set the colour, then some of the sky colour is blended roughly into the clouds.

3 Streaks of cadmium yellow are drawn into the undersides of the clouds and blended with the fingertips to create a hazy effect.

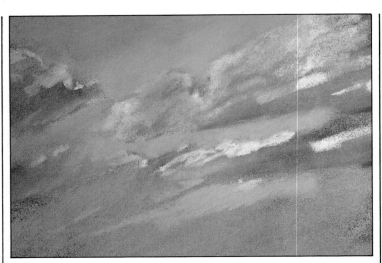

4 The sunlit areas of the clouds are now highlighted with thick strokes of white, and the sketch is complete. Positive marks contrast with softer passages in this picture, to create a feeling of movement and light.

Cumulus Cloud • Watercolour
Cloud shapes can change very quickly, and the fluidity of watercolour allows you to work with great spontaneity and achieve delightful, rapid effects.

1 The artist works on a stretched sheet of 200lb Bockingford paper, dampened with a sponge and clear water. He first lays a flat wash of cobalt blue for the sky, using a No. 8 Dalon brush. While the wash is still wet, a small natural sponge is used to lift out the cloud shapes.

2 This detail shows the artist using a soft round brush to make scumbled strokes at the edges of the clouds, to give a soft, ragged effect.

3 While the paper is still damp, a pale wash of Payne's grey and cadmium yellow is brushed into the lower, shadowed edge of the cloud, then softened and blended with clear water. The brush is rolled over the surface of the paper, suggesting the rhythm of the clouds and their heaped texture. When mixing the shadow colour, remember to allow for the fact that it will dry much lighter in tone than when wet. Only the brightest, sunlit tops of the clouds are left as bare white paper.

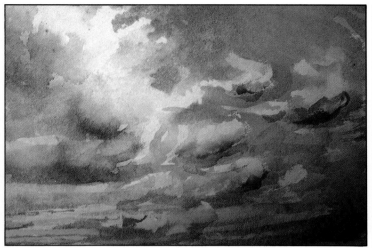

4 The finished effect. The upper part of the cloud is brighter and better defined than the lower part, which is darker and more ragged. The combination of warm and cool colours gives a rounded, three-dimensional feel to the clouds. Note, too, how the smaller clouds beneath give a suggestion of depth and perspective, and how the light scumbled strokes convey a sense of movement.

Fast-moving Clouds

A fluid, expressive medium such as watercolour is invaluable for making on-the-spot cloud studies, particularly on a breezy day when the clouds are moving fast. It is impossible to paint moving clouds with great accuracy, but that doesn't matter — the important thing is to use expressive brushstrokes which follow their movements and gestures.

The artist began by analysing the distinctive shapes and tones of these fracto-cumulus clouds, and then brushed them in as quickly as possible with loose, curving strokes. The beauty of watercolour is that you can push the colour around while it is still wet, flooding the paint in and lifting it out until you achieve the desired effect.

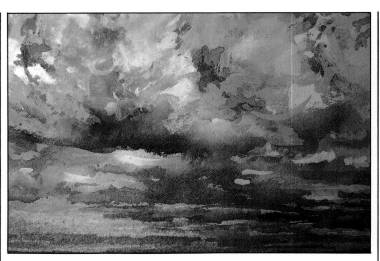

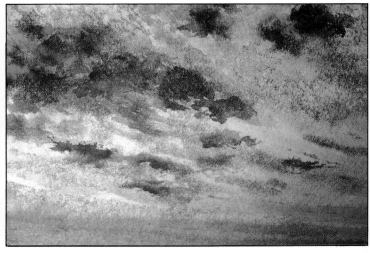

Storm clouds

For maximum dramatic effect, a stormy sky should take up roughly two-thirds of the picture space, with the land occupying the lower third. This allows you to give full rein to the swirling shapes of the clouds, which should be painted progressively smaller towards the horizon to heighten the feeling of tension.

Storm clouds give the artist plenty of scope for creative interpretation. Use a large brush and work WET-IN-WET, letting your brushstrokes follow the sweep of the windblown clouds. Model the cloudforms with warm and cool greys, mixed from various blues, yellows and earth colours — not black and white.

In this painting the artist uses vigorous diagonal and horizontal strokes to reflect the violent movement of the clouds as they are pushed by the wind. The impact of the clouds rushing towards us is accentuated by the strong perspective, which gives further depth to the scene: the shape of the cloud in the foreground advances forward, in contrast to the distant clouds, which are smaller, darker and less distinct.

SUNSETS

When painting sunsets and sunrises, the most common mistake is in piling on too many pinks, oranges and reds; this only results in the clichéd image often found on cheap postcards. The secret of success is to use your hot colours sparingly. Interwoven with the cool blues, greys and violets in the rest of the sky, and offset by a shadowy landscape, the warm hues will take on a subtle, translucent glow.

Exercise restraint with your brushwork, and be selective with your colours. It is tempting to put in every little streak of colour — and more — but the result is fussy and amateurish. It is far better to understate the patterns in the sky, thereby creating an air of mystery and calm.

Sunsets • Mixed Media

A cloudy sky at sunset is particularly striking. Because the sun is lower than the clouds, the undersides of the clouds are brilliantly lit while their tops are thrown into shadow. For the same reason, the brightest clouds are low in the sky, becoming darker farther away from the sun. In this Turneresque sky study the artist has used watercolour and gouache, the former for its transparency and the latter for its brilliance of colour.

First, the background sky colours were brushed in loosely, wet-in-wet with watercolour. Then small strokes and dabs of opaque gouache were touched in for the clouds and allowed to diffuse softly into the still-damp colours beneath. The appearance of bright, luminous colour is achieved by layering warm yellows, oranges and pinks with cool blues and greys which, by contrast, accentuate the warm colours.

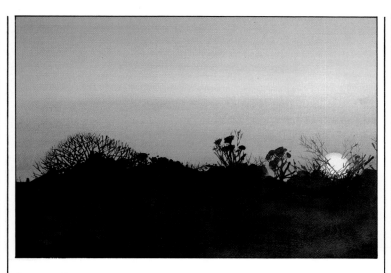

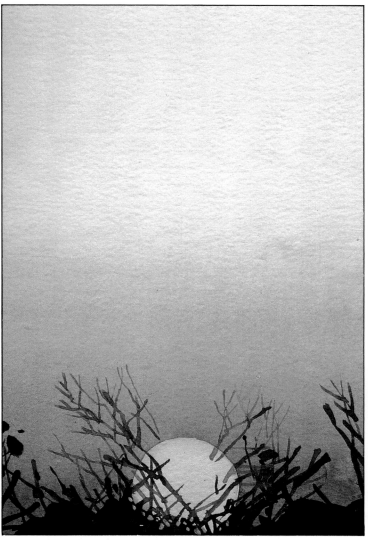

Sunset • Watercolour

In this painting, the artist uses delicate watercolour washes to describe the glowing, translucent quality of the sky at the point just before the sun sinks below the horizon. The dark silhouette of the landscape and trees helps to heighten the warm glow of the sky's colours.

The artist began by establishing the position of the horizon and the setting sun with very light pencil marks. He then used masking fluid to block out the round shape of the sun before painting the sky. When dry, the masking fluid would allow the sky washes to be brushed in freely, without the artist having to work carefully around the shape of the sun and possibly spoiling the clarity of the sky.

When the masking fluid had dried, the artist dampened the paper and covered the entire area with a graduated wash of colour for the sky. Ultramarine (a warm blue) was brushed across the top of the paper, then a pale tint of lemon yellow beneath it, and finally a mixture of alizarin crimson and lemon yellow near the horizon. Each band of colour was applied separately, leaving a narrow space between them. The colours spread outwards and melted softly into each other where they met on the damp paper, but without running out of control.

When the sky wash was completely dry, the artist brushed in a loose wash of ivory black for the foreground, lifting out colour here and there to create texture and tonal variety. Using the tip of a No. 2 brush, he then painted the delicate silhouettes of the trees against the sky.

This detail shows how the artist achieved the glowing effect of the sun sinking behind trees. When the painting was dry, the artist rubbed off the masking fluid from the sun, revealing a circle of untouched white paper. He then painted the outer rim of the sun with cadmium yellow, making the colour paler towards the middle and leaving the centre as white paper. This was left to dry, and finally calligraphic strokes of cadmium red and orange were used to describe the delicate tracery of branches against the sun.

STILL LIFE

Still life paintings often present a fascinating commentary on our lifestyles and can be a sort of potted social history. The Dutch masters of the sixteenth and seventeenth centuries, for example, were commissioned by merchants and other members of a growing middle class made rich by trade from the Dutch colonies. This contact with the East, and the consequent material wealth, is reflected in the magnificent still lifes painted at this time, which are crammed with exotic fruits and flowers, gorgeously embroidered cloths and shimmering silver and glass, all rendered in faultless detail.

Still life is an ideal subject for painting, because it contains myriads of possibilities for personal expression and interpretation. The objects we choose to paint reflect something about us, as does the way in which we arrange them and render them in paint: the artist may choose to focus on elements such as shape, texture and colour; or he or she may prefer to tell a story through a still life arrangement — for example, an open book or the remnants of a meal left on a table lend an air of mystery, as if someone has just left the scene for an instant.

Unlike landscape and figure painting, still life allows the artist to be in complete control. You have a virtually limitless choice of subject matter to begin with, and, provided you can set up your group where it won't be disturbed, you can spend as much time as you like on composing the arrangement and getting the lighting right. Working under these controlled conditions, you can study at leisure the effects of light and shade on objects, which will be of great value to you in other aspects of your painting.

When setting up a still life group, don't be tempted to include too much. A simple, carefully organized group will have far more impact than a motley assortment of objects in ill-matched colours. Choose just a few objects which you find visually pleasing and which have something in common: a collection of kitchen crockery with some vegetables, fruit and bread, for example. Above all, look for a variety of shapes, forms, colours and textures.

Your choice of background is important, too. Generally, a fairly neutral colour is best because this helps to throw the subject forward in the picture plane. But if the overall tone of the group is light, then use a contrasting dark colour for the background.

Having chosen your subject matter, the next step is to arrange the objects in a pleasing and harmonious way. It is worth taking the trouble to rearrange the elements several times, until you are satisfied with the composition of shapes and the overall balance of colours. Try to place objects so that some of them overlap, forming connections that lead the eye naturally into and around the whole composition. Move around the subject in order to find the angle which is visually the most exciting. You could also make a frame from stiff card, cut to the same proportions as those of your support, and hold it in front of the group so that at a glance you can see within it any pitfalls in the composition: make sure that no two objects in the group are of the same height, for instance. Look for a pleasing, flowing pattern of light and dark tones. Decide which object or area is to be the focal point of the piece, and ensure that it contains more light, colour or texture than the other areas. Normally, the most visually satisfying spot for the centre of interest is just right of centre, because the human eye instinctively reads a picture from left to right.

Another aspect which should be carefully considered is lighting. The way in which light moves through the picture helps to give it a feeling of depth and three-dimensional space. Choose a single source of light, preferably coming from the side, because this creates a clear pattern of lights and darks that help to explain forms. In addition, it casts shadows, the shapes of which serve to link up and unify the elements in the group.

Whether you choose natural daylight or artificial light is a matter of preference. Daylight will give you more realistic colours than artificial light, but it is not constant. Artificial light gives you the advantage of being able to alter its position or make it hard or soft, depending on your requirements. It is of course constant, but it does tend to affect the colours of objects, giving them a slightly yellow cast.

Unless you are painting ALLA PRIMA, the best way to begin the painting is by covering the support with a TONED GROUND in order to lose the stark whiteness of the support, which can be so intimidating. You can choose to use a neutral grey or earth colour, a colour close to the dominant

hue of the group, or its complement. For example, a warm orange undertone beneath a painting which is predominantly blue creates a shimmering effect when the undertone is allowed to shine through in places. This can then be followed by a monochrome UNDERPAINTING, which establishes the tonal pattern of the arrangement and gives you a strong base from which to work when adding colour.

As you paint, you should constantly compare tone with tone, colour with colour, and be aware of spatial relationships between objects. Try not to paint objects in isolation: work back and forth between the background and the still life elements, bringing the entire painting along at once. Work from the general to the particular, leaving highlights and details till last. In this way, your finished painting will have harmony and unity, and a sense of space and air.

FLOWERS

When painting flowers in a still life arrangement, do not go for photographic realism, but try to capture the essential characteristics of the various blooms; the rich, velvety texture of roses; the simple, classical grace of tulips; the intense colours of anemones. Because flowers are so lovely to look at, it is hard to restrain the urge to paint every detail lovingly. This is a dangerous trap to fall into, because the resultant painting begins to look like a botanical study. Your concern, as an artist, is to create a living picture, to convey an impression of depth, mystery and transience, emphasizing the subtle effects of light on the subject.

Detailed over-emphasis of every leaf, bud and blossom leads to confusion, making the flowers look hard and brittle instead of soft and graceful. In addition, the three-dimensional appearance of the image is lost.

When we look at a profusion of flowers, our eyes can only focus on one area at a time — the outer edges of our vision are comparatively blurred. Aim to convey this effect in your painting through the interplay of hard and soft edges, bright and muted colours, and dark and light tones. Observe the group carefully and pick out the one or two flowers which receive the most light and emphasize these with bright, clear colours and crisp edges. Allow the rest of the flowers to fade gradually into the background by softening their edges and muting their colours, particularly in those that are near the back of the group: these soft colours and tones make the bright spots appear even more vibrant by contrast. In addition, the flower group will have a feeling of roundness and three-dimensionality, rather than appearing as a flat pattern.

When arranging flowers in a still life painting, remember that they should look fresh and natural. Keep the arrangement natural and avoid symmetry. Formal and stylized floral arrangements do have their place — but not in a painting. Somehow, they strike a false note, whereas a simple, even haphazard, grouping looks natural and spontaneous.

A well thought out composition is important. Arrange the blooms so that they overlap each other and face in different directions. Include profile views of flowers and add variety by introducing some flowers in the bud stage. Greenery is important, too, in enhancing the colours of the blooms and providing dark, shadowy tones that give a three-dimensional feel.

Unless you specifically want the container that holds the flowers to be an integral part of the still life arrangement, it is best to underplay it by partially obscuring it with overhanging blooms and foliage. If the vase is on display, it should complement the flowers in colour, shape and pattern. Ideally, it should contrast tonally with the overall colour of the flowers, and be smaller in size than the floral arrangement.

Flowers • Acrylic

Tulips make an excellent painting subject, because their simple forms are rendered easily in terms of light and dark tones. Here the artist uses acrylic paint, which can be applied to the canvas like oil paint but dries much more quickly, allowing layers of colour to be built up one on top of the other.

1 This picture shows how the artist has outlined the main elements of the composition with blocks of flat colour. The neutral greys and blacks of the background are painted first, and allowed to dry. Then the vase is painted with a dark mixture of ultramarine, cobalt blue and ivory black, with touches of ultramarine and titanium white for the highlights. The stems and leaves are painted in three tones of green, mixed from chromium oxide, ultramarine and white. Finally the tulip heads are painted in various tones of yellow, mixed from cadmium yellow pale, yellow oxide and titanium white. The paint is well diluted with medium, and the flowers are developed from light to dark, each tone being completed in flat patches of colour.

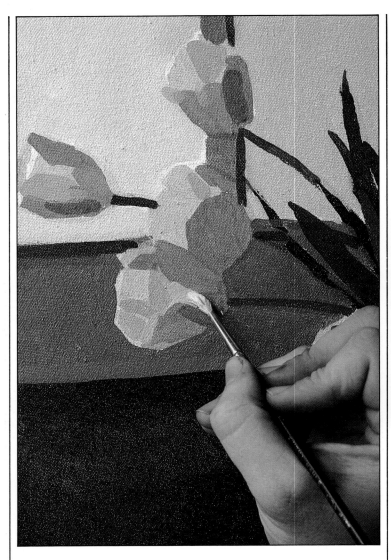

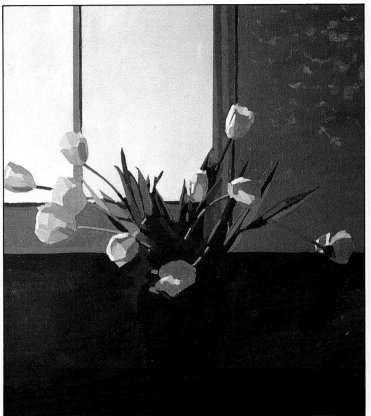

2 This close-up shows how the clear 'blocks' of colour and tone create a sense of three-dimensional form and establish the direction of the light source. With the main shapes and tones in place, the artist now begins to add the bright highlights that make the picture 'sing'.

3 The lightest tones in the leaves and stems are painted with chromium oxide, titanium white and a touch of cadmium yellow pale, and the warm, bright highlights on the flowers with cadmium yellow pale and white.

Notice how the artist has paid careful attention to the composition of this picture. The background is divided into the straight geometric shapes of the wall and window, which provide a contrasting setting for the organic forms of the flowers. The cool, neutral colour of the background also helps to emphasize the brilliant yellows of the flowers. The window provides a strong light source, from above and slightly to the right, which creates interesting patterns of light and shade on the flowers and highlights the luminosity and transparency of the flowers.

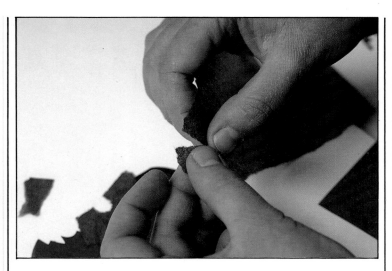

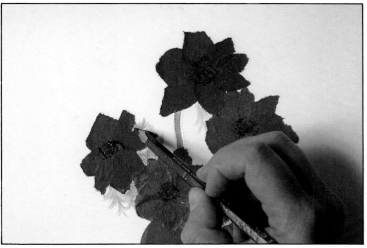

Flowers • Collage

1 The bright colours of anemones are perfect for a tissue paper collage. Here the artist tears the red tissue paper to create the flower petals. Torn edges are always much better than cut ones for natural subjects like flowers.

4 Two coloured pencils are used to draw in the different tones on leaves and stems. The pale feathery quality of the leaves contrasts well with the strong, bold, simple shapes of the rest of the subject.

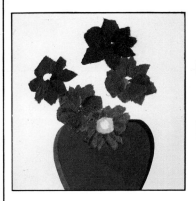

2 You can get richer tones in the petals if you overlap the pieces of tissue paper as shown here. The shadows on the petals can be conveyed in this way too.

3 Once the shapes of the main flowers are put in place, the artist uses coloured pencils to draw in the centres of the flowers.

Flowers • Different approaches
There are many different ways of starting a painting — three of the most useful ones are demonstrated here.

2 Simplify the colours in the subject so that you use three basic tones in each pigment. Here you can see that the tulips were painted in a light, medium and dark red.

1 Having sketched in the outline, use a neutral tone to fill in the areas of dark and light before adding any colour.

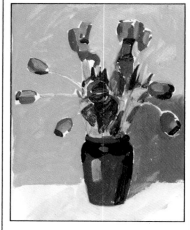

3 Begin by filling in the main areas of local colour, leaving the finer details until later.

Flowers • Oil
1 The artist began painting with two layers of acrylic and then developed the subject further in oils. To begin with the basic tones of the flowers were blocked in, and then the details were added. The paint is thicker on the flowers because more work was involved. Remember to begin by painting thin layers. If the first layer is too thick it will be difficult to add subsequent layers because they will take a long time to dry.

2 Here the artist is adding the details of the petals. With diluted white paint he paints the design on the vase.

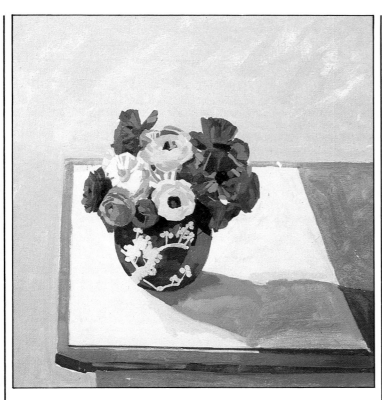

3 The artist continues to work on the flowers, defining and redefining the different forms. The whole composition is unified by means of the overlapping layers of colour.

Flowers • Watercolour
1 After a pale lemon yellow wash has been laid on the petals, a stronger yellow wash is added to the flower centres. Because the first wash is not completely dry the yellow bleeds outwards and into the petals.

2 Always mix watercolour in a white palette so that you can judge the true colour before using it.

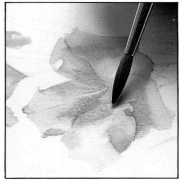

3 Building up washes in watercolour requires skill. The most successful way is to allow the first wash to dry slightly, and then add the second — the two colours should then blend. If you let the first wash dry completely, you will be left with hard edges and if you apply the paint wet-into-wet you don't have as much control over the result.

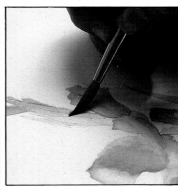

4 The artist laid a wash of olive green on the leaves and stem, and then added Hooker's green to the dark areas.

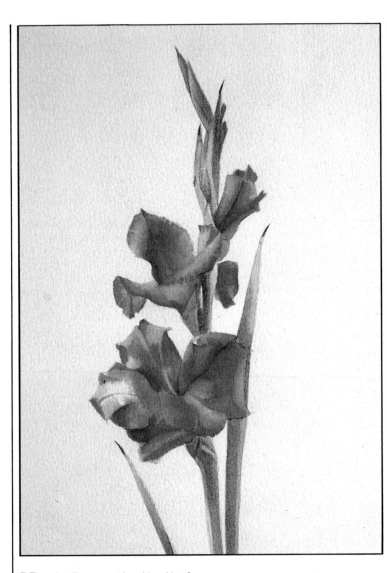

5 Fine details are put in with a No. 6 sable brush once the washes were absolutely dry.

The finished picture is exceptionally delicate in tone and texture. The artist used a No. 5 sable for all the work and limited his palette to four pigments.

FRUIT AND VEGETABLES

Fruits and vegetables are always popular in still life arrangements. Not only do they have fascinating surface textures, but their colours and shapes can be all-important in lending balance to the composition. For example, a painting which is light in tone overall can be given just the right amount of contrast by the addition of a bunch of black grapes; alternatively dramatic chiaroscuro effects can be achieved by introducing pale, luminous green grapes or pieces of lemon into a dark painting.

As with flowers, fruits and vegetables look best when they are not forced into a rigid arrangement. Try to place them so that they appear to have just spilled out of a basket, and introduce variety by including pieces of cut fruit or vegetables such as onions and cabbages, chopped in half to reveal their inner patterns.

Beginners often make the mistake of rendering shadows by adding black to make a darker version of the local colour of the object. In fact, colours become cooler as they turn into shadow, and contain elements of their complementary colour. For example, the shadow side of an orange will contain a hint of its complementary colour, violet. In addition, shadows often contain subtle nuances of reflected light picked up from nearby objects.

Highlights, too, are worth close scrutiny. Even the brightest highlight on a shiny apple is rarely pure white. If the prevailing light is cool, the highlight might contain a hint of blue; if the light is warm, the highlight may have a faint of tinge of yellow. By paying attention to such details, your paintings will take on a greater feeling of light and form.

Apples • Watercolour

Here is another simple watercolour study, in which the artist uses transparent washes and glazes to model the form of the apples and bring out their luscious texture.

1 With a mixture of sap green and cadmium yellow, the artist blocks in the overall shapes of the apples on damp paper. This is allowed to dry before moving on to the next stage.

2 Working wet-in-wet, the artist brushes in mixtures of sap green and brown madder alizarin to build up form and colour, leaving small areas of the pale underwash to create highlights.

Lemons • Watercolour
A still life set-up does not have to be elaborate. Try making a simple study of fruits which have attracted you because of their shape, colour or texture, as the artist has done here.

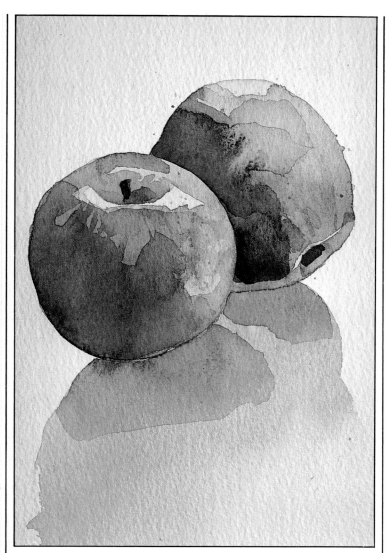

1 Working on a sheet of 140lb Not paper, the artist begins by rubbing the highlighted areas of the lemons with a wax candle. This is done lightly, so that the wax settles on the high points only of the paper.

2 Using a round No. 4 brush, the artist paints the lemons with a diluted wash of cadmium yellow (this colour should be mixed to quite a strong tone, because it dries much paler). The waxed areas resist most of the paint, which settles into the dents of the paper's surface. When dry, the result is a texture which resembles the pitted texture of lemon skin.

3 The reds and greens are strengthened further with transparent glazes, and the artist follows the contours of the apples with his brushstrokes. In places the colour dries with a hard edge. This gives the impression of the crisply modelled form of an apple, which differs from the smooth roundness of an orange or a peach. When the apples are complete, the stalks are painted with raw sienna and a touch of ultramarine.

Finally, the cast shadows of the apples are painted with washes and glazes of indigo and purple madder alizarin. A clean damp brush is used to soften the shadows so that they don't look too harsh. This also gives an impression that the apples are sitting on a shiny surface.

3 When the first wash is dry the artist applies the mid-tones with a wash of cadmium yellow, cadmium orange, and a touch of ivory black, leaving the highlighted areas pale. The mid-tone colour is applied loosely and blotted lightly in places with a tissue to give an interesting variety of tone and texture.

4 A little more cadmium orange and ivory black is added to the mid-tone mixture and used to block in the darkest tones.

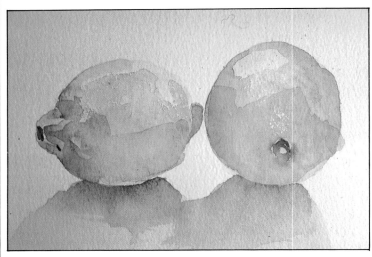

5 The cast shadows are painted with washes and glazes of Payne's grey and indigo. Notice how the shadows are darker and sharper close to the subject, becoming paler and more diffused as they move outwards; this is achieved by fading out the colour with a clean damp brush.

The finished painting has a clarity and freshness which is entirely appropriate to the subject, and the wax resist technique has created perfectly the texture of the lemon skins, which would be very difficult to achieve by any other means.

Melon • Pastel

In some cases, a far more interesting result is achieved by cutting a fruit or a vegetable into segments to reveal the fascinating textures and patterns of the flesh and pips inside. The artist uses pastel and graphite pencil in this study of a cut segment of melon.

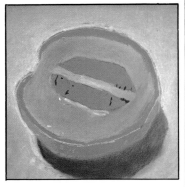

1 Working on a smooth paper, the artist blocks in the overall shape of the melon, using lizard green, lemon yellow and cadmium red. The colours are applied thickly and blended quite smoothly.

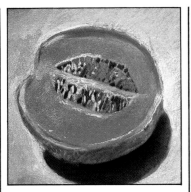

2 Next, the colours of the flesh and skin are consolidated with light scumbles of colour to bring out the three-dimensional form, and the cast shadow is strengthened with lizard green and black. Then the artist uses orange, red, white and yellow pastels, sharpened to a point, to indicate the melon pips.

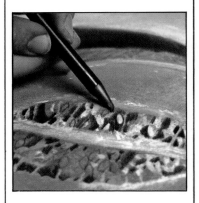

3 This close-up shows the artist using a graphite pencil to create dark accents around the melon pips.

Onions • Acrylic

Onions are a favourite element of still life paintings, with their glowing colours and papery textured skins.

1 Working on a fine canvas board, the artist begins to render the form of the onions with simple blocks of colour. The colours used are raw umber, naphthol red, yellow ochre and titanium white. More raw umber is used for the dark tones, and titanium white for the light tones.

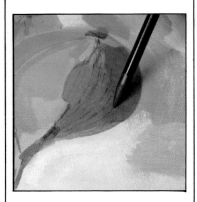

2 When the colours are dry, the artist uses a graphite pencil to draw in the dark veins of the onion skins, which also emphasize the bulbous forms of the onions.

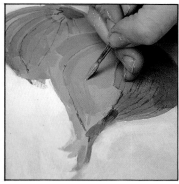

3 With a No. 4 sable brush, the artist now paints in the green parts of the onions with a mix of chromium oxide green and titanium white.

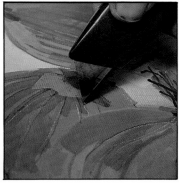

4 When the painting is dry, the artist uses a sharp craft knife to scratch out a few silvery lines in the onion skins.

5 Finally, a few dark accents are added with raw umber and ivory black.

GLASS OBJECTS

Clear glass takes on the colours of objects surrounding it. When painting glass vases, bottles, or other reflective objects in a still life, always indicate the background colours first, being careful to record any distortions of shape reflected in the object. The glass object can then be painted over the background.

The actual painting of glass involves, as Michelangelo put it, 'stupidly copying everything'. Take time to observe the subtle tonal variations between the highlights, mid-tones and shadows, their colours and their shapes which follow the form of the glass object. Then record them faithfully, but not too mechanically. Painting clear glass is much like painting water — less detail says more. Under certain lighting conditions, a clear bottle or glass will contain myriads of reflections and highlights, but painting them all would detract from the transparent appearance of the subject. Paint only those tones and highlights that matter, and keep your lines sharp and crisp, with a minimum of blending and refinements.

On the subject of highlights, remember that it is very rare to find a highlight which is pure white: always modify your white paint with a hint of the local colour of the object that is reflected.

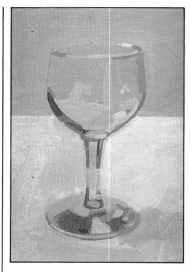

Glass • Acrylic

1 Because glass is clear, the artist must begin first of all with the background tones, rather than painting the object and background together. The artist uses ivory black and titanium white with a touch of cobalt blue for the background, varying the tones by adding more white in the lower section of the canvas.

Next, he draws in the shape of the glass clearly but lightly, using a light mixture of ultramarine painted with a No. 2 sable brush. The lines, and the ellipse of the mouth of the glass, must be accurate. It is often a good idea to leave the painting for ten minutes or so — when you come back to it, any lines out of true will be immediately obvious.

The darks, mid-tones and lights of the glass itself are blocked in next, keeping some edges crisp and others soft. The colours used are cobalt blue, titanium white, and Payne's grey. It is important not to overwork this stage — just a hint of tone is all that is required to separate the glass from the background.

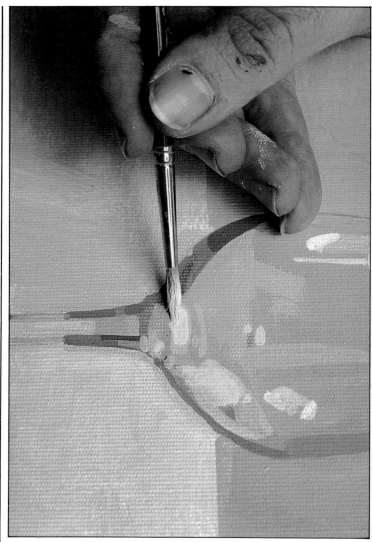

2 The next step is to add small touches of highlight, which make the glass appear to sparkle. Using a No. 6 sable brush, the artist picks up a small amount of titanium white and paints vertical lines down the side of the glass as well as on the rim. These are the brightest highlights — the lesser highlights are painted with mixtures of titanium white and raw umber, with brushstrokes that follow the curves of the glass and stem.

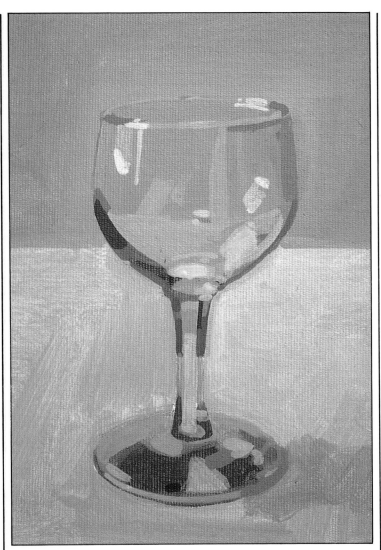

SHINY METAL OBJECTS

The attractive shine of metal containers — everything from copper kettles to aluminium saucepans — makes them a favourite still life subject, but they are quite a challenge to paint. The secret lies in close observation of tone, colour and shape, and in not overworking the subject.

If metal objects are included in your still life, try not to have too much overhead light, which causes a confusion of shadows, reflections and highlights. Choose instead a strong sidelight which emphasizes three-dimensional form while creating relatively simple shadows and highlights.

EARTHENWARE

Earthenware bowls, jugs and vases often come in delightful shapes and lend grace to any still life painting. As with glass, painting glazed earthenware is a matter of recording tonal variations and knowing how to render discreet highlights.

Unglazed earthenware pots are equally attractive, their warm terracotta colour blending harmoniously with any plants and flowers included in the still life.

Earthenware • Acrylic
1 In this painting the artist decided to re-use an old canvas, and painted over it by laying in the main colours with a painting knife. This method of application creates a rough texture in the paint, reminiscent of earthenware.

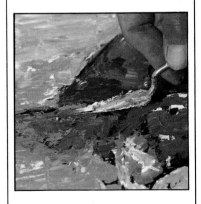

2 The paint was laid on thickly, brown and sap green scraped over yellow ochre for the shaded part of the jug.

3 The artist adds a cast shadow to the background tone with a mixture of titanium white and ivory black. The feeling of transparency in the glass is achieved by keeping the details strong and simple, and allowing just a few shimmering highlights to tell the story.

3 The unfinished roughness of the painting provides wonderful textures, which are ideal for such subject matter.

Earthenware • Oil

The smooth, glossy finish of glazed earthenware, and shiny metal gives tones that graduate from light to dark with very subtle changes. The artist chose to use oil paint for this study of earthenware pots: the creamy consistency and slow drying time of oils allows you to manipulate the paint on the surface as much as you like in order to achieve smooth gradations of tone. However, it is best to avoid overblending, because this creates rather a static effect. Notice how the artist has used lively brushwork to animate the picture surface here, without losing the illusion of roundness of form.

This detail shows the artist painting the mouth of the large pot with a mixture of burnt umber and ivory black. The paint is kept thin, and with a subtle variety of tone, so that the shadow appears luminous and full of reflected light.

Here, the lightest tone is applied in a thicker impasto which makes the bright highlight stand out.

Earthenware • Watercolour
For the terracotta pot here the artist made full use of the technique of applying watercolour wet-into-wet. A lot of water has been used with the paint enabling the terracotta, Payne's grey and ultramarine to bleed into each other. The paper has been left white for the highlights.

CLOTH

Contrary to what some beginner painters think, folded drapery is not an obligatory element of *every* still life. Nevertheless, a softly draped piece of cloth does serve many useful purposes. It offers an interesting textural contrast to the other objects included in the group, and the lines and folds can be an important compositional element, creating visual direction within the picture.

A plain fabric can be chosen to contrast with the busy patterns of flowers, vases and other objects in the group, providing a welcome 'breathing space' for the viewer's eye. Alternatively, choose a patterned fabric if you wish to add interest to a more simple arrangement.

If you do include drapery in your still life, try to make the folds look natural and uncontrived. The lines of the folds should help to guide the viewer through the composition, without looking like busy tramlines.

If the background drapery is to take up a large area, give careful consideration to its colour, because this will affect the overall colour harmony of the group. Tone is important, too: if the tone of the drapery is too similar to that of the objects in front of it, the finished painting will look monotonous and lack 'punch'. It is useful to have several lengths of fabric on hand, in both light and dark colours, and to try out different ones with your still life group in order to compare their effects.

Some artists enjoy painting fabric folds and find it absorbing. Others find it frustrating, because the forms are difficult to define. Before you start painting, it is often a good idea to make a sketch of the fabric, blocking in the dark tones and mid-tones with charcoal or soft pencil and leaving the white

of the paper for highlights. This will give you a clearer idea of the pattern of the folds, making them easier to cope with when you come to paint them.

Patterned fabrics may at first glance seem even more complicated, but in fact the pattern is usually helpful in describing the way the fabric lies (stripes and checks are especially effective).

The best way to paint complicated folds in patterned fabric is to take small sections at a time and describe how the pattern runs in different directions within each section. Observe how the light falls on the fabric, painting the highlighted areas in a lighter tone than those in shadow. In addition, vary the pressure of your brushstrokes to create a combination of hard and soft lines which convey a sense of movement.

Folded Cloth

When painting complicated folds in a piece of white cloth, the secret is to exaggerate the warm and cool shadow tones slightly so that the white highlights sing out more clearly. For the sake of clarity, adopt a systematic approach: before you begin painting, look at the subject through half-closed eyes and pick out just four or five main tones (making a monochrome sketch will also help). Then mix up colours on your palette to correspond with these tones, and you are ready to begin.

1 In this oil study, the artist begins by toning the canvas with a thin layer of raw sienna so that the tones of white can be judged more easily. When the toned ground is dry the artist draws in the main folds and areas of tone in the cloth with a flat No. 6 brush and well diluted raw umber. He then makes a loose underpainting to establish the darks, mid-tones and lights: raw umber is used for the darks, ultramarine and titanium white for the mid-tones, and titanium white alone for the lights. The underpainting helps the artist to see how the overall picture will look. At this point, any corrections or alterations can be made quite easily because the paint is thin.

2 The artist now applies a loose wash of ultramarine and titanium white in the background, allowing the neutral tone of the underpainting to show through. Using the underpainting as a guide, he now begins building up the tones in the cloth with thicker paint.

3 This detail shows how the artist has used crisply defined strokes and thick paint for the highlighted parts of the folds, to make them stand out, while the shadows are thinner and less well-defined to make them recede.

4 The finished painting. By working in a methodical way — starting with an underpainting and gradually refining and sharpening the details — the artist has arrived at a clear, uncluttered statement.

Folded cloth • Oil

1 Use masking tape for making clean lines for the edge of the cloth. Allow the paint to dry and then peel away the tape carefully.

2 When painting a checked cloth like this, use a small sable brush to block in the areas of black carefully. For the shadows use a light grey and for the white checks just let the canvas show through.

Patterned cloth • Acrylic

1 The artist decided to paint the quilt without drawing outlines. He applied broad strokes of paint next to each other, with decorator's brushes, and reduced the pattern to approximate colours.

2 The shape of the bed is described by the square patches rather than by light and shade. The paint is applied thinly so that each area can be developed as the picture progresses.

3 In the final painting, the artist has added further streaks and dots of colour on top of the broad areas of flat colour, making the surface more interesting.

Patterned Cloth • Watercolour
In this painting the artist uses thin glazes of watercolour to give form and substance to the folds of the fabric.

1 Using a chisel brush and a pale wash of ivory black, the artist begins to define the checked pattern of the cloth. The folds and twists in the fabric are indicated by the direction of the lines in the pattern.

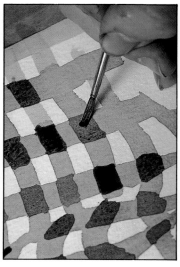

2 When the first washes are dry the artist blocks in the darker squares with a small sable brush and a darker tone of ivory black.

3 When the painting is completely dry, the artist works back into the cloth with a transparent mid-tone of ivory black, creating shadows in the cloth and strengthening the light and dark contrasts.

4 The completed painting. Notice how the black squares in the pattern of the cloth are correspondingly darker in the shadowed areas than in the lighter areas.

WATER

Water is one of the most complex and beautiful sights in nature, and presents the artist with a never-ending source of inspiration. It can be calm and still, as in lakes and quiet rivers with their smooth, mirror-like reflections, inviting contemplation; there is the rushing water of streams and brooks, tumbling over rocks and weirs; there is also the drama of 'white' water, seen in waterfalls and the hissing foam of crashing waves.

Water, like the sky, is an elusive subject, being constantly on the move: highlights and shadows appear and disappear; colours change; waves break and re-form before you even have a chance to put brush to canvas. The basic problem is how to pin down all this action and create a convincing image of it without losing the inherent sense of movement and spontaneity that makes it such an attractive subject in the first place. Don't try to 'freeze' the motion, or render it with photographic precision, but allow a few, carefully placed brushstrokes to convey a general impression of movement and fluidity. Water often contains myriad reflections and highlights, but if you try to paint them all the effect will be merely that of a patterned carpet. Always paint broadly and with a minimum of detail. The more decisively and simply you paint water, the wetter it looks.

Learn to harness the particular qualities of your chosen medium to depict the character of your subject. Oil and acrylic paints, for example, have a certain strength which suits the ruggedness of a stormy seascape. Watercolour and pastel, on the other hand, allow for a swift, spontaneous response to the feeling of light and running water.

Water is usually thought of as being blue, but in fact it is virtually colourless in itself, acquiring its colours from the prevailing light in the sky and from its surroundings. Thus, the sea on a calm day will reflect the blue of the sky, whereas on a stormy day it may look brown-green. Seen at a distance, a river might reflect the cool grey of the sky, but seen at close range in the depths of a wood, it will reflect the dark greens of the nearby trees that obscure much of the light in the sky. In addition, algae, weeds and sediment present in the water itself can add unexpected touches of greens, browns and ochres.

FAST WATER

Painting fast-flowing water demands a keen eye and a sure hand. Once again, the trick is not to be overwhelmed by the apparent complexity of shadows and highlights. Look at the water through half-closed eyes and pick out the most obvious ripples and wavelets. Paint only these, with swift, decisive strokes.

To paint the rushing, white water of rapids and waterfalls, let the action of your brush suggest detail and movement. A few curving drybrush strokes, not too laboured, are all that is needed to create an impression of water falling downward. Using a rough-textured paper or canvas helps, because the raised tooth of the surface catches and drags at the paint.

Moving Water • Oils

The patterns of waves, ripples and reflections in water are a never-ending subject for study. It is a good idea to carry a sketchbook with you so that you can make on-the-spot studies of the form, direction and movement of water in different situations and weather conditions.

Here the artist is making a rapid oil sketch of the surface of a lake on a breezy day, when the water is ruffled by the wind and breaks up into tiny wavelets.

1 Using a No. 4 flat bristle brush, the artist paints the dark ripples with curving strokes of Payne's grey and ultramarine.

2 With a mixture of ultramarine and white, criss-cross strokes are now blocked in for the lighter ripples, and the ruffled white highlights are put in last.

3 The paint is allowed to dry for about 15 minutes, then the artist blends the colours a little by brushing over the surface very lightly with a 2.5cm (1-inch) decorator's brush.

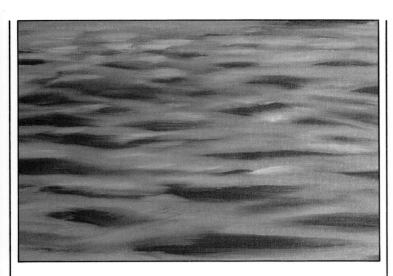

4 The finished study captures the impression of moving water which reflects the grey sky above.

Moving Water • Watercolour

A river view which includes a weir or a waterfall offers the artist an opportunity to practise rendering different types of water: the smooth, glassy surface of the calm water upstream, the tumbling white water of the waterfall itself, and the complex ripples and eddies of the water churned up beneath the waterfall. With a subject like this the main pitfall is including too much detail, so that the painting becomes fussy and the fresh, moist feeling is lost: it is essential to select the most significant lines of motion and leave out the rest.

For this painting of a woodland river, the artist has chosen watercolour as his medium. Watercolour has a unique transparency and freshness which is ideally suited to painting water.

Painting rushing water in watercolour is especially challenging, however, because you can't pile on thick layers of paint to represent churning foam, as you can in oils or acrylics. In this respect, watercolour is an excellent medium with which to practise developing a simple, restrained approach to painting water.

1 Working on a sheet of 200lb Bockingford paper, the artist begins by indicating the dark tones in the water with a pale wash of ultramarine applied with a No. 6 sable brush. The strokes are made smoothly and decisively, leaving areas of white paper for the highlights on the water.

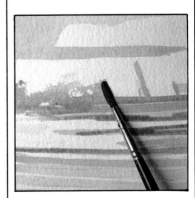

2 At the base of the waterfall, the colour is applied thinly in loose, scumbled strokes with the side of the brush to create the effect of churning water.

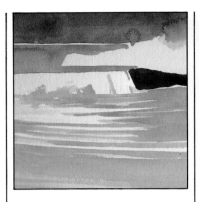

3 A dark wash of Hooker's green is now brushed in to establish the trees on the bank of the river in the background. Beneath this, a thin strip of white paper is left to indicate a sparkling highlight on the distant water. Then the smooth expanse of water above the waterfall is painted with ultramarine and Hooker's green, mixed wet-in-wet.

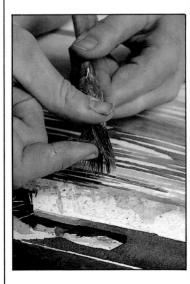

4 Using a stiff bristle brush, the artist spatters a pale mixture of ivory black and Hooker's green across the base of the waterfall to give the effect of spray and foam being tossed in the air.

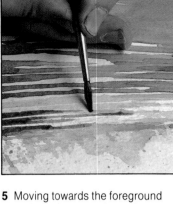

5 Moving towards the foreground now, the artist strengthens the colour of the ripples in the water, which reflects some of the dark greens of the foliage overhanging the river bank. The ripples are painted with Payne's grey, Hooker's green and ultramarine, with the tones becoming progressively lighter towards the foreground.

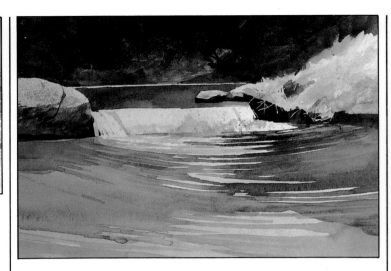

6 Taking a soft brush moistened with clean water, the artist now softens and blurs the colours in the foreground water to show how the ripples dissipate as they move out from the waterfall. Finally, the background trees are developed with mixtures of sap green, Hooker's green and ivory black. A little gum arabic is added to stiffen the paint slightly, allowing the artist to push the colour around with scumbled strokes. When dry, they leave a delightful impression of dappled sunlight filtering through the trees.

The cool, clear water has been rendered very simply, yet it looks real enough to touch! Notice also how a sense of perspective is retained by making the ripples darker and closer together in the distance.

REFLECTIONS

There is something pictorially satisfying about a smooth body of water reflecting the landscape lining its banks. Trees, buildings, bridges and mountains, and their soft reflections in the water, present a balanced and unified image which is always pleasing to the eye.

The best way to understand reflections, in order to paint them convincingly, is to find a stretch of calm water and try to observe the differences and similarities between an object and its image in the water. For example, you will notice that the reflection of a light object is always slightly darker than the object itself. Similarly, dark objects appear lighter when reflected, because of the water's light-reflecting properties.

Anything which leans at an angle, whether in the water or at its edge, will cast a reflection at the same angle. However, objects which are slanted away from you cast a reflection which appears shorter than the object, while objects slanted towards you appear to have a longer reflection.

The real complications set in when the water's surface is broken up by undercurrents, or ruffled by a breeze. These ripples have the effect of breaking up the image so that it wavers and appears distorted. Broken reflections appear longer than reflections in calm water. Indeed, the reflections of tall buildings and trees sometimes appear many times longer than the height of the actual object.

When painting reflections, it is important to bear in mind that they appear to go straight down into the water. Unlike shadows, they don't appear to come nearer to us, so pay attention to the shape of the reflection — if you paint it wider at the bottom when it should be straight, it won't look like a reflection at all.

Broken reflections often look complicated, but rather than trying to copy every detail, it is better to simplify the patterns. A few well-placed wiggly strokes, painted with a soft, round brush, are all that is needed to convey the smooth, undulating surface of the water.

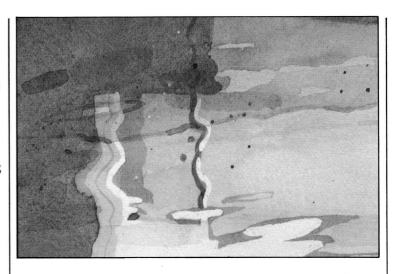

Even the calmest water can be disturbed by ripples or swells, or the movement of boats on the surface. When this happens, reflections become elongated and distorted and form fascinating abstract patterns which are worth studying. This is one area where a camera can be useful for 'freezing' the pattern of moving reflections, enabling you to study them more closely.

In this watercolour study, the artist was fascinated by the distorted reflections of the prow of a boat and its mast, criss-crossed by the horizontal ripples on the water's surface.

SEA

The rough sea crashing against a rock-strewn shore is an exhilarating sight to witness, but trying to capture its power and energy on a small piece of paper or canvas does represent a very real challenge. However, if you can rid yourself of the idea of trying to 'copy' nature, and aim instead to capture an overall impression of the scene, you will find it less frustrating and more rewarding.

An energetic subject like the sea is best painted on location, in the ALLA PRIMA style. If you can hear the roar of the sea and sniff the salt air, you are more likely to enter into the spirit of your subject than if you are painting in the calm of the studio. Before you begin painting, take the time to sit down and watch the waves. Although they are constantly moving and changing, you will be able to see a definite pattern of movement emerging. If you look long enough and hard enough, you will recognize the essential shapes and be able to paint them virtually from memory.

To paint waves convincingly, it helps if you understand how they are formed. On a calm day, a wave travels through the open sea with a smooth, undulating motion. As it gets nearer to the coast, the lower part of the wave is slowed down by the land rising underneath it, but the top part of the wave continues at its original speed — eventually falling over itself and crashing down onto the shore. The white foam is caused by the aeration of the water. The action of the wave is finally stopped by the shore, and it reverses direction. Where this water meets the next incoming wave head-on the churning action causes further aeration, resulting in a swirling mass of foam.

When painting the action of the sea, imitate the movements with your brushstrokes. For example, hold the brush loosely and far back on the handle to create loose, casual strokes that suggest liquid movement; use long, horizontal strokes of fluid paint for the distant waves which appear less and less distinct as they approach the horizon. To suggest choppy waves far out at sea you could use a soft, round brush to make curving, arclike strokes. In the foreground, where all the action is taking place, use vigorous brushwork; downward strokes convey the power of a wave crashing down, whereas upward strokes indicate flying spray.

In opaque media, SCUMBLING, DRYBRUSH and IMPASTO are very effective in portraying white foam, as are STIPPLING and SPATTERING. Watercolour is a little more difficult to use for this subject because you first have to leave white shapes for the foam and then model the tones within the foam afterwards.

Pay careful attention to colours when painting the sea. The foam of breakers, for instance, may look white at first glance, but it may in fact contain subtle hints of gold and pink reflected from the evening sunlight, or it may appear quite grey in stormy weather.

Depending on the weather and the prevailing light, the overall colour of the sea may be blue, blue-green, grey or even brown. Whatever the colour, do not paint it with an even monotone — introduce subtle variations of colour, and alternate dark and light tones to suggest the movement of the water's surface.

Sea • Oil

The drama of foam crashing and bursting against a rock is a fascinating subject, and is the theme of this oil study. When painting a subject like moving water, it is often helpful to use a viewfinder, cut from a piece of grey card, to isolate the main action. Using a camera also helps, though photographs should be used only as an adjunct to your studies, made direct from the subject.

1 Working quickly in the alla prima style, the artist covers the entire canvas with a toned ground of titanium white mixed with a trace of Prussian blue. Using a 1.75cm (½-inch) decorator's brush, he applies the paint thinly and in curving, arc-like sweeps, which will later help to accentuate the sense of dynamic movement in the foam burst.

The sea is quickly painted with mixtures of Prussian blue, Hooker's green and cadmium yellow, applied with vigorous, broken strokes which suggest the choppy movement of the waves.

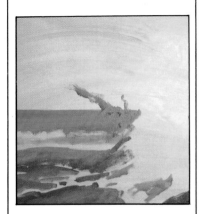

2 The shape and form of the foam burst are now developed. Titanium white is mixed with a little medium to a thick, creamy consistency and applied with heavy impasto strokes, particularly at the base of the wave. Using the 1.75cm (½-inch) decorator's brush, the artist scumbles the colour quickly so that it blends partially with the cool undertone. This gives a sense of volume to the foam burst by indicating areas of light and shade.

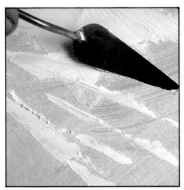

3 Now the artist uses the edge of a painting knife to lay in long, broken strokes of titanium white at the upper edge of the foam burst. These strokes of solid, creamy colour create a dramatic outline against the sky and heighten the impression of the great forces with which the foam splashes upwards.

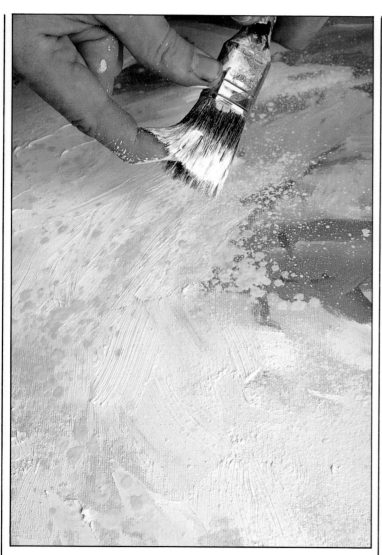

5 The completed picture gives a thrilling impression of the explosive forces of nature. Heavy impasto and bold, vigorous brushstrokes are used in the point of impact — the lower area of the foam, where there is more weight and density. The outer edges of the foam are dispersed by the wind and become more translucent, blending into the surrounding atmosphere. This contrast of sharp and blurred passages gives movement and atmosphere to the painting.

4 The decorator's brush is used to spatter titanium white across the shape of the foam burst to imply broken flecks of foam and further emphasize the directional movement of the wave.

Sea • Oil
1 Working alla prima the artist blocks in the areas of colour on top of a charcoal sketch with a No. 4 bristle brush.

3 The dark tones are deepened with Prussian blue and burnt umber; the lighter areas are developed with mixtures of cadmium yellow, ochre, red and purple.

5 Finally, highlights in cadmium yellow and white are added to the water's surface leaving the underpainting to shine through.

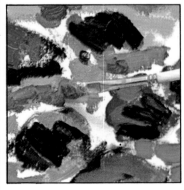

2 Short strokes of burnt sienna and cadmium red are applied to the rocks, the brushmarks defining their forms.

4 To create ripples on the water's surface, a small bristle brush is used to touch in tones of green and other light colours.

Sea • Oil

1 The picture is painted on hardboard covered with scrim which means that the artist has to apply the paint thickly, because the surface is very absorbent. The paint catches on the raised parts of the scrimmed support, adding texture to the surface.

4 The artist smears the blobs of white paint slightly, maintaining the texture.

2 The picure is divided into three zones, the sea taking up the central wedge.

3 To create the effect of rippling water the artist applies the paint directly from the tube in thick blobs. The white paint reflects the light in a different way from the flat surface.

5 As a final touch dabs of yellow oil pastel are added over the water's surface to increase the variations in its texture.

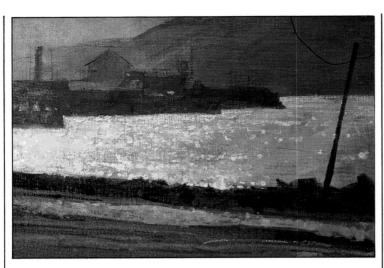

6 The artist has created a lively landscape, the shimmering water contrasting dramatically with the dark tones of the land.

CALM WATER

The smooth surface of a lake or river on a calm day is best depicted with broad, flat washes applied WET-IN-WET. Use a minimum of brushstrokes, otherwise the illusion of the glassy surface will be lost.

Calm water • Acrylic

1 The three areas of the picture are simply blocked in with base colours. The band of water in the foreground is painted in phthalocyanine blue and white.

2 Touches of phthalocyanine and cobalt blue are added to the water's surface to convey the reflection of the sky in the water.

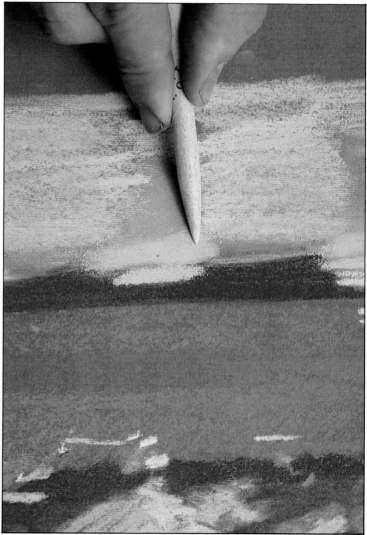

Calm water • Pastel

1 Soft pastel has many advantages when it comes to making sketches and studies outdoors. It is easy and quick to use, and capable of producing a wide range of expression. In this sketch of a riverside scene, softly blended tones and rough hatching are combined to capture the sparkle of a bright summer's day. The artist has chosen to work on a smooth, tinted paper in a light shade of green, which provides a sympathetic background for the landscape greens as well as harmonizing the composition.

2 To give an impression of still, calm water, the artist blends the tones of the reflections together smoothly using a clean rag, bringing the colour down in vertical strokes.

3 The picture is sprayed with fixative to prevent smudging and allow further layers of colour to be added without muddying those beneath. Bright highlights dancing on the surface of the water are applied more thickly, and blended with a torchon to set the colour into the wave of the paper.

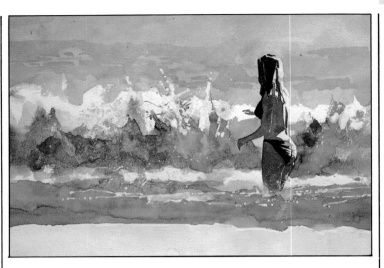

WAVES
Conveying the force and energy of an incoming wave may seem a daunting prospect, but it is really just a question of using your brushstrokes to capture the essential gesture of the water.

The artist painted this watercolour picture very rapidly in order to maintain the spirit of the subject. Working on damp paper, he quickly brushed in various tones of Payne's grey, ultramarine and burnt umber, pushing the colours together on the surface and letting them mix wet-in-wet. A clean wet brush was used to lift out some patches of colour, and the picture was spattered with opaque white to give the impression of splashing foam.

WEATHER EFFECTS

The ability to generate a feeling of atmosphere and mood in a landscape painting is one of the hallmarks of a skilled artist. The prevailing light and weather conditions play an important part in establishing such a mood, and will often turn a perfectly ordinary scene into a memorable one. Strong sunlight makes the very air vibrate with colour and gives rise to deep, dark shadows. Fog and mist act like a veil upon the landscape, turning hills and trees into eerie shapes that seem to float above the land. Storm clouds are particularly dramatic, especially when strong shafts of sunlight break through and spotlight the distant landscape. Lashing wind and rain set the landscape in motion as trees bend and leaves fly. And after a fall of snow, the whole landscape seems hushed and still, the dark shapes of trees and buildings looming in stark contrast to the whiteness of the land.

Though it is possible to recreate atmospheric effects from photographs, there is no substitute for actually getting out there among the elements. Other senses apart from sight have a part to play in painting; if you can smell the sun on the grass, hear the pounding of surf against the rocks, or feel the sharpness of a frosty day, these qualities will come through in your painting, almost without your being aware of it. Even in a blizzard or a downpour, it is possible to work directly from nature by viewing the scene from your car window, or finding some other shelter. If you can't actually set up your easel, weather conditions can be recorded quickly in a watercolour or pencil sketch, so that a finished painting can be painted later in the studio. Indeed, working under adverse conditions often forces you to work directly and spontaneously, capturing the essence of the weather without danger of overworking your painting.

When painting the weather, it is important to switch off the analytical side of your brain and be responsive to the feelings generated by a sparkling spring day or a crashing thunderstorm. Because atmospheric conditions are transitory and difficult to 'pin down', the creative artist turns this to advantage by letting the paint itself suggest the power and drama of nature. The watercolourist has a distinct advantage here, since the medium's fluidity and spontaneity have often been compared to the behaviour of nature itself. But every medium has its own special

qualities, and it is worth experimenting with unusual techniques to express the ever-changing moods of nature.

FOG AND MIST

A landscape which is shrouded in mist takes on a strange, haunting, unfamiliar aspect, and this indefinable quality has attracted artists for centuries. The great masters of traditional Chinese and Japanese painting delighted in rendering, with a few exquisite brushstrokes, an impression of mountains and trees looming out of the mist. Of the European painters, Turner is the unequalled master of depicting the effects of sun, water and light on landscapes and seascapes.

Because fog and mist are actually water vapour hanging in the air, it follows that a fluid medium such as watercolour lends itself particularly well to such a subject. Oil paints, too, can be used with great success, because their slow rate of drying allows for subtle WET-IN-WET blendings. Pastel is another favourite medium, especially for on-the-spot studies; with a few rapid strokes, hastily smudged with the finger, the artist can capture a fleeting effect of hazy light before it disappears for ever. Finally, egg tempera is perfectly suited to the still, mysterious quality that pervades the landscape on a misty day.

Fog acts as a filter on the landscape, reducing forms to simple silhouettes, minimizing tonal contrast and eliminating textural detail. There are many techiques which you can use to render this effect in your paintings. In oils, an excellent method is to apply a TONED GROUND of heavily diluted raw umber and then to render the muted tones and colours of the landscape with

delicate SCUMBLES which allow the ground colour to show through. This technique produces a highly atmospheric, 'soft focus' effect.

Another interesting technique is to TONK the painting with newspaper before the paint dries. This removes much of the colour from the surface and has an overall softening effect on the painting.

Haziness is also achieved through the classic techniques of working wet-in-wet. The best way is to start with the mid-tones and then work the darks and lights into the wet colour, blending the edges of the forms into each other.

In watercolour, some artists prefer to soak the entire paper and work into the wet surface to produce a soft blending of tones. Others prefer to work on a dry surface, using a small sponge to wet those areas where a hazy effect is required. This method gives you more control over hard and soft edges, and is excellent for depicting subjects which are only partially enveloped in mist.

In general, fog and mist reduce the intensity of colours, giving them a cold, grey or grey-blue cast. The exception might be in the early morning or late afternoon, when the sun's rays colour the mist a pale yellow. To achieve this muted effect, keep to a limited palette of harmonious colours.

Fog also reduces the intensity of tones, so tone values become very important when painting a misty scene. To achieve a sense of distance in your painting, always start with the pale, indistinct forms in the background. Then paint the middle ground, with slightly deeper tones. Finally, in

the foreground, include accents of dark tone and sharp detail. This contrast makes the background look pale and more misty and lends a sense of depth and mystery to the scene.

Fog • Oils

A landscape with rolling hills and fields stretching into the distance takes on a special atmosphere when shrouded in early morning mist. The effects of aerial perspective are heightened — foreground, middle ground and background become much more separate and distinct than normal, and the forms of the land become flattened silhouettes, almost like stage flats stacked one in front of the other. In this oil painting, the artist uses the direct, alla prima technique, working the colours wet-into-wet to achieve the softness of tone characteristic of a misty day. He then finishes off by tonking the entire painting to soften the tones even more.

1 With a thin wash of cadmium yellow, titanium white and a touch of ivory black, the artist roughly sketches in the main outlines of the landscape with a No. 2 bristle brush. Starting with the farthest line of trees, he blocks in a pale tone with a cool mixture of ivory black, titanium white and raw umber. The next band of trees is blocked in with a slightly darker tone, containing more raw umber and less white.

2 The artist uses increasingly deeper and warmer tones as he works towards the foreground. The nearest group of trees is painted with a mixture of sap green, raw umber and a touch of ivory black, using a No. 4 flat brush.

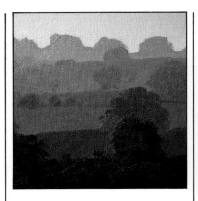

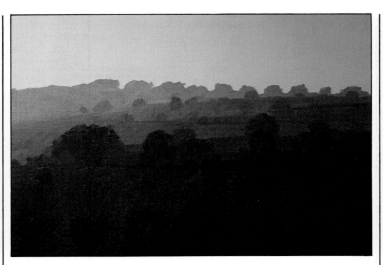

3 Here you can see the gradual change in tone from background, to middleground, to foreground. It is important to keep each separate plane distinct, but at the same time there should be no sudden jumps from one tone to another — the overall effect should be soft and muted. Work the edges of each plane into the one before by blending wet-in-wet, particularly in the background.

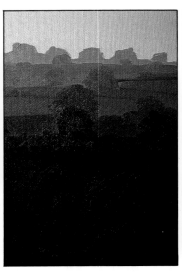

4 Finally, the foreground field is painted with a large bristle brush, using vigorous scumbling strokes to give texture and movement.

6 The paper has absorbed the excess paint from the surface of the canvas and softened the tones overall, adding to the impression of mistiness.

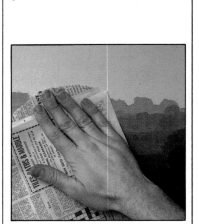

5 While the paint is still wet, the artist tonks the entire painting; a sheet of newspaper is laid over the picture and rubbed gently with the palm of the hand, then carefully peeled away.

Fog • Watercolour

The softness and delicacy of watercolour makes it an excellent medium for rendering impressions of fog and mist. Here the artist uses a combination of hazy, indistinct washes and sharper, crisper detail to create a misty landscape which recalls the understated beauty of a traditional Oriental ink drawing.

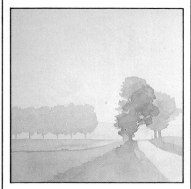

1 Working on a sheet of stretched 200lb Blockingford paper, the artist begins by painting the field and the distant trees with a mixture of ivory black and Payne's grey, heavily diluted with water. When the first wash is dry the foreground trees are further developed by adding a slightly darker wash; this deeper tone gives depth to the scene by bringing the nearer trees forward and making the pale shapes in the background seem more distant by comparison.

2 This detail shows how the washes are painted wet-over-dry to create crisp edges, which gives a suggestion of the foliage texture.

3 The painting is allowed to dry. The tops of the background trees are then flooded with clean water, applied with a soft sponge, and gently blotted with a tissue. This removes most of the pigment from the area, leaving just a slight hint of colour. It is essential to allow the paint to dry *before* flooding it with water, so that the pigment has a chance to stain the paper.

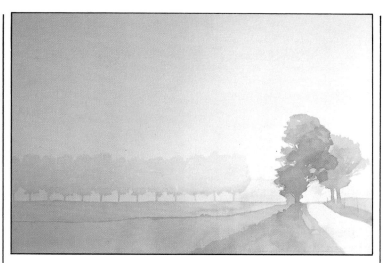

4 The background trees now have an intriguing lost-and-found quality, blending softly into the grey distance. The beauty of the painting lies in the delicate balance between crisp forms in the foreground and soft, hazy forms in the background.

RAIN

Painting an impression of a rainy day can be tackled in several ways. You can indicate falling rain by using diagonal or vertical brushstrokes to build up the painting, or you can ignore the raindrops and choose instead to imply the effects of rain on the landscape by softly diffusing the images. To indicate the wetness of rooftops and roads, paint them very light in tone, and use a contrastingly dark tone for the sky. Puddles on roads and pavements, showing reflections of trees and buildings, also add to the atmosphere of a rainy day.

The dominant colour in a rainy scene is most likely to be grey, but make the greys interesting by mixing them from various combinations of blues, reds and yellows, rather than just black and white.

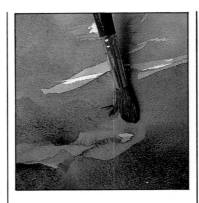

Rain • Watercolour

1 A sheet of 200lb Bockingford paper is taped firmly to the drawing board and then wetted with clear water. A wash of Payne's grey is applied with broad strokes, leaving small areas of white paper which indicate bright light shining through gaps in the clouds. While this wash is still damp, a loose wash of Payne's grey and ivory black is flooded in, wet-into-wet, using a large sable brush.

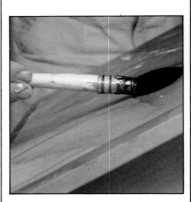

2 Tilting the board up at an angle, the artist allows the colour to drift midway down the paper, using a large mop brush to guide the pigment where he wants it to go.

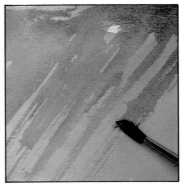

3 The colour is then brought down towards the horizon with diagonal strokes, using a No. 6 sable brush. The artist works quickly and with a light touch, so that the colour is broken up by the raised tooth of the paper.

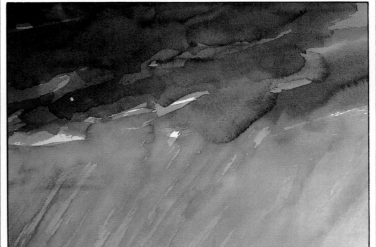

4 The diagonal strokes have softened slightly into the damp wash beneath, creating a subtle impression of drifting rain.

SNOW AND ICE

Snow and ice are generally regarded as being white, but they are in fact rarely pure white, except in the brightest areas. Snow and ice are water in solid form, and, just like water, they reflect colour from the sky and nearby objects. This is especially noticeable in the early morning and late afternoon, when the sun strikes the surface of the snow at a low angle and tinges it a delicate pink or yellow. In fact, these are the best times of the day for painting snow scenes; the light is far lovelier than it is during the middle of the day, casting warm pinks and golds in the highlights, and luminous blues and violets in the shadows. In addition, the long shadows cast by the sun at these times of the day add drama to the scene and help to define the snow-covered forms of the land.

Inexperienced artists tend to think that painting a snow scene means piling on endless layers of thick white paint. On the contrary, the most atmospheric snow scenes are those which contain a lot of shadow, with only small areas of bright, sunlit snow. The bright spots look dazzling because of the contrasting shadows, whereas if the whole picture were painted in bright white the effect would be flat and monotonous, with no feeling of light at all.

When painting a snow scene in opaque media, always begin with the light colours and gradually add the cool shadow colours. It takes less paint to darken a light colour than it does to lighten a dark colour. With transparent watercolour, the opposite applies. You must establish the position of the brightest highlights on the snow in advance, and paint around them, working from light to dark.

After a heavy fall of snow, the objects that it covers take on soft contours and curves. The light planes blur softly into the shadow planes, with no hard edges, so model these forms by WET-IN-WET BLENDING.

When painting shadows on snow, you will notice that they appear crisp near the object casting the shadow, but more diffused further away. This is because a lot of reflected light enters the shadows from the sky or from nearby snowdrifts. Keep the shadows airy and transparent by using thin pigment and fresh, clean colour.

Falling snow

Falling snow cuts out much of the detail in background images, reducing them to faint silhouettes if the fall is heavy.

In opaque media, STIPPLING and SPATTERING are very effective in rendering falling snow. In watercolour painting, you can either spatter with opaque (Chinese) white, or you can create an impression of snowflakes by the use of salt granules, as shown below.

Snow • Gouache and Watercolour

In this painting, the artist tackles the problem of rendering an impression of falling snow so that it looks natural and uncontrived. One of the best ways of doing this is with the technique of spattering: the tiny droplets of paint fall onto the paper in a random fashion which perfectly captures the effect of swirling snowflakes.

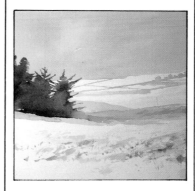

1 Working on a stretched sheet of 200lb Bockingford paper, the artist begins by painting the sky with a pale tone of Payne's grey. Saving the white of the paper for the brightest areas of the snow, he indicates the shapes of the distant trees and hedgerows with faint grey lines. The spruce trees on the left are then painted with a dark wash of Hooker's green and Payne's grey. In the foreground, quick drybrush strokes of burnt umber indicate clumps of grass and earth uncovered by the partially melted snow. This addition of a warmer tone in the foreground accentuates the sense of depth in the painting.

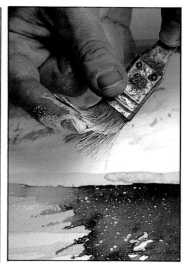

2 The painting is left to dry naturally. Meanwhile, a thick but fluid wash of white gouache is mixed on the palette, ready for spattering to begin. This is the tricky part of the painting — the droplets of paint must be of the correct size and density, otherwise the effect could be ruined. Always do a 'test run' on a piece of scrap paper before applying the technique to an actual painting. This way you will learn to gauge the fluidity of paint required and also the best distance between the brush and the paper (generally this should be at least 15 cm/6 in). Here the artist is using a 1.25 cm (½ in) decorator's brush, running his finger through the bristles to create a fine spatter.

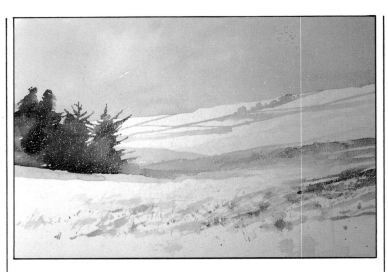

3 In the finished painting, notice how subtly the spatter has been applied to give a naturalistic effect. It is important not to overdo the spatter — too little is better than too much, unless you deliberately want to create the effect of a snowstorm. This 'veil' of semi-opaque gouache also softens the forms and colours underneath, just as real snowflakes partially obscure the landscape as they fall.

Snow • Oil

1 Once the basic colours for the sky and hills have been laid in cerulean blue and white, the artist paints in the long shadows with a mixture of cerulean blue and a small amount of white and black.

2 Then he adds the middle tones of the shadows, using a pale blue mixture.

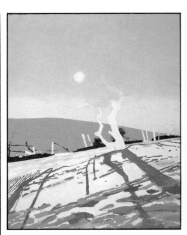

3 As the painting develops the artist softens the hard lines of the snow and shadows by splattering white paint in the foreground to suggest falling snow.

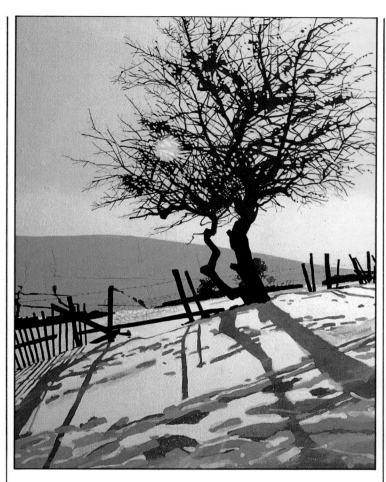

4 In the finished picture the artist has successfully created dramatic contrasts using simple forms and a limited palette for the dark silhouetted trees against the sky, and the blue shadows against the snow.

Snow • Oil
1 The fluffiness of snow is difficult to describe in paint but using a piece of hessian can achieve marvellous results. Tape the piece of hessian over the support and press a brush well loaded with paint onto the hessian, forcing it through the fabric. The paint should not be pure white but tinged with the colours of the landscape.

2 Lift the hessian from the painted surface carefully and you should reveal solid areas of paint with soft rather than hard edges.

3 Sometimes too much paint gets pushed through the hessian — the excess paint can be smudged with a rag.

4 To create the effect of distant snow flurries, the artist splatters paint on the dark trees, using a 2.5cm (1-inch) decorator's brush.

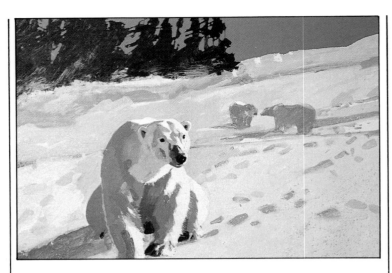

5 With this difficult subject of white on white, the artist has successfully built up the solid form of the bear against the fluffy white background.

BRIGHT SUNSHINE

When painting a scene bathed in bright sunshine, it is all too easy to become 'blinded' by the intensity of colour and light. The result is that the painting becomes too high in key overall, lacks tonal contrast, and generally looks washed out. Interestingly, the secret of creating the effect of bright sunlight lies in painting the shadows. Light looks even brighter when surrounded by darks, which is why many artists employ the compositional device of throwing a shadow across the foreground and placing a small, brightly lit area in the middle ground. The viewer's eye instinctively focuses on that spot of bright light, and the scene looks sunny, even though most of it is in shadow.

When the sun is at its most intense, the colour of the light itself affects the local colours of the objects it strikes, often quite dramatically. Everything the sun hits becomes lighter and warmer in tone, while shadows are correspondingly cool because they reflect the blue of the sky. Balance bright, warm colours with deep, cool shadows so that they intensify each other and create strong tonal contrasts that spell 'sunshine'.

Another important point to watch out for is the reflected light in shadows. On a sunny day, there is so much light about that it bounces from one object to another. Thus, the shadow side of a white house may look blue, reflecting the sky, or it may be tinged with green if there are trees nearby. Being aware of subtle points like this will lend greater luminosity to your painting.

Brushwork techniques also contribute to the atmosphere of the painting. In opaque media, always paint the shadows thinly and use thick IMPASTO (which reflects a lot of light) for painting light-toned areas. In watercolour, the bleaching effect of the sun is rendered simply and effectively by leaving white shapes for highlights. Remember also that intense sunlight diminishes sharp details, so use softened brushwork in some areas.

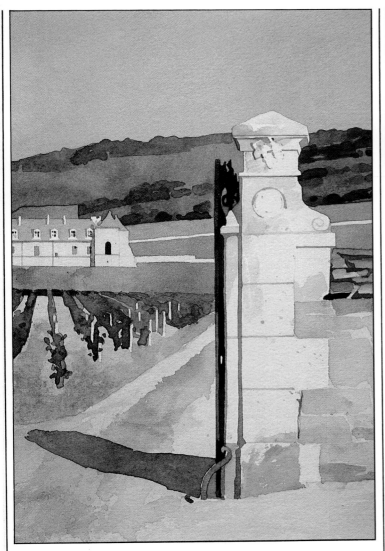

Bright sunlight
In this watercolour landscape, the impression of bright sunshine is conveyed by the contrast between the intense white of the stone pillar and the deep, dark shadow which it casts on the ground.

Dappled sunlight
1 Having sketched the picture in charcoal and laid down the basic areas of colour, use cadmium yellow medium for the light tones in the trees and cerulean blue for the highlights on the water.

2 Once you have roughly painted the trees, add touches of alizarin crimson mixed with cadmium red medium. Brighten this mixture with a touch of white in places.

3 To define the reflections of the trees and sky use the same mix of cadmium yellow light and white used in the sky, on the water.

In the painting the artist has created a marvellous sense of colour harmony by reflecting each of the colours in other parts of the composition.

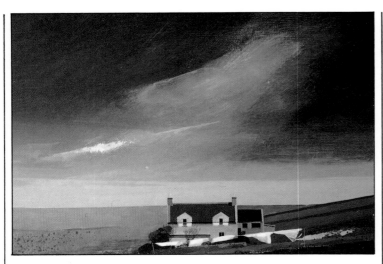

Stormy weather

If you wish to focus attention on a dramatic stormy sky, keep the horizon line low so that the landscape doesn't vie for attention with it. In this acrylic painting, the colour of the steely grey sky has been intensified deliberately so as to heighten the mood; the clouds seem to be bearing down on the lonely house on the hill. The movement of the clothes drying on the washing line also adds to the tension by implying the presence of a gusting wind.

Stormy weather • Oil pastel

1 With strong diagonal strokes the artist roughly sketches the main areas of the sky, land and sea in cerulean blue.

2 He then adds diagonal strokes of grey and white pastel, which he blends together.

3 Oil pastel is a versatile medium and here the artist spreads bits of broken white pastel onto the picture's surface with a palette knife. To create texture he uses the knife to scratch into the pastel.

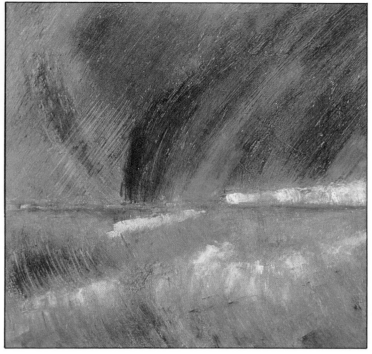

4 To portray the effect of broken water, a cotton bud dipped in turpentine is used to spread the pastel, blending the strokes together.

5 Thick white pastel is added for the headland and breaking waves. Using a palette knife, the artist scratches through the pastel to the paper, making white streaks.

CREDITS

All the demonstrations were painted by **Ian Sidaway,** except for the following: pp.49 centre, top and bottom, 77, 105, 106 left, 175 right, 176 left,**Gordon Bennett**; pp.107 below right, 109 left, **Moira Clinch**; p.151 right, **John Devane**; p.84 far right, **Dietrich Eckert**; pp.15 centre, below, 188, 201 right, **Vicky Funk**; pp.115 right, 117 right, 145, 146 left, 161 right, 162, **Kevin Hennessy**; pp.21 far right, below, 22 far left, **Jan Howell**; pp.167, 169 centre, right, 170 left, **Nicki Kemball**; pp.96 centre and far right, 101 right, **Sally Michel**; p.119 right, **John Newberry**; p.202 right, **Mike Pope**; p.42 right, **Guy Roddon**; pp.116 right, 117, 134, 190 right, **Lincoln Seligman**; pp.140 right, 141 left, **Wendy Shrimpton**; pp.80 right, 81, 82 left, 107 above right and centre, 147, 148 left, 180 left, 189, 190 left, **Stan Smith**; pp.95, 96 right, 99 bottom left, **Maurice Wilson**; 177 right, **Marc Winer**; pp.92, 93 left, 120, 121 **Ken Wood**.

Quarto would like to thank Ian Sidaway for his contribution to the book, and for the use of his studio, and offer special thanks to Daler Rowney for their generous donation of materials and equipment for this book.